PRESTON'S COLLEGE

LEARNING

Tel: 01772 225310
Email: learningzone@preston.ac.uk

Class no: 770 Col Barcode:

(Normal loan) Short loan

Library use only CD/DVD in book

CD/DVD available – ask staff

LIGHT MATTERS

Writings on Photography **Vicki Goldberg**

aperture

Front cover: Martin Parr, *Great Britain, New Brighton, Sunbathing, 1985,* from *The Last Resort*

Editor: Diana C. Stoll
Designer: Wendy Byrne
Production: Bryonie Wise
Proofreader: June Cuffner

The staff for this book at Aperture Foundation included: Ellen S. Harris, *Executive Director;* Roy Eddey, *Director of Finance and Administration;* Lesley A. Martin, *Executive Editor, Books;* Nancy Grubb, *Executive Managing Editor, Books;* Lisa A. Farmer, *Production Director;* Andrea Smith, *Director of Publicity;* Linda Stormes, *Director of Sales and Marketing;* Michael Itkoff, *Work Scholar*

The staff for the paperback edition includes:
Juan García de Oteyza, *Executive Director;* Mary Colman St. John, *Chief Financial and Administration Officer;* Lesley A. Martin, *Publisher, Books;* Susan Ciccotti, *Senior Text Editor, Books;* Inger-Lise McMillan, *Design Manager;* Allegra Fisher, Anna-Sophie Harling, Matthew Harvey, and Faye Robson, *Work Scholars*

The essays in this volume have been edited and updated for this publication; there are slight variations from the texts originally published.

First paperback edition, 2010
Printed in the U.S.
10 9 8 7 6 5 4 3 2

Library of Congress Cataloging-in-Publication Data
Goldberg, Vicki.
 Light matters : writings on photography / Vicki Goldberg.— 1st ed.
 p. cm.
 Includes index.
 ISBN 978-1-59711-165-2
 1. Photography. 2. Photographic criticism. I. Title.

 TR185. G65 2005
 770—dc22

 2004020203

This volume is part of **Aperture Ideas: Writers and Artists on Photography,** a series devoted to the finest critical and creative minds exploring key concepts in photography.

Aperture Foundation books are available in North America through:
D.A.P./Distributed Art Publishers
155 Sixth Avenue, 2nd Floor
New York, N.Y. 10013
Phone: (212) 627-1999
Fax: (212) 627-9484

Aperture Foundation books are distributed outside North America by:
Thames & Hudson
181A High Holborn
London WC1V 7QX
United Kingdom
Phone: + 44 20 7845 5000
Fax: + 44 20 7845 5055
Email: sales@thameshudson.co.uk

aperturefoundation
547 West 27th Street
New York, N.Y. 10001
www.aperture.org

The purpose of Aperture Foundation, a non-profit organization, is to advance photography in all its forms and to foster the exchange of ideas among audiences worldwide.

FOR LARRY, WHO MATTERS

CONTENTS

A QUARTER CENTURY OF PHOTOGRAPHY

ART PHOTOGRAPHY was on a pretty stringent diet for its first century and a half, but in the last quarter of the twentieth century, photographs ate the art world, and then had trouble digesting it.

So many people are at the table. In Chelsea, the newest gallery district in New York, if you fall down you break a photographer. In major cities in other parts of the world, galleries show photographs, or photography in mixed media, as often as other kinds of art, sometimes more often. Museums are just as eager. Photography festivals spread across the world—China, Japan, Russia, Africa. And prices, that index of consumer lust, climbed into the art stratosphere: in 1999, Gustave Le Gray's *Grande Vague, Sète* sold at auction for $838,704, and in May of 2003 an 1842 daguerreotype view of Athens sold for $916,126 (prices include premiums).

How did photography end up not merely conquering the empire it sought but virtually swallowing it? It all began with money, as almost everything does: in the early 1970s, as art prices broke pocketbooks, collectors looked elsewhere for high aesthetics at lower costs; lo and behold, photography qualified. Photography prices then rose; buyers congratulated themselves on wise investments; the market expanded.

This has done photography a world of good and a world of bad. The medium finally achieved the respect that was its due but at the price of being commodified, a price that more traditional art paid long ago. Jim Stone's *Pricerise*, a rephotograph of Ansel Adams's *Moonrise* with a barcode on it, said this succinctly in 1981. Photography as investment, photography as status, photography as another toy in the game of he-who-has-the-most-toys-when-he-dies-wins, photography as an addition to the roster of commodity fetishes—all this is good for dealers and for a few photographers but not exactly what Alfred Stieglitz had in mind when he tried to lift the medium out of the purgatory of craft.

By the late 1970s, photography's place at art's table was promoted by artists who didn't make conventional kinds of art photographs and didn't

like to be called photographers. Postmodernism was hitting its stride; the media were the messages. Richard Prince and Barbara Kruger rephotographed commercial photographs; Cindy Sherman imitated movie stills; Laurie Simmons and Ellen Brooks concocted domestic soap-opera scenes staffed by toys and recorded them in photographs no one could mistake for Westons or Strands. It was safer for the cognoscenti to buy such photographs, because in a sense they weren't "mere" photographs, but had a tougher claim to art and whatever remains of the avant-garde in our time.

Two other factors sealed photography's right to sit with the big boys of art: color and size. John Szarkowski, then Director of the Photography Department at New York's Museum of Modern Art, established color photography as an art medium on a par with black and white in the William Eggleston show at MoMA in 1976. By the early 1980s, photographers had learned how to enlarge color to impressive dimensions without losing clarity. Art collectors were assuaged. It wasn't possible to hang an 11-by-14 Ansel Adams next to a Mark Rothko without producing Mutt and Jeff. The Rothko engulfed you, the Adams demanded nearness, possibly even myopia. But a 20-by-24 or a 30-by-40 color photograph could hold the wall and might even be mistaken for "art" at first glance.

Over the last twenty-five years, color photographs bulked up on steroids. Thomas Struth's reach 7½ by 6 feet plus; some of Andreas Gursky's are 16 feet wide. They have prices to match. They are no longer just big enough to hold their own with art on the wall; now they require mansions, where they elbow paintings out of the way.

Photographic images even bid to take over buildings; artists like Shimon Attie and Krzysztof Wodiczko project compelling life-size or much larger images on walls and towers. Some of these mammoth photographs are real achievements, but size, although we are automatically impressed by it, is neither everything nor enough. All too often that is *all* there is: uninteresting images inflated to levels of unearned authority, scale as a substitute for invention, Chihuahuas masquerading as Great Danes.

The power of monumentality is especially useful to images in a time when so many crowd the view. Advertisers demand our attention with billboards offering ten-foot-high come-hither looks, blank building walls display eight-story-high models in blue jeans. There is no escape from photography, even in the street. Advertisements are the great site for still photography today, with news in second place, galleries a distant third if you're counting the audience. Magazines and newspapers, dependent on

ads for survival, print more advertising than editorial photographs. Some of the ads are artier than the art. For both editorial and advertising, upscale print media of the last couple of decades have become deft appropriators of art trends, which they swiftly disseminate to a large public, spreading a subliminal familiarity with art trends more widely than museums can manage.

The boundaries between commerce and art are blurring everywhere. Some of the newer high-chic magazines such as *Purple* and *Dutch* publish fashion photographs that say much more about artistic ambitions than about the clothes. Photographers with established art reputations, such as Gregory Crewdson, Philip-Lorca diCorcia, Sandi Fellman, Barbara Kastner, Juergen Teller, Joyce Tenneson, William Wegman, and Erwin Wurm, are hired to advertise products or grace high-fashion pages by turning their signature styles to the task. Commercial photographers boldly lift styles from yesterday's art photography or today's without a qualm. In the last couple of years, the *New York Times Magazine* ran one fashion section that openly imitated Farm Security Administration work and another that openly copied Cindy Sherman's. No doubt this is a sincere form of flattery—more, I think, of the readers than of the photographers, for the assumption is that you and I know the originals, and that recognition ensures us the *Good Housekeeping* seal of culture.

Galleries, museums, and auctions have redrawn all the traditional boundaries of art to let in new media, old junk, amateur fancies, scientific data. Photography has done the same. Categories no longer count. Commercial photography, medical and scientific imagery, snapshots, family albums, documentary reports, prison photographs, and news of every stripe are all fodder for the art mill. Some of these are interesting. Some are not.

This inclusiveness is one sign of the breakdown of hierarchies in the visual arts, a breakdown that opened up perceptions and gave the nod to experimentation. When hierarchies crashed, so did the concept of standards of quality. Although the philosophical points that there are no eternal verities in a diverse world and that no individual has the key to some universal rating standard are hard to argue with, the abandonment of ideas and judgments of quality still strikes me as a disaster. When ideas of good and bad abdicate, disorder reigns and trash holds court. There's a lot of twaddle out there claiming to be art. There are a lot of photographers out there trying hard to look as unprofessional as they can. Many succeed. They fall in with a peculiar vogue for uninteresting, uninflected pictures of

chain-link fences or skuzzy backyards, pictures even amateurs might be tempted to throw away.

Inclusiveness, however, has been a kind of salvation for photojournalism, which has been welcomed in art venues while the pages once allotted to it have progressively shrunk in favor of celebrity portraits, paparazzi reports, and single news pictures that have to do an essay's job. Photojournalism is proliferating in one place: on the Internet, which is also making a bid to revive the photo-essay with strings of photographs or brief videos sometimes available on command. Elsewhere, the recent concentration of agencies and stock houses and the enormous numbers of cameras—not to mention the prevalence of TV cameras—covering anything resembling a news event, has squeezed photojournalism hard. Competing news magazines occasionally run the same or nearly identical images on their covers, not necessarily because it's a landmark image but because it's available.

Photojournalism has also suffered from a gathering distrust of documentary. If docudramas and films that play fast and loose with historical fact didn't make people wary, critics would, with their repeated denunciation of the imbalance of power between photographer and subject. Critics accuse photographers of stereotyping the poor and thereby helping to perpetuate their poverty; of exploiting rather than helping the famine-stricken; of abetting atrocity by offering oppressors the chance to be famous for fifteen minutes. Reporting is a dangerous game, in more ways than one, especially now that journalists have become targets in foreign conflicts. The wonder is that photojournalists believe enough in what they do to carry on.

All the more so in that general-interest magazines have been on the decline, more slowly in Europe than America, but declining there too. To a degree, photojournalism, even war journalism, seemed for a while to have shifted from the daily and weekly pages to museums and books, becoming ever more "artistic" in the process as photographers like Sebastião Salgado and James Nachtwey adapted the lessons of recent photographic history. Some of the best art photographers—in the conventional sense of fine composition and/or color (not to mention subjects worth paying attention to)— are photojournalists. Or documentarians, or street photographers, or social reform photographers, all those categories tending to overlap.

When the subject is news, this aesthetic brilliance poses a quandary: what is our relation to images of horror or degradation that could be described as beautiful? And where do such images belong? While the pub-

lic decries the prevalence of violent imagery, museums and galleries frame it on their hallowed walls. In early 2003, one New York gallery exhibited a Chechen rebel's poorly focused, horrific video of a devastating attack on a convoy of Russian tanks and the display of the corpses to the local populace.

The events of the last few years, however, have introduced some radical changes to photojournalism and news photography, and have brought the power of the still image roaring back from its anxious position in television's shadow. TV, of course, still takes precedence in time; the horrors of 9/11 were seen worldwide within minutes, although this time the screen was sometimes a computer monitor. Then it was still photographs' turn. They ran large in every kind of publication, showed up in galleries and special exhibition spaces, and kept reappearing long after television had quieted down. Many of those photographs were taken by amateurs. Amateurs have long had a place in hard news, but the scale this time was unprecedented, reminding us that the ultimate law of news photography is to be in the right (or wrong) place at the right time.

Amateur videos were also aired extensively on network, on cable, in exhibitions. Amateur video had already proved itself crucial to news—the 1988 Tompkins Square riot in New York, Rodney King in Los Angeles in 1991—but this time the number of entries was so high because the attack occurred in such a populated, tourist-attraction city, and because video-cameras have become the kind of staple equipment that still cameras became long ago.

Terrifying and heartrending as the videos of the airplane impacts and the collapsing buildings were, still photographs that pierced the soul lingered in New York: family, graduation, engagement, business portraits of missing people were tacked up in endless arrays on walls and fences in hopes that someone, somewhere, would recognize the faces and know their whereabouts.

The distinction between amateur and professional was effectively erased in the records of 9/11. One show turned this fact into philosophy. "Here Is New York," an exhibition put together by Charles Traub and Michael Shulan in the SoHo district of Manhattan, included pictures by anyone and everyone who brought in photographs related to the attack on the World Trade Center. All were scanned into a computer and printed, then tacked to the walls or hung up on clotheslines with no names attached, so you didn't know whether you were looking at work by a

big-name photographer or an accountant who lived in the neighborhood. (The exhibition traveled around the world and was published as a book.) "Here Is New York" fulfilled the inherently democratic nature of photography, which, if it did not promise that everyone could be an artist, did randomly offer anyone, talented or not, the possibility of making a deeply meaningful record.

Gulf War II injected, or certified, certain changes that were already overtaking photography. Real-time transmission from a war zone was not new but easier, and now it came from within the troops as they moved and occasionally even from an actual battle. Because pictures no longer went through a laborious military censorship, photographers had more leeway than they had had in other recent wars, but "embedding" produced its own subtle kind of censorship, and the different images published and broadcast in Europe and especially in the Arab media made it blindingly clear that the distribution of images to the public was governed by political and social issues as much as by military ones.

The 24/7 flow of information on television did not produce a ceaseless parade of arresting images, and print media and even television hastened to publish or broadcast portfolios of still photographs taken with an eye for significant moments. After Baghdad fell, numerous books of photographs, many with previously unpublished images, were rushed into print. Still photographs, more lasting in the mind than moving images, continued to bid for a large share of the public agenda.

And then they took over that agenda in an unexpected manner. The photographs that had the greatest influence on public opinion, with the possible exception of the images of Saddam Hussein after his capture and the horrific pictures of hostage beheadings (which were shown very little), were entirely amateur photographs, many made with little cell-phone cameras: the pictures from Iraq's Abu Ghraib prison. Once these images of American soldiers physically abusing and sexually humiliating Iraqi prisoners (and often enjoying it) got onto the Web they could not be removed, censored, or stopped; they promptly raced around the globe. Photography itself had not changed, but its distribution had, and that had cost the military and the government a prerogative they thought they owned: control of the imagery of war.

When the magazines downplayed journalism in favor of celebrity in the 1970s, portraiture had already begun to shift from flattery to put-down,

from glamour to caricature, as rock stars had proved that looking debauched, outrageous, or extreme was a ticket to fame. In the past twenty-five years, in an effort to make standard stars blaze in a crowded firmament, portraits by photographer-stars such as Annie Leibovitz, Herb Ritts, Matthew Rolston, and Helmut Newton veered toward eccentricity, drastic stylization, and the transformation of public personas into emblems and fetishes. A celebrity-crazed public was enchanted. When Leibovitz's portraits went up at the Smithsonian, the crowds were so great that the museum ran out of toilet paper and paper towels.

Postmodernism came in about the same time as the celebrity craze and turned to photography as a major vehicle. One of the movement's prime messages was that life had been ineradicably changed by the media, which so heavily influence attitudes, behavior, and culture that representation had in effect replaced experience. The weight of countless simulacra was so great a burden that it had killed off the potential for originality. Now photographs critiqued what photographs had wrought.

And women held the cameras. Unlike painting and sculpture, photography had neither a strong academic tradition with rules, conventions, and requirements for entry, nor an old boys' network that was hard to breach; women like Cindy Sherman, Barbara Kruger, Laurie Simmons, and Ellen Brooks just forged ahead.

While photography was swallowing the art world and throwing authentic experience into the garbage, it continued to respond to cultural forces on many levels.

As multiculturalism became a byword, black photographers such as Carrie Mae Weems and Lorna Simpson, as well as recent immigrants and photographers of mixed ethnic heritage, came to the forefront in America, and photography from Russia, Asia, Africa, and Latin America that had seldom been exported before was introduced to Western countries. Here at least, globalization enriched the social fabric on every side of the exchange.

National and ethnic issues stirred up and mirrored a crisis in identity late in the century, as self-definition grew increasingly fluid and elusive. People sought ways to distinguish or label themselves other than money or fame, which had crowded out most other signifiers. Gender and sexuality issues and ambiguities had joined ethnic identification in a quest for and a questioning of the self, even before the Internet made it possible for everyone to be anyone where no one could be seen. Arthur Tress photographed himself as both bride and groom in a single image. Joel-Peter Witkin

photographed hermaphrodites. Diana Thorneycroft tried on a mask of her father's face, as well as a fake penis.

Photographers like these have brought into the open hidden facts and desires. The rush to sexual liberation in America in the 1960s combined with other trends to make the fundamental voyeurism of modern existence one of life's necessities and inalienable rights. In that decade, Diane Arbus's photographs offered a limited absolution to those who could not help staring at dwarfs and transvestites; paparazzi provided keyhole views of the private lives of the famous; Eddie Adams, Ron Haeberle, and Don McCullin put more unambiguous horror on paper than TV generally permitted.

Levels of violence and sexual explicitness in the media continued to ratchet upward, unsettling even Europe. In America, the Robert Mapplethorpe court case and the police raid on Jock Sturges's studio for his pictures of adolescents posing in the nude reflected the depth of the right wing's dismay about the new permissiveness (and in Mapplethorpe's case, the fear of homosexuality). In France in 2001, BVP, the advertising watchdog, drafted standards to rein in porno-chic ads. The next year, a Dior ad with a sweaty woman in what looked like the throes of orgasm and a YSL ad with a full-frontal male nude (discreetly cropped at the torso in most American journals) occasioned protests. Today, many Europeans are newly worried about how violence in the media is influencing their lives.

Restrictions were relaxed on privacy as well, both one's own and others'. It was a tell-all time, when feminists wrote novels about their ex-husbands, film stars spoke publicly about childhood sexual abuse or adult addictions (and were applauded by their fans), and the not-yet-famous agreed to be watched by TV cameras at every moment, nothing restricted, nothing withheld. Perhaps this was a logical consequence of what Christopher Lasch referred to as the "culture of narcissism": as much of the self as possible on display. At any rate, while computer data banks and security measures increasingly threatened individual privacy, a number of art photographers opened up their own and others' lives to public inspection.

Larry Clark set an example with pictures of his teenage friends' drug addictions and sex lives in *Tulsa* in 1972. Nan Goldin was already photographing by that time; her camera clicked on herself and her friends day in, night out, in bathrooms, in beds, beaten by lovers. By the 1990s, some photographers were recording their own sex lives in detail in hopes of showing them off to a sophisticated audience. Sophie Calle bested them on invasion of privacy, having her mother hire a private detective to follow her,

then exhibiting his photographs in galleries; following and secretly photographing a perfect stranger; taking a job as a hotel maid and photographing the contents of the guests' rooms while they were out. In Ukraine, Boris Mikhailov paid homeless people to pose, some with their pants down, their scars exposed, their toothless mouths on show.

Even as privacy has gone public, photography has been exploring its counterparts: distance, disengagement, alienation. The rush to public intimacy, essentially a contradiction in terms, may be an indication of how difficult intimacy has become, how divorced from direct experience the citizens of a media-saturated (and now digitized) world feel.

Detachment, the philosophical heritage of Conceptual art, is most lucidly represented by German photographers like Hilla and Bernd Becher, Andreas Gursky, and Thomas Struth, but it finds adherents everywhere. Gursky's photographs are occasionally so cool they could save you money on air conditioning. Objectivity, inherent in the camera but not in the photographer, is the goal and means of expression; these are documents to the nth degree, which translates as art. The imagery may follow a program, as in the Bechers' topological catalogs of industrial forms; it may imply commentary, but overt emotion is generally suppressed as extraneous to cameras. This particular kind of objectivity is not so rigid as the Conceptualists were; it does on occasion let beauty walk in the door.

Photographers commented on the distancing effect of the media's overwhelming invasion of life by setting up tableaux acted out by dolls or by staging intricate but clearly inauthentic scenes with human players. Another kind of fiction eventually stepped in to ratify a feeling that people had been displaced from their own lives. Some photographers, such as Weems, Crewdson, and Anna Gaskell, have devised allusive and obviously fictional narratives, often with uncomfortable overtones, but there was a larger trend toward elaborately devised scenes of studiously boring or insignificant events. A whole host of staged candids depicted uninteresting moments in the lives of forgettable young women. Ordinary existence having proved too tame in comparison to *The Sopranos* and *Survivor*, photographers, apparently unable themselves to find meaning in whatever was left of the world beyond TV, made it look tamer still.

The reality problem comes up here: the fact that photographs can lie and digits can lie prodigiously has become a major preoccupation of society—Was the event rigged? Has the news been slanted, censored, manipulated?—and of photographers. Photographers who stage "reality" have

introduced a new level of fiction to the medium that already fooled the eye exquisitely. James Casebere constructed some nearly believable sets; Hiroshi Sugimoto photographed wax figures out of their display cases and looking at first glance like actors costumed as historical figures; Vik Muniz photographed mountains and mines erected on tabletops and traversed by toy vehicles. Photographs lie, fib, and mimic reality almost as readily as they record it.

Of course digitization has produced more flagrant fictions, too, such as Pedro Meyer's miniature people, the Russian photographer Olga Tobreluts's fashion shots of models in computer-generated science-fiction cities, or Lucas Samaras's fantasies of himself in exotic landscapes. Photography, a medium that reached great heights when limited by its dependence on whatever was before the lens, is no longer hampered by visual fact or the camera's range of vision. Photographers can now claim the artist's privilege of working entirely from imagination. Still, the abolishment of constraints, like all experiences of unbounded liberty, has proved a mixed blessing. Computer-generated photographs seldom outdo the old kind—yet.

Although it has reportedly been dying for years, photography (in the sense of art photography) is out there reproducing faster than rabbits. Yet it is in danger from more quarters than mere liberty at the moment—from the possibility that digitization will discredit standard photographic practices altogether, from other media, from shrinking print outlets, and from a kind of interior malaise, perhaps due to getting fat without getting sassy. Video is currently in the position still photography was in thirty years ago: edging rapidly into art galleries, taking space away from other art (including still photography), becoming merely another instrument in an artist's toolkit. Computer imaging on monitors is also muscling into the field. Photography is far from dead, but the challengers are already in place, and fully armed.

What shall it profit a medium if it gains the whole world and loses its own soul? Art in general is floundering right now, too often neither addressing matters crucial to society in any meaningful way nor affecting the heart. Photography, having achieved parity with other art forms, suffers the same malaise. The sins of capitalism afflict it: too much of the work on gallery walls is directed at collectors, at hot trends, at money. Too much of it dabbles in stagnant backwaters on the mistaken assumption that the neglected margins are the cutting edge. Too much of it is Johnny-come-lately, jumping on boats that have already gone by. To paraphrase Yeats,

the best lack all conviction, and the worst don't even have any passionate intensity.

Photography finally succeeded in entering the art world, dazzling it, and then swallowing it whole—and at that very moment found itself sorely threatened and in danger of becoming irrelevant. Yet don't count photography out. There is fine, even splendid work out there, exceptions to the graceless run of things, that may yet be its salvation, and the Euro-Americocentric scene is receiving refreshing and challenging infusions from what used to be considered out-of-the-way places like China and Africa. One of the things that happened to the art world late in the twentieth century is that it grew so fast and so haphazardly that it overdosed, ingesting a lot that was mediocre or inferior. Inspiration and conviction do not necessarily increase at the same rate as art galleries. The cream may rise to the top after a while, but in the meantime, discriminating taste is forced to sample a lot that doesn't really belong on the menu. Critical disdain for the old-fashioned notion of standards of quality has spread further and, it seems, has had more severe consequences than even the critics imagined. As for me, I may be a philistine, but I'm on the side of standards and quality, shaky as those terms are. They can still be found in still photography; they have made their way into video and are finding their way into computer-generated imagery. It's only that they're scarce, which is, after all, their nature.

Many thought that the power of photographs to influence events had been drained by television, the multiplication of channels, and the diminishing number of newspapers and general-interest magazines, but the electronic media and the spread of small cameras (and, yes, videocams) turn out to have made photographic images more powerful than ever. Many think photography is a major force in today's art market, and they are right. Also, in the last couple of years, the cultural pages of some upscale newspapers have made feints toward privileging photographs over text, handing photography a win at a loss for words. It's not clear, in a world where nothing is constant but change, whether photography, a dominant medium in the twentieth century both in news and, at the end, in art, will retain that position in this century.

As they say on that other medium, TV: stay tuned.

This essay originally appeared in *American Photo*, May/June 2003. It has been significantly expanded for this volume.

ANSEL ADAMS

Steadying his tripod on a rock halfway up a mountain, Ansel Adams extracted a 5-by-7-inch dream from an infinite landscape. The dream was of America the beautiful and victorious, the West as it once was, and the implicit promise that the soul might be restored within its mighty embrace. The photographs were exquisite evidence that the land was still the seal of America's glory and had not been buried under tract houses and parking lots. Adams became the most popular photographer in our history, and was the first to appear on the cover of *Time* (in 1979), where his bearded face beneath his signature Stetson hat beamed like a cowboy Santa Claus. He was admired and loved by everyone—except the critics.

Beaumont Newhall, who wrote the first history of photography in this country, privately called Adams "the greatest photographer that there has ever been." In the 1970s, when both the Metropolitan Museum and the Museum of Modern Art in New York gave him retrospectives, collectors bid up his prints to unheard-of prices. In response to requests, he printed *Moonrise, Hernandez, New Mexico*, a quietly moving image of a modest village tranquilly coexisting with vast eternities of land and sky, some 1,300 times.

Adams, who died in 1984, was an enormous influence and a force, but critics, especially Eastern critics, were reluctant to cozy up. A force is unavoidable, but you don't have to like it. Some said he was an outdated holdover from the nineteenth century. Some thought him inhumane, stone cold without a warm body in sight. In the 1930s, even photographers declared him irrelevant; Henri Cartier-Bresson exclaimed: "The world is going to pieces and people like Adams and Weston are photographing rocks!" Others found him much too operatic for their tastes: trumpets on the mountaintops, bassoons in the darkling lakes, an overdose of violins in the sky. By the 1970s, when Adams had won over everyone else, serious students of photography dismissed him as a kind of Norman Rockwell of the

ANSEL ADAMS, *Frozen Lake and Cliffs, Sierra Nevada,
Sequoia National Park, California,* 1927

medium, saying he had abandoned the lonely virtues of art and committed the sin of popularity.

Yet, much as Wagner's music was once said to be better than it sounded, many have long suspected that Adams's photographs were even better than they looked. There was always a scattering of fiercely compelling images. "Ansel Adams at 100" (he was born in 1902, but who's counting), a show of 114 landscape photographs at the San Francisco Museum of Modern Art, takes up the cause, making a case for him as a rigorous Modernist. Nearly a third of the images have never been published before.

John Szarkowski, Director Emeritus of the Department of Photography at New York's MoMA, curator of "Ansel Adams at 100" and author of an accompanying book (Bulfinch), writes that it was Adams who successfully reconciled landscape photography with Modernism, and that he was in fact a twentieth-century photographer through and through. Nineteenth-century photographers may have seen the West as geology but Adams saw it as *weather*, not just the thunderclouds and clearing winter storms he was noted for, but all the transience and impermanence that weather implies.

Unlike any previous photographer, Adams was constantly aware of "the contemporary omnipresence of the provisional, the potential for anxiety," as Szarkowski puts it, elements that decisively mark the Modernist style. Adams's photographs are mindful of a kind of perpetual, minute-to-minute evolution, written in time and light, poised for instant change under the capricious instructions of wind and seasons. The dawn glides for one silky instant across the woods; the glimmering trunks or glittering leaves of trees in autumn dance on the surface of the print and spill across it like shards of light.

In what may well be the first time any photo-historian has compared Adams to Cartier-Bresson, Szarkowski says that the former, lugging his view camera uphill with a mule, was just as intent on recording the ephemeral as the latter, who wandered down the street with a Leica, prowling for split-second, decisive moments. The shadows on a mountain that has refused to budge for an eon are after all no more permanent than the position of a man leaping over a puddle.

The complex truth seems to be that Adams encoded a nineteenth-century idea about the land in a distinctly twentieth-century idiom. The nineteenth-century part is a sense of deep spiritual communion with nature, an Emersonian transcendentalism. Adams's father read Emerson constantly.

The young Adams read him as well, and once described his own photographic aspirations as "transcendental." His photographs are imbued with the notion that all creation participates in a universal soul. "I look on the lines and forms of the mountains and all other aspects of nature," Adams wrote a friend, "as if they were but the vast expression of ideas within the Cosmic Mind, if such it can be called."

By the late nineteenth century, transcendentalism had become a kind of tourist's salvation, a program that Adams bought into and many still do: that experience of the Western monuments and wilderness could assuage the anxieties of urban existence, which were gradually displacing the natural world. Adams's photographs were messengers bringing this faith to a hungry audience.

The twentieth-century part of his impact is a graphic boldness connected to strategies of Modern painting and united to the precariousness Szarkowski notes. Critics long ago recognized Adams's ability to fuse strong emotion with near abstraction and spirituality with strict artistic discipline and technical precision. *Frozen Lake and Cliffs, Sierra Nevada* records a remoteness and implacability so bleak, hard, and cold they would provoke terror were they not so admirably encompassed by a rectangular frame and inserted into a nearly geometric, human sense of order. In *Wanda Lake, Near Muir Pass, Kings Canyon National Park*, the foothills and mountains unite with their reflections to float in a textured band between flat expanses of lake and sky—a composition an Abstract Expressionist might have envied, yet recognizably composed of rock and ice and light acting on water. The stunning five-part *Surf Sequence* wrests dramatic designs from a confrontation between the camera's ability to stop time and the inability of anything, anywhere, to do so.

Adams frequently cropped out any baseline in the foreground, setting the mountains afloat; his long-focus lens then flattened and compressed even the deepest landscapes. He could play the graphic and rectilinear forms of summits and shadows against ruffled patches of fallen snow and tentative wisps of cloud in pictures that would have been entirely abstract had they not so clearly been photographs of actual places.

He also celebrated the unspectacular, hidden corners of nature with extreme close-ups of blades of grass adrift on water like random scratch marks or patches of deadwood that imitate Expressionist landscapes—transformations akin to Paul Strand's close-ups of rocks or crockery or Georgia O'Keeffe's metamorphic details of flowers.

The grand, transcendent landscape, America's proud claim to monuments as great as Notre Dame or Saint Peter's, was not a mere ploy but Adams's very existence. Yosemite had transformed his life while he was still a boy. He was hyperactive before that was a diagnosis (or required a prescription for Ritalin), and his attention and behavior were so erratic and disruptive in school that he was regularly expelled. At ten he fell prey to sudden bouts of weeping. His father mercifully decided to end his formal schooling two years later, and in its stead soon handed him a year's pass to the 1915 World's Fair.

Adams's parents took him to Yosemite on vacation when he was fourteen; there, the wilderness excited his curiosity, harnessed his energy, and finally led him to meet friends with common interests. A couple of years later, he barely survived the global flu epidemic, and emerged morbidly frightened of germs and handshakes and doorknobs; once more, Yosemite restored him to both physical and mental health. He would return to the valley every year of his life. The Western wilderness had blessed him, and he meant to pass his blessings on.

But he really meant to be a concert pianist. At twelve, Adams had discovered a talent for music, and although he began photographing seriously while still in his teens, he considered music his lifework until well into his twenties. His musical training instilled an exacting discipline and perfectionism—he merely exchanged an obsession with musical scales for an obsession with *tonal* scales. In a book on Adams, Jonathan Spaulding traces his combination of precise order and romantic emotionalism to his early immersion in Bach and Beethoven.

Adams himself famously said: "The negative is equivalent to the composer's score and the print is equivalent to the performance," and he worked relentlessly in the darkroom in search of a more perfect rendition of his response to the landscape. By the late 1950s his printing style became darker, more dramatic and baroque, with more intense and showy contrasts. By then his best work was behind him; by the 1970s Adams himself had decided that his finest work had been done before 1960. He may not have known it, but from the early years on he was often in danger of being outdone by his own effulgence, which can make him all too dazzling in large quantities. He made a few astonishing pictures throughout his life; it's just that his penchant for grand opera took over after a while, at the very moment that the culture was downplaying theatrical emotionalism in

favor of the subversive alienation of Robert Frank and the deadpan mien of Pop art.

In the 1960s, too, art lost faith in beauty, preferring Campbell's soup and rows of bricks to sunsets. At the same time, people were becoming aware that the land Adams found so achingly beautiful scarcely existed outside his photographs anymore. By the 1970s, photographers like Robert Adams and Lewis Baltz had replaced the traditional landscape of hope with the constructed scenery of disappointment, cluttered with jerry-built developments and cars. Ansel Adams still offered people dreams, but critics no longer believed them.

His achievements, some of them out of sync with his times, were multiple. By dint of taking on an enormous number of jobs, he supported himself and his family (barely) on commercial photography through all the years when no one bought photographs. (When he allowed a view of Yosemite to be printed on a coffee can and agreed to appear in a Datsun commercial—they promised to plant a tree each time a Datsun was test driven—many thought he'd sold out.) His fortunes finally changed after 1975, when photography at last had a market and his recently acquired business manager announced that Adams would accept print orders until the end of the year, then never again. Thirty-four hundred orders poured in. By 1976, he was a millionaire.

His books and workshops taught photographers technique. His landmark "zone system" provided a reliable, science-based means of previsualizing images so that the final prints would more closely resemble the photographer's intentions. From the 1930s on, Adams insisted that his own prints be meticulously reproduced in his books; he was instrumental in raising the level of photographic reproduction in American book publishing. And his very popularity over more than half a century helped convince Americans that the low-life medium of photography deserved a high place in the arts.

Beginning in the 1920s, when he became an active member of the Sierra Club, Adams was one of the staunchest, indeed one of the most successful, advocates of conservation in this country. In the 1930s, one of his books attracted the support of the U.S. president and the secretary of the interior for legislation declaring the Kings Canyon area a national park. After 1960, every president but Nixon consulted with him on the environment.

Meanwhile, the parks were suffocating, and he knew why. Bad policies, and too many visitors: "All factors considered," he once wrote friends, "the only way to save things is to eliminate 2/3 of the world population!" Too much emphasis on entertainment, too. Someone suggested that creating a lake in the Grand Canyon would make it easier for people to see things; Adams counterproposed that the Sistine Chapel should be filled two-thirds of the way with water so tourists, floating, could see the ceiling paintings up close.

But, in a paradox inherent to photography, Adams himself must have contributed to the problem. His photographs gave us a pride we yearned for, then whispered that we might replenish our souls, shriveled between office dividers, in the winds streaming off the mountains. Thus reassured and bolstered by travel ads and cheap gas and the newfound holiness of vacations, we loaded our cars and set out for the unspoiled wilderness, only to find we had spoiled it.

In fact, a good part of the wilderness that is left exists mainly in Adams's photographs, which is what most people see anyway: landscapes not of earth but of emulsion. The photographer who merged landscape photography with Modernism has met the fate of postmodernists: his images have replaced his subjects in the eyes and aspirations of the public.

It's conceivable that Adams was simply too good. His art hit a nerve and drew people to his sources. His own devotion to the Western landscape re-awoke the nation's; maybe, just maybe, that's loving the land to death.

Vanity Fair, August 2001

ELEANOR ANTIN

The movie marquee inside the Los Angeles County Museum of Art says: "Now Showing: Eleanor Antin." Beneath it are a few stills of Antin's most famous roles, plus a freestanding cutout of her in full ballerina regalia. If you can't find Eleanor Antin in your movie guide, try the deadpan dictionary, the feminist gazette, the lexicon of subversive notions, or better still, the catalog named after her by Howard N. Fox, curator of "Eleanor Antin," the first retrospective of thirty years of this artist's work. A lot of this show stars Antin on video, as the marquee promises, and even more of it is theatrical in a quirky way, fleshing out the female role in the human comedy with laughter and cultural smarts and a deep curtsy to despair.

Female *roles*, rather: Antin hooked up early to the idea that personality, even gender, are not unified and static but various and shifting, and at different times she has tried on fantasy autobiographies as a king, a ballerina, and a nurse. In real life (whatever that is these days) she was a painter and an actress first, then in the later 1960s a conceptual artist. She became a feminist artist, a video artist, and a performance artist in the first years of the 1970s, coming early to all three parties and helping make them memorable.

Antin made a kind of still movie in 1971–73: *100 Boots*, a set of fifty-one photographic postcards that were mailed to hundreds of people around the world. These chronicle a picaresque domestic journey taken by a staunch corps of boots from the Pacific Ocean to the Museum of Modern Art in New York, with a number of standard-issue adventures such as going to market and to church, being unemployed, doing their best, and taking a hill (a victory of sorts), before going to the big city and ending up in a seedy dump. This reverse journey, from middle-class military to scruffy bohemia, is made by the most independent articles of clothing since Gogol's overcoat or Dr. Seuss's pale green pants with nobody inside them.

Mail art was still rather new, but male art bestrode the world and always had. Antin wryly commented on society's expectations of women

Eleanor Antin, *L'Esclave*, 1981

and on women's possibilities of redefining themselves. *Carving: A Traditional Sculpture* (1972) is a pseudo-scientific record of her weight loss on a strict thirty-six-day diet. She had herself photographed naked every morning, front, back, left, right, as she "carved" her "ideal" self through abnegation. In a wall-text, she refers to Michelangelo, "our great predecessor," who wrote that a sculptor could not create anything that was not already in the marble.

In the early 1970s, women were tossing around the heady idea that they could do something other than diet themselves to perfection. Feminism released a slew of female fantasies into the realm of artistic expression, including autobiographies as explorations of gender, *pace* Marcel Duchamp. Antin paraded in the costume of a king for a while, in her self-appointed kingdom of Solana Beach, California, documenting her transition to manhood in a video of herself applying a beard. (Costume loomed large in feminist and performance art: big girls dressing up.) Her subjects were somewhat puzzled when she greeted them graciously on the sidewalks, pushed a marketing cart, and thumbed a ride, but this was California, so perhaps it did not seem so strange.

This kind of limited public performance—no audience but the people who happened to be on the sidewalk that day—foreshadowed Cindy Sherman's impersonations of nurses or New Jersey housewives at New York parties, as Antin's subsequent role-playing on video foretold Sherman's movie stills. Possibly Sherman did not even know this work, but ideas get loose in the air like germs, and strangers catch them.

Antin was not a cheerleader for the feminist movement, and did not think women were any more likely to have it all than men were. Her king appeared in a video leading his (or her) followers to the promised land, which turned out to be a realm of bones and ashes. Her stories tend to be quixotic comedies wrapped around an elegy.

The exploration of the naked self and the clothed fantasy was one tactic in the campaign to introduce "feminine" material into the mainstream of art. Although male artists such as Jackson Pollock and Mark Rothko had abstracted their angst in the preceding decades, by the 1970s self-revelation was assumed to be predominantly female. When men revealed themselves, they did it under wraps. No messy confessions on Roy Lichtenstein's canvases or in Carl Andre's lines of bricks; no tears or hysteria, no leaky emotions or insecure moments hung out to dry. At least not recognizably.

Women, on the other hand, put their inner lives, their well-kept secrets, their embarrassing imaginations on view. In Judy Chicago's 1979 *Dinner Party*, the female genitalia, which nature has discreetly tucked away, came barely disguised to the dinner table. In novels like Erica Jong's *Fear of Flying*, women's sexual fantasies—at least one woman's—were laid bare.

Around that time, narrative swung in on the oscillating art pendulum as a reaction to Minimalism's insistence on the circumscribed, storyless, hard material fact of the object. Antin, a low-life playwright in a high cause, had been hooked on stories for some time. In the 1970s, she put aside her royal male self for another fictional autobiography, this one the most feminine of fantasies, the ballerina. Millions of little girls once dreamed of being a ballerina, paragon of grace, beauty, and weightlessness, soaring above baby fat and acne on delicate clouds of tulle. Antin had herself photographed on point in classic poses.

She also had the photographic session filmed for a piece called *Caught in the Act*, where she is seen galumphing shakily off her toes, or clinging to a prop to steady herself for her fabulous split second aloft. Giselle is a klutz! Deadpan, Antin deals a mortal blow to the illusion of beauty and perfection offered by photography and foisted by all the media—and hints that even dreams of twinkling toes wear running shoes by day.

The scenarios of "The Loves of a Ballerina," a series of short, silent films viewed through the windows of a mock movie theater, unfold like romance novels written by Harpo Marx. In *Love's Shadow*, the ballerina's shadow is implored by a three-dimensional lover who, when she rebuffs his suit, impetuously shoots her silhouette. At once he is overcome by despair and tenderly clasps her dying shadow. In *Swan Lake*, the ballerina, in a brief, black tutu, leans over and waggles her cute little behind. *Et voilà*, there emerges from the groin of her male companion the head and long, curved neck of a plush swan. Alas, it soon droops, but the ballerina coaxes it up again, and the couple exits to applause.

I am honored to report that I briefly (*very* briefly) became part of Antin's art. As I was making notes on the films, a woman strolled up to the movie window, watched me a moment, realized what I was doing, and said with a startled laugh: "Oh. I thought: 'Isn't that interesting! That piece includes someone writing.'" The line between art and life gets thinner and thinner, a result of art like Antin's.

Her most extensively pursued role was that of Eleanora Antinova, the only black ballerina in Diaghilev's company. In Antinova's first dance, *L'Esclave* (The slave), she was chained and never moved her feet. "I was the only dancer in the world to do a stationary dance," her text says. "Luckily, the artists adored its self-referential ironies."

The feminist movement in its early years was a white women's movement, not overly concerned with race or ethnicity. Antin had brought up the race issue early, and she was criticized for playing a black woman. (She recently said that African-Americans didn't criticize her, only white liberals did.) The idea of a black ballerina in Diaghilev's company in the 1920s, when ballet was white to the tippy-tip-tips of its satin shoes and Paris was enamored of American-born Josephine Baker clad in bananas and dancing bogus jungle dances, is more pointed than a ballerina's big toe.

In 1981, Antinova, by then past her prime, down on her luck, and subsisting on sherry, gave performances in New York and elsewhere in a salon that the Los Angeles show re-creates, decorated with photographs of her great roles, her own amusing accounts of her choreography, and her elegant watercolors of Diaghilev and his scintillating circle. In performance she recalled her days of glory and slowly sank into her sherry. Again the fantasy does a smart jeté and lands on the lip of the abyss.

Antin kept reinventing herself, proving that American fantasies had second and third acts. In an interview with curator Fox in the show's catalog she remarks that "service is the main role our culture has allotted to women, and we've been put down for it ever since." In comes Nurse Eleanor, cheerfully exploited by all manner of men and involved in soap-operatic adventures, some a bit too long-winded to be gripping, although she does perform an operation by herself. A plane she takes to Washington is hijacked by revolutionaries who insist on being taken to Washington. Nurse Eleanor and company are acted on video by cardboard cutout dolls who are moved about and whose voices are spoken by the other Eleanor, still playing at dolls. Antin's fantasies wait in line at the bank, outlive their own triumphs, and lose at love, but at least they dream.

Nurse Eleanor had another incarnation as Eleanor Nightingale, the heroic (heroinic?) founder of the profession. Her all-too-properly buttoned-up family and her landmark career in the Crimean War are playacted by Antin and others in fine, fake period photographs. The war photographs include several images of the wounded and dead, subjects that Roger

Fenton, a photographer who actually went to that war in 1855, never photographed because the British were not supposed to see them.

In the 1990s, Antin's references grew wider. In *Vilna Nights* (1993), the windows of a mock-up of a bombed-out building in the Jewish ghetto in Vilna show scenes of the people who once lived there. A sobbing tailor ceaselessly mends the tattered clothes of dead children. A woman clutches letters in anguish before burning them. Two frightened, hungry children are miraculously visited by a menorah and a Hanukkah feast, only to have it all disappear when they sit down to eat. This view of the Holocaust is similar in spirit to work by Shimon Attie, who at about the same time projected prewar photographs of residents and establishments of the former Jewish district in Berlin on the buildings that still stand there.

Antin, Jewish, a woman, and an artist, considers herself an outsider through and through, so in a way a piece like *Vilna Nights* is but a more desperate comment on the identity and experience of the outsider than her comedic saunters through fantasy autobiographies. "I may be ironical, I may be funny," she says in the catalog interview, "but I'm not kidding." She also says that even in her baby days she had her calling: causing trouble. Lucky us.

New York Times, August 8, 1999

DIANE
ARBUS

Diane Arbus's photographs insist that strippers, female impersonators, and eccentrics (the self-proclaimed Bishop, for example, who claimed she was Jesus' twin sister and that when she was married to Solomon his wisdom came largely from her telling him what to do) are just as importantly, poignantly, and ordinarily human as the white-washed middle classes. Her pictures assert just as provocatively that the most ordinary, everyday folks, when looked at hard enough, are every bit as extraordinary as any giant or sword swallower or dominatrix in the world.

When Arbus looked at a Mexican dwarf sitting on his bed, naked save for a towel and a fedora, she saw him as sensuous, sorrowful, and far too recognizable to be exotic. When she looked at Mrs. T. Charlton Henry, a representative of the lacquered bourgeoisie whose huge, perfected hair might break if you sang a high note, she saw someone wearing couturier armor to keep her pristine disappointment at bay.

Mrs. T. and the dwarf meet where Arbus pays more than lip service to the democratic notion of humanity. She embraced the entire spectrum of society, from the dim stars of sideshows to the optical illusions of trans-vestites, from the unpublishable bodies of nudists to the neglected inner lives of pampered conformists, all within one unified field of humanity. Her photographs imply, subversively, not only that all men are created equal but that each and every one of us is an exceptional individual.

It is probably this drastic overturning of social expectations (and of the comforting smugness of assuming oneself better) that continues to makes spectators uneasy—the disquieting recognition of ourselves in the Other. John Szarkowski, who included her in her first museum show in 1967 and organized the first retrospective in 1972 (both at New York's Museum of Modern Art), suggests that Arbus's best pictures were so com-pelling that they made us confront the idea of human frailty and failure—not the most reassuring of life's lessons.

The power, if not the meaning, of Arbus's photographs has been acknowledged by critics, scholars, and the market, as well as by her

DIANE ARBUS, *Untitled (6)*, 1970–71

ongoing influence on photography, art, and culture. In the 1960s, she was a major force in shifting the documentary approach away from the social causes left over from the 1930s to the private lives that now obsess society. Her photographs of gays, sideshow performers, and fringe populations helped spark a rapid expansion of what was permissible to see and stare at, and even what must be accepted, so that what was once shocking is now ho-hum. Transvestites were so closeted in the 1960s that Peter Bunnell, then in the photography department at MoMA in New York, says that when no one was looking, people would surreptitiously change the label on her picture *A Man Being a Woman* to just plain *Woman.* The department was kept busy making new labels.

Then too, her suicide in 1971 at the age of forty-eight made her an instant legend. (Suicide, at least in America, is a good career move.) Her photographs have become such icons that Stanley Kubrick gave us one of them in *The Shining* and two images have been marketed as soft sculptures, putting them on a par with those omnipresent plastic replicas of Edvard Munch's *The Scream.*

Still, although she left behind 7,500 rolls of contact-printed film and 1,000 finished prints, as well as notebooks and letters, the estate kept such a tight rein on the material and restricted reproduction so severely that scholars unwilling to hand over control of the text had to publish articles without illustrations. Now at long last a more expansive view of Arbus's life and career has opened up.

"Diane Arbus: Revelations," which opens at the San Francisco Museum of Modern Art this October, is the first retrospective of her work since the 1972 show at New York's MoMA. It was co-organized by guest curator Elizabeth Sussman and Sandra Phillips, San Francisco Museum of Modern Art senior curator of photography. Unpublished photographs map her progress on the road to becoming Diane Arbus and enlarge the scope of her artistry. A book of the same name, from Random House, not only provides a chronological biography, but also prints a lot of unpublished writing, proving her pen to be as sharply discerning as her eye.

This exhibition makes clearer than ever that her reputation as a photographer of freaks (a reputation she hated) is exaggerated, for the great majority of her portraits are of Mr. and Mrs. Average American (more likely Mrs., for women predominate in her work) who march to an average drummer until Arbus convinces them their own tune counts. She photographed

such common New York apparitions as three Puerto Rican women who appear to be alarmed by the incontrovertible realities of the world, or a woman atop a pyramid of mink, her face a topographical map of anxiety, or two ladies in the Automat confidently pitting their good grooming against the years.

Arbus did freely admit that she adored freaks and considered them the heroes of the human struggle: "Most people go through life dreading they'll have a traumatic experience. Freaks were born with their trauma. They've already passed their test in life. They're aristocrats." But it was being whoever you are, whatever you are, that mattered. Her eccentrics are simply people who live our dreams in exaggerated form and wear them as costumes—people like us, but more so. Marvin Israel, a brilliant graphic designer and art director who gave her magazine assignments and became her most intimate friend, once said to her: "If we are all freaks the task is to become as much as possible the freak we are."

Many critics complained that she made the rank and file look like freaks themselves, and Norman Mailer, whose portrait she took, said that "giving a camera to Diane Arbus is like putting a live grenade in the hands of a child." She did have an explosive impact and may have damaged a few egos besides Mailer's. In a few celebrity portraits and less successful pictures, and frequently by the social fiction standards of studio photography, she could be called unkind. The photographer Benedict J. Fernandez says he once found an intern for her, a young woman who "looked like a German milkmaid, blond, blue-eyed, and very simpatico. . . . Diane started to ask her questions, and while I was watching . . . she transformed this innocent little girl, milkmaid-looking, into this horrible, ugly girl, then she took the picture, and then the girl just reverted back to what she was always."

Yet Arbus did not steal her subjects' souls; they lent them to her, with interest. Her pictures are dialogues, her subjects as curious about her as she is about them. She was perfectly well aware of the photographer's advantage and the camera's rudeness, and once told a reporter that "the camera is cruel, so I try to be as good a person as I can to make things even." Seeking revelations that only intimacy, however momentary, could provide, she rarely made her subjects ugly but frequently permitted them to be complex. Around 1962 she gave up her 35mm camera, stopped cropping her pictures, and switched to a 2½-by-2½ Rolleiflex—a twin-lens reflex, held at waist height, that gave her more direct contact with her sitters (and a wealth of precise detail).

Rather than taking day trips into people's lives, she spent time with them, often repeatedly. She stopped people on the street and somehow convinced them to invite her into their homes and then to pose next to their beds or on them. Tough adolescents, matrons in veils, and burlesque comediennes cooperated with her, looking her right in the eye and voluntarily giving her themselves. Clearly, they trusted her.

She was slight, she was shy, she probably seemed vulnerable herself; she was immensely seductive. Friends say she had a very soft voice, which made you come close, and that when she spoke there were spaces between her thoughts, which made you pay strict attention. Anne Wilkes Tucker, who was an intern at MoMA when she met Arbus, says: "She was the most seductive person I ever met in my life. You suddenly found yourself telling her stories that you simply had no intention of telling anybody. . . . She had this way of asking you this very personal question and then giggling. It was *so disarming.*"

Joel Meyerowitz once watched her mesmerize a stranger into telling her his life story in an instant. "She had this kind of open-eyed stare," he recalls (another friend, Isabel Eberstadt, says: "She quite improperly had the most innocent-looking eyes"). And, Meyerowitz goes on, "she was *listening*, she gave herself fully to this guy. . . . She had a way of relating that was just dazzling."

Her unprecedented mix of subjects presents a prescient picture of her times. From the mid 1950s on, artists and journalists, chafed by conformity and pressured by television and media overload to find something novel to pay attention to, began to remake the rigid traditions of the culture. Tom Wolfe, early in the New Journalism, expounded on hotrods for the intelligentsia in an extravagantly personal voice. Andy Warhol withdrew into impersonality in the company of a soup can.

Private and inner lives began moving into the public arena, as confessional poets such as Robert Lowell put theirs on paper, and *Life* magazine ran photo-essays of a newly subjective turn. Sexual barriers fell: Vladimir Nabokov's *Lolita* appeared in 1958, the Pill in 1960, and the Supreme Court bestowed legitimacy on Henry Miller's *Tropic of Cancer* in 1964. Women burned bras and donned trousers, virginity went the way of white gloves and crew cuts.

Americans waxed uneasy about gender roles. Magazines warned that boys would grow up to be sissies if their mothers didn't play properly subservient feminine roles. James Baldwin and Allen Ginsberg wrote openly

about homosexuality; Jasper Johns injected it into art. Arbus, who had a strong interest in myth and "a worn copy" of Ovid's *Metamorphoses* in her library, zeroed in on the state of becoming, the ambiguous, in-between, transitional genders: a man becoming a woman by tucking his genitals between his legs; a lesbian in traditional female garb who towers over and puts a protective arm around her thin, small, more masculine partner; a hermaphrodite. Here and elsewhere, Arbus reconfigured mythic paradigms for an era that generally assigned them to some secondhand shop of the mind.

Apolitical herself, she was still embedded in her times. The Cold War and Vietnam are only obliquely referred to in a couple of pictures of patriots at parades, but they do suffuse her work with a sense of tension, wariness, isolation, and moral disillusion. Even in the 1950s, the standard image of America as a community of leave-it-to-Beavers, *McCall's* magazine's "togetherness," and happily-ever-after was fraying at the edges. A few photographers—such as William Klein and Robert Frank—reported that it was torn.

Born in 1923, Arbus had an upholstered childhood. Her father, David Nemerov, was a director of Russek's, a fur and fashion store that in 1924 moved from downtown to Fifth Avenue. "The family fortune," she said later, "always seemed to me humiliating. When I had to go into that store . . . it was like being a princess in some loathsome movie of some kind of Transylvanian obscure middle European country and the kingdom was so humiliating." Life with governesses on Central Park West seemed to her a silk-lined isolation ward, although it produced three talented children: her older brother, Howard Nemerov, was a Pulitzer prize–winning poet and author, her younger sister, Renee Nemerov Sparkia, an artist.

At a startlingly early age, Diane Nemerov was fundamentally the person she would become. Her gimlet eye for distinctions, uniqueness, the flaw that set someone apart, was fully developed when she was young: she'd scan the line of dancers for the Rockette who was out of step. Maybe she saw more than most people do. Allan Arbus, her husband, says she was like an X-ray; Jane Eliot, a longtime friend, says: "She was eyes on stilts." In a senior-year high-school paper on Plato, Arbus wrote about her passion for difference: "Everything that has been on earth has been different from any other thing. That is what I love: the differentness, the uniqueness of all

things and the importance of life. I see something that seems wonderful, I see the divineness in ordinary things."

When she met Allan Arbus he was eighteen and working in Russek's advertising department. She was thirteen years old. He says: "She really knocked me out when she came into the office where I was working and announced that she was very well read." (She read prodigiously all her life—Dostoevsky, Blake, Kierkegaard, Rilke, and later, at Marvin Israel's suggestion, Kafka and Céline. After photographing the Tattooed Man she gave him a volume of Kafka, who, she wrote, "he used to think was a fictitious character on a Shelley Berman record.") According to Patricia Bosworth's 1984 biography of Arbus, she was determined to marry Allan virtually from the beginning. Although her parents tried for some time to dissuade her, in 1941, after she graduated from Fieldston and turned eighteen, she married him instead of going to college.

Even before that they had haunted MoMA together—she was a high-school art major—and saw the first history of photography show in America in 1937 and "Walker Evans: American Photographs" the following year. Allan gave her a Graflex camera in 1941 and grew fascinated with photography by watching her use it. She took a course with Berenice Abbott, learned a bit of technique and taught it to him; he had a real knack for it, read books by Ansel Adams, and became an expert.

She always claimed to be technically inept, and Allan Arbus does say that "if something went wrong with her camera, she would have some whimsical solution to it, like putting it aside for a day or two, then trying it again." But he taught her an exacting method of printing, and her prints are exquisite, and unlike anyone else's.

Allan Arbus recalls how eager they were to absorb the history of photography. "We were quite passionately exploring everything that had gone on in photography" he says: Mathew Brady—Diane "adored" war photography—Timothy O'Sullivan, Carleton Watkins. (And not much later Brassaï, Bill Brandt, August Sander, and Weegee.) They visited Alfred Stieglitz in his gallery and showed him photographs several times. "We were kids," Mr. Arbus says; "and it was sort of like seeing God"—a sentiment Stieglitz would have approved. Allan Arbus says they showed photographs to Nancy Newhall too, when she was the curator at MoMA. "She said, with a very patient smile" (here his voice becomes patronizing), "'You're having *fun*, aren't you?'"

Before Allan went into the Signal Corps as a photographer in 1943, Diane modeled for him for some fashion photographs, and David Nemerov hired them to do Russek's newspaper ads. Doon, their first daughter, was born in 1945; Amy, their second, in 1954. In 1946 they embarked on a career in fashion photography, Diane doing the styling and Allan taking the photographs. They published a fair amount under contract to Condé Nast and on assignment elsewhere, but it was a massive strain on them both, since it was not what either of them wanted to do (Allan wanted to be an actor, but he was aware that meant semipermanent unemployment). And they never believed they could quite match up as fashion photographers, especially to Richard Avedon. In 1955, Diane studied photography with Alexey Brodovitch, art director of *Harper's Bazaar*, but that didn't take her where she wanted to go either.

Finally, one evening in 1956, when she was describing the afternoon's sitting for *Vogue* to a friend, she burst into tears. That night she quit the partnership, although Allan continued to run it as the Diane & Allan Arbus Studio for years. Diane Arbus went to find her kingdom so she could inherit it at last.

"One of the things I felt I suffered from as a kid," she wrote, "was I never felt adversity. I was confirmed in a sense of unreality which I could only feel as unreality. And the sense of being immune was, ludicrous as it seems, a painful one. It was as if I didn't inherit my own kingdom for a long time. The world seemed to me to belong to the world. I could learn things, but they never seemed to be my own experience."

She was intent on erasing the humiliation and forging a connection to reality. Late in life she told a class: "First I set out to get poor"—here she giggled—"which I did terrifically well." Then she set out for freedom, to own her own experience. Wayward means would do: "I think my favorite thing about photography. . . " she told her class, "I always thought it was a sort of naughty thing to do. . . . When I first did it it was very perverse . . . I'd live to do everything right, and suddenly it was a kind of license . . . [to] see what it really seemed like and do exactly what I wanted to do." Her brother Howard, whom their father expected to join Russek's, escaped in a similar way into his art: "Writing was for me at the beginning sinful and a transgression."

Lisette Model, an émigré photographer whose close-ups of the overweight, disaffected bourgeoisie lounging about in the south of France before World War II had hinted of social breakdown, gave her the key. Arbus took

her grainy 35mm pictures to Model in 1956, studied with her for two years, and they remained close ever after. The meeting with Model "was a most magical happening," Allan Arbus says, "because three sessions with Lisette, and she was a full-fledged photographer." Diane said Model "finally made it clear to me that the more specific you are, the more general it'll be," convincing her that the larger human experience could be written on the most singular face.

Arbus spent much of her brief working career trying to figure out who we remarkable creatures are. She said she was looking for the flaw, by which she meant the distinguishing characteristic, the gap between person and persona, and the vital difference: "Everybody has that thing where they need to look one way but they come out looking another way and that's what people observe. You see someone on the street and essentially what you notice about them is the flaw. It's just extraordinary that we should have been given these peculiarities. And, not content with what we were given, we create a whole other set. Our whole guise is like giving a sign to the world to think of us in a certain way but there's a point between what you want people to know about you and what you can't help people knowing about you."

In 1959, she moved out of her home with her daughters, although neither she nor Allan told their parents for three years, and they remained so friendly that Ruth Ansel, a graphic designer, recalls being at Diane's for dinner one night when Allan appeared, washed the dishes, and then disappeared again.

Arbus explored the land of reality she had been shut out of as a child and shut out of yet again in the artificial world of fashion. She was omnivorously curious; she peered into dark corners and absorbed environments with the avidity of a camera, which sucks up detail as if it were vacuum cleaning the universe. Over and over she examined the perilous line between reality and fiction—which were often, in her estimate, on the verge of changing places. In 1960 she photographed murder scenes in a wax museum and clouds on a drive-in screen—a bright sky in daylight superimposed on the invisible dark of night. Then there were the headless man and woman, the transfigured genders, the self beneath the one that people put on each morning before leaving home.

It took courage to enter some of the worlds she visited; people wondered how a woman whom Szarkowski described as still resembling near the end of her life "a game but slightly worried child" could get the pictures

she got. The photographer Hiro says that Irving Penn once asked him how Arbus got the nude photographs. "Do you think she's nude herself? Has a Rolleiflex hanging between the bosoms?" (She did.)

She had a supply of courage large enough to conquer her own fears. (Mary Frank, artist and friend, thinks she displaced her real fears onto intense anxiety about technical competence.) In high school, Arbus said she was always considered the most daring but was sure she was more afraid than anyone. In 1967, she told a reporter: "For eight years I've been exploring, daring, doing things I'd fantasized about in my sheltered childhood. I'm a little foolhardy rushing in to explore all these freaky things, but dangers of violence—rape, murder—are more moving and less frightening than making a living at fashion photography."

Anyway, like many photographers, even in war, she felt safe with a camera in her hands. And she loved it, she reveled in it. She wrote a friend in 1964: "If my cup doesn't run over it is only because I am always drinking." But she was also subject to draining depressions for years—Isabel Eberstadt says sometimes she had trouble getting herself out of the house, but a camera around her neck made it possible.

Arbus once wrote Marvin Israel that she wanted to photograph everybody; instead, she made do with a project to survey contemporary mores and myths. She won Guggenheim grants in 1963 and 1966 to photograph "American Rites, Manners, and Customs." In the first application she wrote: "I want to photograph the considerable ceremonies of our present because we tend while living here and now to perceive only what is random and barren and formless about it. While we regret that the present is not like the past and despair of its ever becoming the future, its innumerable inscrutable habits lie in wait for their meaning. . . . These are our symptoms and our monuments. I want simply to save them, for what is ceremonial and curious and commonplace will be legendary." (Friends report that she spoke with the same humor and quirkiness, the sly detail, the combination of innocence and worldliness, imagination and fact, poetry, shock, and surprise that animate her writing.)

She said that her special interest in photography was "as a kind of contemporary anthropology" and late in her life thought about making a book called *Family Album*. A new book centering on her unpublished commission to photograph a New York family—Anthony W. Lee and John

Pultz, *Diane Arbus: Family Albums* (Yale University Press, 2003)—expands on this idea.

She followed her curiosity on projects—and wherever she could get an assignment: to Hubert's flea circus, where through a magnifying glass you could see a flea wedding, complete with a bride in a wedding gown; to orgies that she told her goddaughter she participated in in order to photograph them (but she didn't think the pictures conveyed the experience well enough); to the Russian baths, where naked fat ladies got massaged on a marble slab by a naked thin masseuse who wore an apron and, after finishing each lady off with an oak-leaf rub, took a flying leap into a cold pool.

She went to three nudist camps. "There's not much to it, you might say. It's like walking into an hallucination without being quite sure whose it is." The first man she saw was mowing his lawn. Nudists, she wrote, occasionally "feel the impulse to slip into something more comfortable. One little boy asked for clothes for his birthday." You could be expelled if you got an erection or if you stared too hard; her pictures invite us to stare too hard without getting expelled from anything but our sense of virtue. She told a class that "a seduction scene in a nudist camp is, without a doubt, the most terrific experience . . . because they're playing around and they're already . . . you're all completely ready."

Releases were hard to get from some of these subjects. She wrote one editor plaintively: "Today I saw a man lying on the steps of a church on Lex Ave [*sic*] under a sign saying Open for Meditation and Prayer, with his fly open and his penis out. I couldn't ask him to sign a release, could you?"

Her pictures were almost always portraits rather than pictures of events in any photojournalistic sense. After she turned to a square format, often using a slightly wide-angle lens and a flash, she depicted her subjects in exacting detail and brought them forward into our space so that we seem to meet them intimately. The backgrounds fall off fast, sometimes splaying out toward us in exaggerated perspective, thus plunging the figures ever closer.

While photographers like Frank, Klein, Lee Friedlander, and Garry Winogrand were disrupting the stability of 35mm photographs, Arbus was centering figures within a classical frame, a compositional gambit that harks back to studio portraiture, although Arbus photographed in the subject's environment or on the street and made the moment seem spontaneous.

The style also glancingly refers to the snapshot tradition at a moment when art was toying with the vernacular.

Many of her photographs were made on assignment for magazines. She tried to earn a living as a magazine photographer just as the magazines began to falter in the race with television. Between 1960 and 1971, while separated from her husband (who continued to help her) and raising their two daughters, she published more than 250 pictures in more than seventy magazine articles. In 1965 she earned approximately four thousand dollars.

It was not an easy time for photographers. In 1967, MoMA mounted a landmark show called "New Documents," an exhibition of photographs by Friedlander, Winogrand, and Arbus. (Not until 1969 did New York have a gallery devoted to photography alone.) Friedlander says that about ten days after the show had opened, the three of them phoned one another; someone wanted to buy a single print from each of them. All three requests were from the same person—a museum guard. They didn't know what kind of price to ask and decided that $25.00 was fair enough. No one else inquired.

In 1966 Arbus had a bout of hepatitis, a disease that typically brings depression in its wake. When the hepatitis recurred in 1968 she was hospitalized and, according to Bosworth, taken off all antidepressants and birth-control pills. In 1969, the Arbuses divorced, but remained friendly. Allan moved to California to pursue his acting career. (Later he played the psychiatrist on the TV program *M*A*S*H*.) Diane wrote to a friend that at moments she felt like Little Orphan Annie.

She began photographing in state residences for the retarded, a project she would work on in the next two years, and a change of subject that heralded a change of style. "FINALLY what I've been searching for," she wrote Allan. That seems to mean people, many of them masked for a Halloween party, who had neither social masks nor self-consciousness but wore their true, complete, and unprotected identities at every moment. There is an open affection among them, an unfettered joy of a sort Arbus seldom recorded, and a hefty dose of the difficulty of being alive, all registered with a profound lyricism and a deep and disquieting poetry. In their Halloween costumes these figures might be votaries of some raggedy religion, or people going to a ball in a ruined palace of the mind. One image might be a Goya come to life. Doon Arbus wrote about these pictures that in them her mother had surrendered "irony for emotional purity, authority for ten-

derness." In their romantic encounter with awkwardness, these pictures produce a baffling and moving intricacy of feeling.

Ruth Ansel visited Arbus around 1970 when Arbus was researching newspaper photographs for MoMA. Huge, torn blowups of exploded stomachs and bleeding corpses covered the walls. Ansel says that for the first time she was frightened for Arbus.

In July of 1971, Diane Arbus slit her wrists, took barbiturates, and died fully dressed in her bathtub. Marvin Israel found her there after failing to reach her by phone for two days straight.

Joel Meyerowitz said that when she died, "a ripple went through the community of serious photographers. Here she'd had this relatively recent success, visibility, and we thought, if photography didn't sustain her and she had to kill herself, what, what about us? . . . We thought we could devote our lives to doing it." At this point he choked up. "She gave us that lesson that it's not worth it, guys."

Yet Arbus's photographs continue to perform one of photography's more paradoxical tricks: preserving memories of people who were of much less consequence to the world at large than their photographs have been. Thirty-two years after her death, in a world she never lived in, her images still bristle with questions like Who are we? And insights, like who we are.

Vanity Fair, November 2003

RICHARD AVEDON

The first assignment Richard Avedon ever had was to photograph a dead man. At eighteen, having enlisted during World War II as a photographer in the Merchant Marine, Avedon begged so hard to photograph anything at all that the powers-that-be assigned him to autopsies.

He began with the body of a very young man. "He was slit from the throat to the . . . all the way down, and his ribs were open," Avedon once told an interviewer. "His feet were off the edge of the table like a child's off the edge of a bed." Avedon lugged his camera up a ladder, "and as I looked down, his feet seemed so vulnerable! They were perfect—they had nothing to do with the body that had been opened up . . . I remember being devastated by those perfect feet. It wasn't until I left the room that I passed out."

Already he was struck by the fragility of perfection, by the contradictions between outward appearance and what goes on beneath the skin, by mortality, by the fate that knocks you down after you leave the room. The Merchant Marine soon put him to work taking identity-portraits of live subjects—"I must have taken pictures of maybe 100,000 baffled faces before it ever occurred to me I was becoming a photographer."

After the war, Avedon would record, even at times construct, the identities of an astonishing number of the most important figures of the second half of the twentieth century. At the core of his work even today lies a deep apprehension of the human quandary: how to live with the knowledge that your passport to existence could be revoked at any moment. Although he's made an exceptionally handsome living taking innovative pictures of high-powered models in high-cost clothes, his greatest admiration is reserved for a certain bravado and will to accomplishment in people who dared to dance gracefully on the edge of the precipice. His camera intensifies what he finds almost perversely attractive: the marks, the price, the *damage* of struggle, achievement, and life itself.

RICHARD AVEDON, *Ezra Pound, poet, at the home of
William Carlos Williams, Rutherford, NJ*, June 30, 1958

This year, the Metropolitan Museum of Art will put on view 180 of his portraits from the late 1940s up to this past spring. "Richard Avedon Portraits," organized by Maria Morris Hambourg, curator of the Metropolitan's department of photographs, assisted by Mia Fineman, centers on a group of portraits first shown together at the Marlborough Gallery in New York in 1974–75 and now a promised gift to the Metropolitan. Abrams is publishing an accordion-folded catalog that lets the viewer arrange the images in any order.

The Marlborough show was a landmark in several ways. A breakthrough for photography, which was still only a fledgling market and had never made a big splash in a major art gallery, the show amounted to a tidal wave. Prices began at $175—today, they generally range from $10,000 to $150,000. Jeffrey Fraenkel, Avedon's dealer, says three enormous triptychs are valued at a half a million dollars for insurance purposes, although they are so rare they are probably not for sale at any price.

The show at the Marlborough Gallery was a breakthrough for Avedon as well. His reputation as one of the great names in fashion photography had previously superceded what he considers his serious work, the portraits. Many of these were as large as life or larger, uncommon enough in photographs then, and combined with the remorseless detail and shallow depth of focus of the 8-by-10 view camera, the scale forced viewers to confront the subjects as if they were right there, advancing out of their stark white backgrounds and staring—at us.

There was the pianist Oscar Levant, mentally ill and drug addicted— he once told Avedon that when he'd hugged Judy Garland it was "the greatest pharmacological embrace in history"—here raging against the dying of the light with a cry of pain or defiance uttered through teeth suitable for a backhoe. Bert Lahr as Estragon in *Waiting for Godot* compressed himself into an anguished plaint on the lonely human wait for one who will never come. The harrowing price of a life lived for good clothes can be glimpsed through the cracks in the polished façades of the Duke and Duchess of Windsor. (Avedon had watched their reactions to losses night after night at a casino in Monaco, but during the sitting they maintained only couturier manners. Knowing how they loved their pugs, Avedon quickly invented a tragedy: "If I seem hesitant, it's because my taxi ran over a dog." Their royal armor immediately slipped.)

Faces like these reached levels of uncertainty or pain seldom seen in ordinary life, raising the question of whether it was impolite, improper,

voyeuristic, even immoral to stare so freely at people so exposed. Flattery was in short supply: Isak Dinesen looks like a benign mummy's head atop a monument of raw fur (she hated her portrait), and the activist Reverend Martin Cyril D'Arcy is a grittier version of Iago. A large public was made aware that by mid century, Avedon, along with Irving Penn, his great colleague and rival in fashion photography, had broken the tacit compact between photographer and sitter.

For the first hundred years of photography, politicians, generals, and actors, like the rest of us, went to portrait studios in search of nobility and fine looks, expecting that cowardice and pimples would be finessed or deftly retouched. In fact, the portrait-studio compact really applied only to people who commissioned a picture and paid to have their vanities gratified. Avedon's subjects came at his invitation, generally because he admired them and wanted to register the life behind the achievement. In accepting, they left themselves as open to interpretation as Cézanne's bored and plank-stiff wife or Picasso's frenetically aggressive Dora Maar had been to the painters. There is a risk as well as a potential for glory in becoming a work of art.

Avedon had something more urgent than beauty or dignity in mind. By the early 1950s his portraits had responded to the postwar, post-Holocaust anxiety that spread like radiation through the nuclear era. He detected in others' faces the existentialist belief that the crack in the sidewalk opened upon the abyss, that you hadn't any choice but to walk on anyway, and that it took great bravery to do so.

He could be mellower with some subjects, especially as the years went on, and he kept an eye out for signs of joy. The joys of performance could stave off nightfall for a moment: there is Charlie Chaplin playing a horned devil with a neon-light grin (the day before he left America after being accused of being a Communist); the opera singer Marian Anderson as rapt in song as an oracle in prophesy; and then Marilyn Monroe, vacant and collapsed, hollowed out by the pressure of sustaining a myth.

The Marlborough show also broke open the high-low strictures that had not quite crumbled yet—fashion, or commercial, photographers weren't ordinarily granted admission into the gated community of art. Marvin Israel, a talented art director who worked often with Avedon, designed the show, which was not so much hung as *installed*. Installation and imaginative presentation were virtually unknown in photography, although Avedon himself had played with size, scale, and medium in a 1962 show at

the Smithsonian, tacking up photostats, contact sheets, original prints, and one engraver's plate, turning a hallway into a kind of photographic collage. At Marlborough, freestanding walls held what must have been some of the biggest photographs ever made: a triptych of the Mission Council (the eleven men who were running the Vietnam War over there); another of the Chicago Seven (yippies who went on trial for conspiring to incite a riot at the 1968 Democratic convention); and one of Andy Warhol's Factory, some of the troupe in street gear and some stark naked, including Candy Darling, who had the face, the lipstick, the lashes, and the long swooning pageboy of an ingénue, plus a penis and a brash patch of pubic hair. The largest of these images, *The Factory*, is ten feet by thirty-five feet.

There was also a photograph of a former slave whose face blazed with sufficient determination to power an entire battalion marching down a hill; Avedon took it down South during the civil-rights crisis.

The Vietnam War, the antiwar movement, Warhol, civil rights, loose sex—Avedon practically wrote a history of the 1960s. In more than fifty years as a photographer, he recorded enough high achievers and significant figures, in every area but sport (as well as a group of working-class types and drifters out West), to define a profound view of the second half of the twentieth century and its marked ambivalences. He is a seismograph, a delicately tuned mechanism that picks up every shiver of the zeitgeist, sometimes even before the zeitgeist realizes it is shivering.

Avedon's record of his time is not an objective definition but an opinion, avowedly seen through a temperament. He once said: "Sometimes I think all my pictures are just pictures of me. My concern is—how would you say—well, the human predicament; only what I consider the human predicament may be simply my own." His interpretation is neither pretty nor reassuring; it is merely unforgettable.

In effect, Avedon regards both life and portraiture as performance, and in this, too, he has been a measure of his time. The author Adam Gopnik has written that "if there's a single insight that animates Avedon's portraits, it's that in the last half of the twentieth century, at least in the higher reaches of the professional and artistic classes, both the private self and the public one came to be conceived dramatically." In a 1959 book called *The Presentation of Self in Everyday Life*, the sociologist Erving Goffman—whom Avedon never even heard of—argued that human interactions are essentially performances designed to make an impression on whoever is listening, and that it is through such performances that the

persona, or social identity, is developed. John Lahr, the senior drama critic at the *New Yorker* (and son of Bert Lahr), says Avedon has written a chronicle of the nature of twentieth-century individualism. He notes that the decade after World War II saw the greatest change of wealth in history, and "with that came the license to be yourself. People didn't have to postpone their personal projects, they *were* their projects."

In Avedon's studio, they are his. He turns portraiture into a stark and unrehearsed performance without the relief of setting or the comfort of props. Against a white background as blank as the Void his sitters attempt to project their individuality, the selves—or the personas—they have created at the core of their fame. They do so in a subtle, split-second interchange with the photographer, who wants to know what they spent on this creation, and what could happen in the moment when both of them stare at it fixedly.

Controversy homes in on Avedon's photographs like a heat-seeking missile. The critic and director Robert Brustein once wrote that Avedon had turned his subjects into "repulsive knaves, fools, and lunatics"; John Durniak wrote in *Time* that he was "one of the most important photographers in the world." The critic and philosopher Arthur C. Danto said the portraits "strip their subjects of dignity and worth" and seem to transcribe "an aggression, a will-to-power, a cutting-down-to-size . . . on the photographer's part." Maria Morris Hambourg, who believes that "this is what the twentieth century is going to look like in one hundred years," assesses Avedon's vision as the finest and most classic of his time.

Any subject other than Monica Lewinsky that inspires that much debate is likely to be meaningful on some deeper level. The response to Avedon's work in the 1960s and 1970s hinged partly on the fact that the traditional distinctions between high and low were disintegrating, leaving a quagmire where ideas of quality had once stood on firm ground, and many people couldn't yet believe that a commercial photographer could be an artist, or photography an art.

More urgently, Avedon's portraits seemed like definitive proof that photographers, that photography itself, was not to be trusted—already a widely held suspicion. In the age of the camera and the era of the image, these pictures trained a spotlight on the thorny questions of how identity is formed, who owns and who controls one's image, and what were the allowable limits of voyeurism.

Avedon brought into the open the extent of the photographer's influence on the subject and the radical imbalance of power in the studio, a situation politely hidden for years. He wrote that "the subject imagined, which in a sense is me, must be discovered in someone else willing to take part in a fiction he cannot possibly know about. My concerns are not his. We have separate ambitions for the image. His need to plead his case probably goes as deep as my need to plead mine, but the control is with me." Since the late 1960s he has used a large camera that he stands next to, looking at the subject directly rather than peering through a viewfinder. The drama of personality has to be found in what Avedon calls this "unearned intimacy," a subtle personal interchange, perhaps even a contest. Sometimes his subjects lose.

Candid about his reliance on the camera's power, Avedon has said that he became a photographer out of terror of the uncontrollable. "Everything I couldn't control as a child, or for that matter as a man—time, motion, other people, their appetites, and mine—I could embrace safely from behind the camera."

Some who have obviously been overpowered were grateful to be seen with such icy clarity for the first time. Billy Mudd, a working-class man out West whom Avedon photographed as someone whose soul has died and left him only a few shreds of humanity, said that seeing his portrait in the museum was the most profound experience of his life and indeed had made him change that life for the better.

Yet Avedon's laserlike gaze at wrinkles and hairs and pores has been immensely threatening. It menaced the American culture of youth and reminded us of what we preferred to forget: that everyone who lives long enough grows old, and that even in America, which for a long while had the franchise on the denial of death, death was waiting patiently at the intersection.

He made one work explicitly about dying that is excruciatingly personal and intimate, yet meaningful on the widest possible level. It is one of the toughest, most searing, most compassionate sequences of photographs ever made of one man: pictures he took of his father in successive years in order to come close to a remote and authoritarian parent. Avedon wrote his father late in life asking him to pose—"I love your ambition and your capacity for disappointment, and that's still as alive in you as it has ever been." In the photographs, Jacob Israel Avedon begins as a healthy, spruce

old man and ends, four years later, staring directly into the face of cancer. After he died, his son found the letter saved "in the inside pocket of the jacket of his best suit, the one he never wore."

Avedon's tragic sense of life and reliance on performance were already operative in his childhood. His father, who had grown up in an orphanage after *his* father had abandoned his wife and six children, believed that life was a battle and one needed education, physical strength, and money to cope. He became co-owner of a successful women's-wear department store on Fifth Avenue, but lost it during the Depression and was reduced to selling insurance. The family lived near the Metropolitan Museum; Dick would wander over there to do his homework. His grandmother, who lived on the Upper West Side, kept the family going with her poker winnings (often at the expense of George Gershwin's mother).

Avedon has said that performance was "a survival technique" in his family: "A successful performance—good grades, a good joke, a good lie— was the only way you earned the right to live." At the age of four he fell in love with his two-year-old cousin Margie; they formed a constant, unbreakable bond. Through adolescence it was their joint role to cheer up his depressive family by making up wild adventures, performing invented lives to amuse their elders.

In their off-duty hours, they watched others perform. In the 1930s, Avedon's mother bribed ticket takers and sneaked them into theaters and concert halls. The cousins already had a sophisticated and fatalistic view of things and were the only children watching Eva Le Gallienne play Peter Pan who cried out that no, they did not believe in fairies and no, they did not want Tinkerbell to live.

They heard Rachmaninoff play. The great man had an apartment above Avedon's grandmother's; the two children would sit on the garbage cans behind his apartment raptly listening to him practicing. Rachmaninoff was Avedon's first subject. (If you don't count Louise, his beloved younger sister. His father gave him a Brownie when he was nine; he made a negative of Louise and pasted it to his back, then went to the beach and returned with an image of her face burned into his skin.) The young Avedon, ambitious to be recognized somehow by the famous musician, pursued Rachmaninoff until he convinced him to pose for a snapshot. As a boy, Avedon collected autographs too, one way of saying he wanted to be

one of those who performed extraordinarily well in life, and he papered his room with photographs of actors and actresses by Edward Steichen, Martin Munkacsi, and Anton Bruehl torn from the pages of the original *Vanity Fair*.

What he wanted most was to be Fred Astaire. "The best men of my generation wanted to be Fred Astaire," he says. "He made love with his feet, and he was funny looking, and he got the girl." Yet it was Astaire who got to be Avedon, playing a photographer named Dick Avery in the 1956 movie *Funny Face*. Avedon was hired to teach Astaire how to play Dick Avedon.

His own family had its personal performance rites. The Avedons didn't own a dog, but in almost every family snapshot they posed with a borrowed dog—Avedon once counted eleven different dogs in one year—in front of expensive cars and homes they didn't own, either. "All the photographs in our family album," he once wrote, "were built on some kind of lie about who we were, and revealed a truth about who we wanted to be."

His mother thought him marked out for something special. He was born with a caul; she put it in their safe-deposit box.

Avedon was co-editor (with James Baldwin) of an award-winning high-school literary paper, was named Poet Laureate of the New York City High Schools, published doggerel in newspapers, and considered a career in poetry, but: "I saw my own poetry in the deep shadow of T. S. Eliot. Photography was a fallback position."

For years, he could not live up to his father's expectations. He couldn't concentrate at school, couldn't pass *hygiene*, forged all his report cards, and finally flunked out. His father had dire visions of him playing a violin in front of Carnegie Hall. Although Avedon reads prodigiously, voraciously, encyclopedically, he thought of himself then as Dopey Dick, and in his twenties had nightmares that everyone would find out he hadn't even finished high school. "Everything we thought were curses turn out to be blessings," he says now. "Without the despair I wouldn't have made portraits." (Once, when he went to accept an award he assumed was for photography, he was startled to find himself representing learning-disabled people who had after all performed uncommonly well.)

Yet he was tenacious from the start. Determined to work for Alexey Brodovitch, the hugely talented teacher and art editor of *Harper's Bazaar*— Diana Vreeland said Dostoevsky never wrote his best novel because he hadn't met Brodovitch—Avedon turned up week after week in Brodovitch's

reception area, begging for an appointment. Avedon was then in love with a model; he had made her a portfolio and sent it to Alexander Liberman, the art director of *Vogue*. Liberman called him to say they couldn't use the model but would like him to come work for *Vogue*. "No," he replied, "I'm going to work for Alexey Brodovitch and *Harper's Bazaar*." He still had no appointment. (Eventually he got both the appointment and the job.)

He married the model, too; they divorced five years later. Avedon remarried and had a son named John; he and his second wife now live separately. John Avedon, whose portrait will be on view at the Metropolitan, is currently writing an authorized biography of the Dalai Lama.

It is no great surprise that Avedon trusts performances and considers life itself a series of dramatic presentations each of us is under obligation to perform. Theater merely offers the bravest examples. (Avedon goes week after week to the same play if it's remarkably acted or directed; he flew four or five times to Sweden to see Ingmar Bergman's production of Eugene O'Neill's *Long Day's Journey into Night*.) "I'm moved by every kind of performance," he says. "If you're going to leave the house, pick up the phone, go to bed, you have to be ready to give too much. It's what we owe each other." No doubt in a photographic studio most of all.

He regards the act of photographing as "a kind of nervous performance," and says that at least until the late 1960s he had such performance anxiety before a sitting that he must have communicated that tension, consciously or unconsciously, to his sitters—a studio that guaranteed a state of unease, as if the Age of Anxiety couldn't do the job on its own.

Actually, he lives life like a playwright, constantly writing dramas that demand intense reactions to almost everything, whether it's watching city life with eyes that always seem unusually wide open, or conversing in his gravelly voice, or getting so excited about a play that he takes his shoes off and squats on his haunches throughout. He admits to great highs and lows: "I go down very deep and just as high up. It's very strong in me, the sense of joy in me and the knowledge of being stuck in this world we can't explain, or change." Both gleam through his photographs.

He stages not merely portraits but life events. Ted Hartwell, Curator of Photographs at the Minneapolis Institute of Arts, who gave Avedon his first big museum show, in 1970, says that in the hours before the opening, Avedon and Marvin Israel rode around town handing out invitations to crazy or hippie or student types who wouldn't ordinarily go to the museum

openings. "This freaked out the trustees, who thought the revolution had caught up with them," Hartwell says. "It was show business, but it worked. It made a point about the power of photography." In the last gallery, before the mural of the Chicago Seven, an opera singer suddenly began singing "God Bless America," and trustees and hippies alike raised their voices in song.

Owen Edwards, who has written about him several times, says Avedon once came to Patmos, in Greece, to visit when Edwards and six or seven families he knew had houses there. "He transformed all of us. The first day, without a word of Greek, he hired a bunch of donkeys and donkey tenders and got someone to make a great feast. He said: 'Tonight's the night of the full moon. We're going to the highest spot on the island and we'll dance beneath the moon.'" Which they did, and throughout the week joyfully performed Avedon extravaganzas. "He's like a force of nature," Edwards says, "like a guest from MGM."

His friends say he is also the most generous of men. He was so angry that *Rolling Stone* hadn't given proper credit to people who had worked with him on an issue of the magazine entirely devoted to his portraits of major figures that he woke up *Rolling Stone*'s publisher Jann Wenner and exacted a promise that things would be changed, for the presses had just begun to roll. Still suspicious, Avedon went to the printer's at 3:30 in the morning; nothing had been changed. The men in charge said it was too late for this run; they'd make the changes on the next. When no one was looking, Avedon ripped the paper with a key so they'd have to start afresh—and give credit where it was due.

He invited the subjects of his Western portraits to the opening in Fort Worth at his own expense. Art patrons planned events in Avedon's honor; he accepted the invitations on the proviso that he could bring the people who helped him make the pictures. That turned out to be a busload of sitters, assistants, editors—anyone who had ever had anything to do with the photographs.

Avedon's family provided him with a sense of social justice. In high school, when the elevator man in his building ordered Dick Avedon's friend James Baldwin to go up the back way, Avedon reported this to his mother. She rang the elevator bell and when it arrived immediately hauled off and punched the elevator man. Years later, Avedon photographed in the South during the civil-rights crisis. Threatened by phone one night, he decamped

from his motel at 3:00 A.M. and went to hide out in, and photograph in, a mental institution. (His sister died in one at the age of forty-two.)

Like his moods, Avedon's responses can turn on a dime. Edwards, who considers Avedon "Svengali as Santa Claus" because of what he sees as his penchant for benignly controlling others' lives and his ability to "charm me out of any ounce of objectivity I had," once wrote in an article about the photographer's controlling nature. When the piece appeared, Edwards received a case of 1971 Dom Pérignon; he and his wife immediately polished off a bottle. A week later, Avedon changed his mind and wrote a scathing letter to the magazine with a copy to Edwards. "Incredibly foolishly," Edwards says, "I wrapped up the rest of the champagne and sent it back. Which I have regretted all my life—I could have written 'Up yours' and drunk the champagne." Eleven bottles of champagne richer, Avedon sent Edwards a conciliatory letter.

He has been called a control freak, and difficult to boot, no doubt because he is a perfectionist and is so driven to do better that he considers *Dovima and the Elephants*, that masterpiece of fashion photography, a failure because the sash doesn't make the right line. No one who works with him has any complaints. When Peter MacGill, director of the Pace/MacGill Gallery, was asked if Avedon was difficult during his show at the gallery, he burst out: "Look who we represent! Sure they're difficult. For Christ's sake, they're the geniuses. We just put in the nails."

Avedon the genius, a slight man with a great sweep of gray hair, has been a towering figure on the photographic scene. His first pictures of the Paris collections right after World War II, of models in couturier confections actively twirling and hugging their way through cafés and streets with acrobats and bicycle racers, instantly made him famous. He had caught not only the wartime-defying luxe and emphatic femininity of the clothes, but the feeling of release from restriction and fear, the sense that life could be free and active, even a hint that classes might mingle democratically (if properly attired).

He went on to register the sexual revolution while it was still unfolding, introducing the first nude model—a countess, no less—to *Harper's Bazaar* in 1961 and a threesome consisting of two women and one man, all stylishly alienated, in 1964. In 1962 he imported both cinematic narrative and the relatively new phenomenon of paparazzi photography into high fashion with a tale of rabid journalists chasing the actor Mike Nichols and

BRASSAÏ

The only thing about Paris that interested Brassaï was everything—which was pretty much the way he felt about the world. Paris was his microcosm. A young Hungarian who came to Paris to paint in 1924, Brassaï fell so in love with the thousand secrets of the city's night that he stayed up until dawn each day and forgot to paint. In time he learned to photograph and made the mundane corners of the city sing.

In the early 1930s he photographed not just monuments but parks and cafés, bookstalls and pissoirs, scruffy walls and glittering street fairs, bridges, kiosks, brothels, and the entire spectrum of professions and social classes along its cobblestone streets: cesspool cleaners, women in ball gowns and feathered masks, bare-breasted dancers at the Folies, bums hunkered down on the quais. Paris was his and he gave the world its image.

He was so broke that once he had to fork over the last coins to his name to receive an express mail with insufficient postage. The letter turned out to be a desperate friend's appeal for a hundred sous; the two of them had been wiped out by a single stamp. Still, he had a camera, a pack of cigarettes, and a boundless passion for the world—enough to make him one of the major photographers of the century.

Thousands and thousands of photographs of Paris were taken before he made it memorable, but the night belonged to Brassaï. Other people photographed after dark, some of them well, but none so assiduously, devotedly, poetically as he. Only Brassaï recorded the statue of Marshall Ney waving his sword heroically at a hotel sign in the fog. Only Brassaï saw the shadow of a homely buttress as the profile of a big-nosed man, or recognized that the Tour St. Jacques, dressed in nighttime light and scaffolding, was really the ghost of a Gothic wedding cake.

And only he recorded the vital, ribald lowlife of byways and back streets. No one else photographed inside the bordellos; Brassaï snapped three naked women displaying their wares to a customer. No one else hung out in the homosexual and lesbian bars, where men in fancy gowns and floppy-brimmed hats danced with partners in business suits, and even butchers in their workaday clothes shyly and happily led each other across the floor. No one else got the hoodlum gangs to stare into his lens.

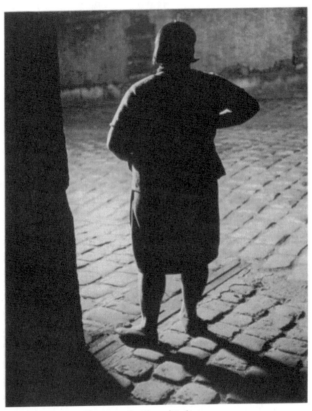

BRASSAÏ, *Streetwalker near the Place d'Italie,* 1932

Nor had anyone before him noticed the brute force of graffiti, those primitive carvings of love and death and magic that would influence the paintings of Antoni Tàpies (who saw Brassaï's photographs in magazines), Jean Dubuffet (who saw them at his apartment), and other artists, most of them introduced to these rough signs by Brassaï.

Born in 1899, Brassaï died in 1984. Just in time for his centennial, the Museum of Fine Arts, Houston has organized "Brassaï: The Eye of Paris"—that's what his good friend Henry Miller called him. The first major retrospective in the United States since 1968, with approximately one hundred forty photographs, drawings, sculptures, and books, this exhibition showcases Brassaï's multiple talents (an endowment he considered both blessing and curse) in a way that has never before been done here.

And in April 2000, an even larger retrospective, also in various media, will open at the Centre Georges Pompidou in Paris. This exhibition will concentrate on work that has not been shown before in an effort to illuminate the multifaceted man himself. Brassaï had such a hungry curiosity, such eagerness and facility—he designed sets for ballet, built a shadow-puppet theater, drew up a chronology of world history, discoursed on St. Augustine—that Henry Miller said he wouldn't be surprised if Brassaï became an embalmer or a member of Parliament.

The splendid aura of his photographs has eclipsed the real brilliance of Brassaï's writings (hundreds of articles and seventeen books) as well as the far milder charm of his drawings and sculpture. Gilberte Brassaï, Brassaï's widow, says François Mitterand, a highly literate man, invited artists and intellectuals to a party one week after his election to the presidency in 1981. "Jack Lang [the Minister of Culture] said to Mitterand," as Mme. Brassaï tells it, "'Brassaï is a very great photographer.' Mitterand said, 'He is above all a very fine writer.'"

Mme. Brassaï still lives in the Paris apartment she and her husband lived in until he died. His albums of photographs, arranged by subject as he had them in life, are neatly lined up on shelves; a Brassaï tapestry covers one wall; some of the old utilitarian objects he collected sit about: a glove-maker's wooden form, laundry irons heavy enough to weight down his photographs and keep them from curling. She locates everything quickly, from his baby pictures to magazine clippings to World War II mail-in forms, with printed choices to cross out or check: "In good health/tired/wounded/killed/dead/without any news."

Mitterand notwithstanding, even Brassaï had to admit that photography was his finest means of expression. He hadn't meant to be a photographer. He didn't *want* to be a photographer. He never considered the medium an art, or entirely satisfying. In the catalog of the Houston show, Anne Wilkes Tucker, the Gus and Lyndall Wortham Curator of Photography at the museum and curator of "Brassaï: The Eye of Paris," quotes him as saying he once detested the camera. He changed his mind.

He first took pictures late in 1929, when photography was not yet an art, nor even a very respectable calling for an artist. Although many were experimenting with photographs, painting was their life and pride. Poor Man Ray was indignant all his life to think he might be better known as a photographer than a painter, and even Henri Cartier-Bresson thought of himself as a painter for several years while honing his photographic talents. Picasso thought Brassaï was wasting his time on photography. "You're a born draftsman," the artist said in 1939 when Brassaï showed him his student drawings. "Why don't you go on with it? You own a gold mine, and you're exploiting a salt mine." Even a great painter cannot know everything.

Gyula Halász, who renamed himself Brassaï in Paris, had considered himself a painter. (Brassaï means "from Brasso," his birthplace in Hungary.) His father, a professor of French who had once wanted to be a poet, took his children to Paris in 1904 for a year and hoped one of them would live there. World War I and subsequent upheavals in Hungary, however, made Brassaï a Romanian citizen and France an enemy; the young man went to Berlin in 1920 to study art and stayed until 1922. His friends there included László Moholy-Nagy, Wassily Kandinsky, and Oskar Kokoschka, but what impressed him most was reading Goethe. Asked once what was the most essential encounter of his life, he replied: "Discovering Goethe."

Goethe's thought would shape Brassaï's photography and his life. Over and over he spoke of Goethe's shift from a romantic youth to a classical, totally objective outlook. Over and over he said that Goethe had found the world more fraught with genius than himself, and quoted Goethe's declaration that objects eventually elevated him to their level.

Brassaï took Goethe's maxims as his goal. Although his photographs of nighttime Paris are wrapped in mist and delicate light, that is only what he saw. His approach is unprejudiced, "objective," never political, never judgmental or satirical about either the high and mighty or the fallen. He records. He describes. He accepts. A faint sense of tenderness hovers about the edges of so many pictures that one might say he is sympathetic, with a

sympathy that extends to the limits of his vision. The least part of the world is valuable and worth paying attention to, a rock as precious as a street lamp, a leafless branch as deserving of respect as a naked woman.

He had barely set down his suitcase in Montparnasse in 1924 before being introduced to the city's nightlife. Instantly he became a nocturnal wanderer, in a city where the moon watched over a continuous spectacle. The cafés were crammed until all hours with artists and writers, many of them expatriates and refugees who had streamed into this capital of intellect and art. The proper bourgeoisie, the working classes, and the artistic fringe all mingled in theaters, clubs, and brothels, and the raucous life of the popular dance halls and dives spilled out onto the sidewalks. Brassaï said his life seemed so amusing and bizarre that he could not imagine closing himself up to paint and so for four years did nothing.

What he did was to prowl the city, sometimes with friends like Miller (even before they could speak each other's language), drinking in Paris and soaking up sights. During the day he earned a precarious living writing for Hungarian and German journals on politics, sports (about which he knew nothing), art, and culture. Evidently his loving parents believed in him; they helped support him into his thirties.

Occasionally, Brassaï sold a drawing or a caricature to the press, sometimes ghostwrote pieces, sometimes sold previously published articles to other papers. Once he invented an interview with a former Russian prime minister, based on one he'd read two years earlier. After fifteen German papers ran it, an editor asked for the Russian's address. Brassaï panicked. Suppose the man was dead? Happily, he was with us still, and extremely forgiving.

In the 1920s, photographs made their way onto the printed page more and more frequently, and at length Germany gave birth to the illustrated photo magazine. A mass audience immediately responded with joy and subscriptions. Already in 1924, Brassaï was supplementing his meager income by turning himself into a kind of photo agency, collecting photographs, selling them to agencies and papers, and commissioning photographers to take pictures to illustrate his stories. By 1925, a "lady photographer" was on call for his assignments; by the end of the year one agency suggested it would be more efficient if he took the pictures himself. He did, but not until four years later.

When he finally took up a camera, he already knew a lot about photographs. He had suggested ideas and worked on several articles with his

fellow Hungarian André Kertész, already a first-rank photographer, who taught him a thing or two about night photography. Kertész would later claim that he lent Brassaï a camera and taught him everything he knew, but it wasn't so. All his life Brassaï read prodigiously—Baudelaire, Beckett, Freud, Genet, Gide, Kafka, Nietzsche, Proust, Sartre, quantum physics, and more—and when he wanted to learn about photography he read a lot, and then experimented.

He said he was so full of reverberating images he could no longer hold them inside, yet he could not translate them properly with paint and had to find a more direct form of expression. Convinced that art was dead and had been replaced by engineering, he decided that photography, which was not an art, was the crucial, expressive medium of our times. Later, he wrote that the contemporary world had a deep hunger "to capture life at its source, in its immediacy, and without the intermediary of the artist, whether that artist is brilliant or boring. . . . Even the most mediocre photographs contain something unique and irreplaceable, something that no Rembrandt, Leonardo, or Picasso—no masterpiece and no artist, living or dead—can attain or equal or replace."

He bought a Voigtlander Bergheil 6-by-9-cm with a Heliar lens. It took glass plates (he adapted it for film after three years) and he couldn't carry more than twenty-four plates at a time, so many of his photographs were taken within walking distance in Montparnasse. He seldom made more than two or three pictures of a subject, and occasionally when making a portrait took but a single picture. With an old wooden tripod that would later be described as repeatedly kneeling down like a camel, he devised simple means for difficult night photography.

Gilberte Brassaï says he carried a measured piece of string so he knew where to place his camera and invented a black sack with sleeves so he could change his plates on the street without exposing them. Nighttime exposures were long, sometimes up to ten minutes. Brassaï, an inveterate smoker, timed his shorter exposures with a Gauloise and the longer ones with a Boyard, which was so dense it was known as a *chômeur*, or unemployed person, because only someone without a job would have the time to smoke it.

To avoid halation, the dead-white patch of haloed light that a direct light can leave on film, Brassaï simply moved his camera behind a tree or a lamppost or whatever would block out the light source. He discovered that the best way to diffuse light was to shoot in fog, or even rain, one rea-

son his night pictures of Paris are so often suffused with romance and nostalgia. "Fog," he said, "is the cosmetic of the city."

Flash had recently been invented, but Brassaï thought the contrasts too harsh, so he stuck with old-fashioned magnesium powder until sometime after World War II. Magnesium was devilish stuff; usually he had an assistant to handle it. The powder, placed on a flat pan, was lit at high heat, setting off a great flare and a mighty noise. Gilberte Brassaï remembers that he once burned his whole arm and another time set a girl's communion dress on fire.

Unlike other European photographers, he always did his own printing. Usually he converted his bathroom into a darkroom, once had to leave a building because his fixing agent had seeped through the outside wall. Alexander Liberman, who worked for the French magazine *Vu* in the mid 1930s, recalls that for a while Brassaï was using a woman friend's bidet to develop his pictures.

About this time he moved into his lifelong apartment near Montparnasse, and converted the kitchen into a darkroom. Pierre Gassmann, who assisted him for a year, says that when they wanted to eat, they had to stop work and clean everything up—one of the reasons they worked late at night. The kitchen remained the place to cook up photographs throughout Brassaï's life; one dealer recalls dining at the apartment at the last minute on bread and a bottle of Hollandaise sauce.

The real products of that kitchen were astonishing pictures. In 1932 Brassaï's first book, *Paris de Nuit*, was published to enormous international acclaim. It made him, instantly, a legend, and established his place in photographic history. His photographs looked like no one else's. Brassaï often said that one of the inexplicable aspects of photography was that no matter how mechanically you used the little machine, no matter how hard you tried to purge the image of personal opinion and psychology, the photographer's personality still left an indelible mark.

Paris de Nuit influenced night photography everywhere and specifically influenced photographers like Bill Brandt, whose *A Night in London* is a direct descendant; Diane Arbus, who said Brassaï reintroduced her to the thrill of darkness; and Helmut Newton, whose fashion photographs taken by the light of street lamps, and particularly a pair of women, one of whom is cross-dressed, derive from Brassaï. (Although Newton did go the master one better by posing the "feminine" partner stark naked.)

Brassaï's Paris at night is a city that sighs in the fog, where the arches of bridges kiss their reflections, city lights make dancing constellations far off between dark walls, and the atmosphere is dense with a sweet and plangent melancholy. He had already ventured into a tougher part of Paris and, curious about what lay behind the doors and windows that sealed him out and others in, had gone inside.

He was young. He was insatiably curious. He was intoxicated with photography and reckless with life. Sometimes the police arrested him, because they couldn't figure out what he was doing, loitering so long at night; no one photographed after dark. Sometimes he went into ramshackle buildings, climbed rickety stairs, and knocked on a stranger's door to ask if he could photograph out a window. The small-time hoods and pimps were dangerous, and there were places where he was altogether unwelcome, "and yet," he wrote, "drawn by the beauty of evil, the magic of the lower depths," he went anyway. "My passion for capturing these pictures made me almost oblivious to danger."

He would hang around, doing his best to look invisible, discreetly showing his photographs to a few people, until finally they asked him to take pictures of them. He was small, poor, foreign—a marginal man himself, with a charm so intense that he complained in letters home of too many friends who liked him too much, and people who knew him later would refer to him as "enchanting" or even "a bit angelic."

Still, some of the lowlife needed to be anonymous. Sometimes Brassaï was chased, his camera broken, his bag stolen. After one thug saw his picture published in a magazine that labeled him a murderer, he came to Brassaï's room with a knife, and the photographer barely bought him off. When gang members lifted his wallet, he never told the police. "Thievery for them, photographs for me. What they did was in character. To each his own."

He photographed fat prostitutes, commonly referred to as "bedbugs" or "codfish," stolidly planted on the sidewalk near Les Halles, in wait for butchers and tripe sellers—as Brassaï described them: "men who were accustomed to dealing with huge masses of flesh." He photographed pimps and hoods and spit-curled dollies in bars where the mirrored walls reflected relationships in fragments, like exercises in some sort of emotional cubism. He photographed a performer dressed as a dim-witted gorilla in a plaid suit, carrying his pale, blond, impossibly innocent child.

Brassaï planned a book about this other Paris, and one was published, but he apparently lost control over the way it was put together and in effect disowned it, never mentioning it in his bibliography. So *The Secret Paris of the 30's*, his astute and memorably touching version of the insistent role desire and aggression play in life, did not get published until 1976, when it ratcheted his legend up another notch. The photographer Louis Stettner, who knew Brassaï from the late 1940s, says he was a most compassionate person and explained to everyone that he didn't want these pictures exhibited (here Stettner begins to laugh) until the women in them were old grandmothers, having presumably become respectable in the interim.

Brassaï single-handedly turned the underworld into a serious subject for photography—inviting, amusing, sinister, and complex, as beautiful and haunting as more familiar places, and as profoundly human. Enough of these pictures were published in the 1930s and exhibited in more recent years to earn Brassaï the credit for having opened up a whole new world for the camera. The American photographer Joel Meyerowitz says: "Brassaï verified that photography was a form capable of revealing your strong feeling. . . . He gave me license to extend my curiosity to the world I lived in."

There are gaiety, bravado, and disaffection in his images, and poignancy, and a muted note of tender affection now and again, but not an ounce of disapproval. "He respected everyone," Gilberte Brassaï says—whores and thieves, clerks and financiers—and it shows. So does his taste for life in whatever guise it wore. The photographs seem to say that no matter how guilty our interest, we had best accept what we see as a part of our world.

Brassaï believed that a good photograph went beyond anecdote, transmuting its subjects into types that stood for humankind. As his friend Roger Grenier put it: "He loved to paraphrase Flaubert in saying that life provided only the accidental, and that the task of the artist was to transform the accidental into the immutable." He disliked instantaneity, yet his pictures of people were so natural, so unself-conscious, that they seemed to be entirely candid and unposed, as if snatched on the run with one of the new 35mm cameras that were so small they were scarcely noticeable, so fast they could shoot by available indoor light—impossible with Brassaï's equipment.

People would have noticed Brassaï, what with his enormous, dark, and slightly bulging eyes, the lower lids drooping a bit so the whites were

visible below the iris. Not to mention his tripod, assistant, and blinding flash. But his mammoth store of patience outlasted their awareness, and he either asked them at some point to hold it or he simply took the picture when it looked right. The result was a kind of improvised theater, where all the participants, well cast and rehearsed for a lifetime, played themselves.

He seldom actually posed people, but there were exceptions. Anne Wilkes Tucker writes that one assistant, Frank Dobo, acknowledged posing as the lover tenderly holding his beloved in one of Brassaï's perfect pictures of young love. Since it was illegal to photograph inside a bordello, the man surveying the naked women or tying his shoe while the prostitute tends to her business on the bidet was a friend of Brassaï's, and Brassaï himself stood next to a pissoir in one picture and played a bum in another.

His life had its own theatrical aspects. When he and Henry Miller hadn't a sou between them, they would order sandwiches and coffee at the Dôme and sit there for hours hoping for a friend to wander by and pick up the tab. (In later years, partly in memory of this life, he was immensely generous, which sometimes distressed his economical French wife.)

While still young and penniless, he was taken under the wing of Mme. Marianne Delaunay-Belleville, a wealthy and talented woman eighteen years older than he and devoted to him for several years. (His parents were shocked, although apparently they were not when he wrote home about another woman's "hot and dazzling thighs on the puma's fur.") Mme. D-B introduced him to society and taught him the proper maneuvers.

His suit might be in the pawnshop, but he could navigate handily between two worlds, one night dressed as a bum to photograph in mean streets, the next at a soirée with aristocrats. He was able to trace the breadth and depth of Paris life with the sweep of an anthropologist and the close attention of a lover. With easy entrée to the upper reaches of society, he photographed at clubs that wouldn't have admitted him and costume balls worthy of Marie Antoinette, staged by Parisian society in the 1930s while Hitler was drawing up plans to burn their city down.

He sold most of his pictures to journals and later put them into books or exhibitions, drawing no line between commercial necessity and art, but bearing witness to his era. Once he told an interviewer: "It is not sociologists who provide insights but photographers of our sort who are observers at the very center of their times."

He actually lived in three worlds, for he had quickly became friends with members of the literary and artistic avant-garde, such as Georges

Bataille, Salvador Dalí, Robert Desnos, Le Corbusier, Michel Leiris, Pierre Mac Orlan, André Masson, Jacques Prévert, Maurice Raynal, Tristan Tzara. Their world had its own madcap adventures and stratagems, and Brassaï, who was a superb storyteller in both pictures and words, often recounted them.

Item: Once when Mac Orlan was penniless but could not get his editor to advance him money, his friends put him to bed and told the editor he had died. The editor came to pay his respects, shed a tear, and left behind twenty francs—a fortune that revived the dead man instantly. Item: Once the painter Hans Reichel came home so drunk he thought the elevator was his bedroom, stripped off all his clothes, put one leg up in the cramped space and fell asleep until his bedroom woke him by ascending.

In 1932, Brassaï was asked to photograph Picasso's sculpture, which no one had yet seen; this was the start of a lifelong friendship. The pictures were published in the first issue of *Minotaure*, the exquisite magazine of Surrealism, in 1933. (After Brassaï published *Conversations avec Picasso* in 1964—*Picasso and Company* in English—Picasso told the novelist Ilya Ehrenburg that if he wanted to understand him he should read this book.)

Minotaure published Brassaï a lot: graffiti (the book by that name would be not published until 1960); "Sculptures Involuntaires," a collaboration with Dalí (objects seen so close up and magnified they could not be recognized as mere rolled-up bus tickets or smears of toothpaste); curlicued details of the Art Nouveau entrances to the Métro, which the camera's scrutiny converted to praying mantises.

The Surrealists liked to claim Brassaï—but he wouldn't be claimed. Independent to the core, he did not join groups and besides, he was irritated by the Surrealists' refusal to value any element of a painting but the subject. On the other hand, their notion that poetry could be found in the street, in ordinary life, anywhere at all, matched his own. "A simple leaf that grows, that lives," he said, "any living being whatever, even a crystal, a molecule, constitute, when you look at them attentively, a sort of miracle that surpasses dream a thousandfold, surpasses a thousandfold the most absurd inventions of the 'surrealists.'" Another time he said: "The great event, the sensational event, is daily life, the normal and not the exceptional conditions of existence," a conviction that permeates his oddly affecting, even lyrical photographs of cobblestones gleaming under a street lamp, a wall graced by the shadow of trees, a hefty worker at Les Halles.

Brassaï was almost explosively creative during his first two or three

years of photographing; most of his greatest pictures were taken then, and in that short interval he produced a body of work that remains unparalleled. There were wonderful photographs later, but during those first years he made picture after picture of perfect conviction and emotional complexity that he never equaled in anything near that quantity again.

Much later, he said he had a theory that everything a man accomplishes he has in his head by the age of twenty or twenty-five; he spends the rest of his life carrying out those early ideas. He told another interviewer: "I think photography is as rich as the world, but for a photographer it is limited. . . . A photographer may change his subject, but he cannot change himself. His vision stays the same." He went on to say: "When I began photography I had done everything I could within two years; I came to the end of myself entirely. I can still take photographs— but I cannot renew myself."

And yet, determined not to scant the profuse gifts he'd been given, he did try to renew himself from time to time by shifting into other arts. There was film, which he tried out for money and promptly gave up. In 1932, the filmmaker Alexander Korda hired him for good pay as a set photographer and trained him as a cameraman. He was bored, and the twelve-hour days cost him his photographic career for a time, and that was that.

Still, cinema had lodged in Brassaï's mind since early childhood. When he was a boy in Paris in 1904, movies were so new that some big stores played little snippets of film in their windows every half hour, and Brassaï would refuse to leave until he'd seen them again. As a grown man, he had a very strong narrative sense. Some of his pictures of people in cafés—men and women locked in love or quarrels, groups whose relationships fracture in mirrors or shift in comparison to others at nearby tables— have the complicated emotional potential of short stories.

If he made photographs that were a form of theater, their mise-en-scène struck him as a filmset. In an article on "Techniques of Night Photography," he wrote: "At night, a city becomes its own decor, studio-like, recomposed in papier-mâché. The overhead lights are out, the projectors set on movable platforms are unplugged." Also, he sometimes photographed sequences, like "A man dies in the street": a fallen man seen from his window, a crowd gathering, the police arriving and taking the body away, the empty sidewalk where the corpse had been—a little stretch of film in still pictures. He planned a book of sequences that, like so many other projects,

never got done. In 1937, he was a founding member of the Cinemathèque in Paris.

And in 1956 Brassaï decided to make a film himself, just to see if he could. So he went to the zoo one day, took pictures of a swan's feet waggling above the water, llamas chewing in syncopated rhythms, polar bears lolling and scratching their tummies and hips and underarms and crotches (especially their crotches), giraffes twirling their heads on long necks like drunken ballerinas, and the great looping arcs that gibbons make swinging with uncanny grace between trees.

From this "ballet of animals," as he described it, he made *Tant qu'il y aura des bêtes* (As long as there are animals). A musical score by Louis Bessières made witty comments on the animals' all-too-human antics, but not a word was spoken. Brassaï, out to prove that motion is the essence of film, produced twenty-three minutes of lolling, bouncing, twitching, wiggling delight, a short that was bought by some thirty countries and won a prize at Cannes that year. Not bad for a first film.

Soon after he finished this one, he wrote Frank Dobo that he was at work on a film about domestic animals, and four years later wrote that he wanted to do a film based on his graffiti and another on the material for *The Secret Paris*. He never made a second film. When asked why, he said that he'd been invited to do so many times but found the idea of exploiting a success offensive, although no doubt (he added in his role as virtuous artist) that was the key to making money.

He had finally begun earning a decent living in the second half of the 1930s. In 1937 he could resign from a magazine called *Coiffure de Paris* and sign on with *Harper's Bazaar* instead. Later he would say: "After a brief period of slavery—I too worked for a hairdressing magazine!—I achieved complete freedom." Brassaï, who wanted to do so much and took such joy in what he did, would do what he wanted to. The photographer Jonathan Becker, who was friendly with him from the mid 1970s, says he "tried hard not to complicate his life with doing things that were outside what he thought he was meant to do with his talents. . . . He thought he had something to express, and he was always in touch with that spirit." Gilberte Brassaï says once her husband detested an idea proposed by *Harper's Bazaar*, which no one ever refused, so he instructed her to say no. She became the official naysayer, preserving Brassaï's reputation for unlimited graciousness and charm.

He had begun to draw again in the late 1930s, which served him in good stead during the war. He fled Paris in 1940 for the south of France, found no work, returned to the capital to make sure his negatives were safe, and stayed for the rest of the war. He refused to work for the Germans and was therefore forbidden to photograph or publish, so he was penniless once again. Gilberte Brassaï says that when the Germans demanded to know why he would not work for them, he said he wasn't photographing anymore, only drawing.

Picasso did arrange for him to photograph his sculpture, but even Picasso had so little heating coal that Brassaï had to wear an overcoat and gloves while photographing. Canvas was so scarce that Picasso bought up bad paintings to paint over and was so tickled with one kitschy reclining nude that he got Brassaï to photograph him pretending to paint it, while the actor Jean Marais, fully clothed, lay on the floor with his hands behind his head as if he were the model.

It was so cold in Brassaï's apartment during the war that his pet fish froze. For a while he lived there in a kind of tent made from large exhibition prints, and once lit a fire on the floor—the burn marks are there to this day. He had been an army officer more than twenty years earlier in Hungary, which then became Romania, and was still a Romanian citizen. Mobilized to serve in the Romanian army, Brassaï deserted by fleeing his apartment and living on false identity papers.

One day, not long after war's end, he was waiting for a man who worked for one of the magazines to pick up an urgently needed picture. The bell rang. Brassaï answered. The fellow had been replaced by a remarkably beautiful young woman in her twenties, Gilberte-Mercédès Boyer. She says Brassaï disappeared almost instantly; she was left staring at an empty hallway.

He had answered the door shirtless; he returned properly dressed. He invited the messenger in, introduced her to his little collection of bones, explained their articulation. He must have been smitten. He sent her back with the wrong photograph. (One wasn't half-dressed when meeting a woman then; anyway, Brassaï was a middle-European gentleman of another generation who spent a good deal of his life in a tie, even at home. The photographer Marc Riboud, who revered Brassaï, says that when he knew him other French photographers all tried to look like one another and especially tried to look poor, but Brassaï, still neatly, formally, and in his way elegantly turned out, looked like a provincial notary.)

Gilberte refused to marry him until he became a French citizen, saying she did not want to be Romanian. Nor did he. They married in 1948. He was twenty years older than she, and late in the marrying game. He had, of course, been broke a long time, and was determined to be free. In the 1930s he fought against the conditions that come with success—a permanent address, responsibilities, and social status—but he lived for fifty years at the same address and was married until he died.

He always clung to the liberties of the bohemian life and protected himself against the demands of success, which came late. He had a house in Eze, in the Midi, high on an isolated hill with a view of Cap d'Antibes. To escape the pressures of Paris he spent up to six months a year there, tending his cactus garden, recharging his sense of self, and working. Gilberte Brassaï says the fashion photographer Erwin Blumenfeld once told her husband he was foolish not to trade on his renown with publicity campaigns, but Brassaï told her he didn't want to be a slave—Blumenfeld was still working at midnight, and his nails were bitten to the quick. Mme. Brassaï says her husband was determined not to be a prisoner of luxury.

Harper's Bazaar, a mainstay of his income for a time, published some of his most famous early pictures and commissioned reportages and portraits of leading artists and writers. Having no studio, he photographed artists in their studios and writers at home. (Jean Genet, just out of prison, was homeless; Brassaï photographed him in a saloon.) In 1982, Brassaï published *The Artists of My Life*, with pictures of artists at work—Matisse soberly sketching a nude, Maillol lovingly carving one. (Maillol told Brassaï: "I love to caress buttocks, lovely full buttocks. They're the most beautiful shape nature ever created!") Brassaï photographed the jumbled statues, orderly canvases, and lively counterpoint of works arranged by artists for themselves. His text opened a window into the life and thought of men like Picasso, Bonnard, Giacometti, Braque, Miró.

Many of the artists and writers he photographed were old friends. Gilberte Brassaï says that when they went to Spain to photograph Dalí, the artist was so eager to have his picture taken he had the entire house whitewashed, changed costume four times in one day without being asked to, and one morning, early, tossed a note wrapped around a rock through their open hotel window to say: "The sun is iffy, the sea very calm. Perhaps we could profit from this. Good morning."

Brassaï insisted that portraits too were objective. "I take a portrait as if it were a potato," he said. "One doesn't need psychology. . . . When I do

a person's portrait, I like to photograph the immobility of the face, so as to refer each of us back to his own solitude. The mobility of a face is always an accident. I search for what is permanent."

He never ambushed a subject. He told the critic John Gruen: "You must look into their eyes and see what is inside of them, but then you must look away because they don't like that." But Brassaï *had* looked inside. His portraits have a psychological subtlety that potatoes cannot match: *Le môme Bijou*, the aged courtesan, her eyes burning behind her jewels; Giacometti, straightforward but a bit sad, a bit hesitant behind his sculpture of a bony arm and hand with stretched-out fingers.

In 1946, Brassaï ventured into a new field: sculpture. He picked up small stones on the beach and coaxed from them a form he said the water had already begun blocking out. Sometimes these pebbles suggested faces, but most of the time the ocean had been unusually preoccupied with the female body. Brassaï repeatedly produced headless female nudes with swelling hips and small breasts—a shape that brings to mind (a little too readily) Arp, Brancusi, and Cycladic art—Brassaï admired the latter above all. This was a whole new career, and he pursued it for the rest of his life, as passionately as he pursued all his art, attacking his stones with such zest and making such a racket while carving on train trips that his wife was embarrassed to be with him.

Brassaï obviously loved women. Almost all his drawings and most of his statues were nudes, and he made some early, tantalizing nude photographs, such as a woman seen from the waist down wearing a black corset and net stockings with nothing covering her delicious derrière. In the 1930s he scratched drawings onto some plates, turning photographs of nudes into hybrid creatures: half-nude, half-musical instrument; half-nude, half-African mask.

His delight in women and the female form shines through his photographs of women, whether they wear clothes or not. One would expect no less of a man so delighted by the pleasures of the eye, a man of such vitality and charm that the art dealer Virginia Zabriskie said the energy radiating from him well into his seventies struck her as a mix of creative and sexual intensity.

Late in life, he savored the adulation that came his way. The photographer Inge Morath, who met him in Paris in the 1950s, says he was revered and knew he was and would hold court in his favorite cafés. Friends and admirers gathered around to hear him talk about Picasso blowing a

trumpet out the window in the 1930s whenever he finished an illustration for his editor across the street; or Jacques Prévert leaving his scribbled poems behind him in cafés when he'd been drinking, and an editor traipsing after to collect them for a book. At the Marlborough Gallery opening in New York in 1976, when the "Secret Paris" material was received with an outburst of enthusiasm, Louis Stettner steered all the pretty young women Brassaï's way and told them to give him a kiss. "Louis, you're my pimp," the seventy-seven-year-old photographer said, no doubt with his usual twinkle, for he later wrote Jonathan Becker with relish about the young women who "fainted with emotion or sobbed in [his] arms" at the show. Stettner also says that on weekdays Brassaï would wander around his show, tap someone on the shoulder and say: "Look, I'm the photographer," in expectation of a flattering response.

He never stopped writing. In 1949, his first book of text without pictures, *L'Histoire de Marie*, was published. It briefly records the thoughts and one-sided conversations of Marie, his uneducated maid, who gets hauled into court for making too much noise at night with a lover, although she doesn't have one and, as her own lawyer points out, is so old and ugly no one would believe she did. Tough, salty, vernacular, original, it is written with the same kind of objectivity, the same hearty acceptance and refusal to judge that characterize his photographs. Samuel Beckett, who was a friend, sent Brassaï a note saying he had read it "laughing sadly," which seems just right. *Conversations avec Picasso* originated with scribbled notes about conversations that Brassaï stuffed into a box in the 1930s and later found again. He never used a tape recorder, but reconstructed conversations from his prodigious memory, saying the important things were what persisted, precisely his feeling about photographs. His ear was as good as his eye at finding the telling anecdote and the essence: Picasso ruining a bronze of his mistress Dora Maar by urinating on it to improve the patina, or refusing to scratch graffiti into walls because he would have to leave them to their fate, or saying he never let anyone dust his things because he wanted to know if they'd been meddled with—so he usually wore gray suits that wouldn't show the dust that settled on him too.

In the 1960s Carmel Snow, Brassaï's brilliant editor at *Harper's Bazaar*, died. And magazines were changing; there wasn't so much place for his kind of work any more. He preferred sculpting and writing by then anyway, and virtually gave up his camera. He took a few color photographs in America at the end of the 1950s, and more elsewhere, mostly of walls that time and

weather had remade into abstract paintings. He preferred black and white but thought American civilization cried out for color.

Whatever he did he insisted on doing with passion, and he had used up his passion for photography. He began to make bigger sculptures in marble, sometimes in bronze. He designed several tapestries—another new medium for him—by combining images from various graffiti.

Then in the early 1970s, the photography market started to bloom, first in America, and gave Brassaï new worldwide fame. Honors rained down. Gilberte Brassaï says the French government offered him a major award when he was eighty, but he wrote to say he didn't need any more honors at his age and they should keep them for younger people.

Extravagantly gifted as Brassaï was, he thought it a virtual calamity to have so many talents, and said that he was constantly waging a kind of interior civil war, torn between things he wanted to do and aware he could not do them all. Once, asked on TV whether he had had a happy life, Brassaï looked confounded, thought a while, finally smiled a tiny smile and said he wasn't entirely happy because he had too many desires. But then, he said, that's life, and if all your desires were satisfied, that was the end. His widow says her husband was good-hearted, generous, and an optimist, that in a difficult situation he would say: "It will arrange itself. Courage. Life is courage."

He was convinced that people liked to work (perhaps he was just projecting) and that the best way to rest was to change activities. At his death, he was finishing a book on Proust and photography, which has only recently been published (*Proust in the Power of Photography*, University of Chicago Press, 2001). An interviewer once asked if he worked a lot. "Me?" said Brassaï, smiling. "I never work!" Taken all in all, it looks like an enviable life.

He had always meant to live on the heights. In 1924 he wrote his parents: "I don't need a 'nice' life but a great one—otherwise everything, everything is meaningless." From the beginning, before he published anything he cared about, before he could earn a living, he had total confidence in his talents. Rightly so; he was every bit as good as he thought he was. As David Travis, curator of photography at the Art Institute of Chicago, puts it: "He was not the best of his kind—he was the only one."

He was. There has never been another.

WALKER EVANS

Richard Benson, Dean of the School of Art at Yale, says that Walker Evans is *the* great artist of our time. Benson, who printed Evans's negatives for him at one point, will hedge a bit if you bring up Picasso, but if you restrict the dialogue to American photography, even American art, it gets harder to disagree with him anyway. Evans rescued entire realms of American life from being undervalued and overlooked. Down-and-out buildings and orphaned architecture, scattershot letters on hand-painted signs, orderly garages and jumbled-up barbershops, empty streets, junkyards, abandoned cars, and worn-out faces had few pretensions to the status of subject matter before Evans took them on. When no one else was looking, he recognized or maybe even invented the dignity of anonymous objects and modest achievements.

In the 1930s, Evans coaxed vernacular culture and ordinary existence to center stage, turned representation and images—signs and billboards and photographs—into significant themes in photography, and raised documentary to a new level of complexity. Just as the French Revolution took courtiers out of blue satin knee breeches and clad them in sober black suits, Evans put art photography into workaday clothes.

This brought on one of the quietest revolutions in history, establishing a new field and a new mode of vision. Evans didn't manage it single-handedly; he just did it better than anyone else. Not many people realized that a revolution was underway until thirty or forty years later, but if we now know that a tiny wooden church without any grace but God's is touchingly beautiful, that is because Evans's photographs proved it to a nation that hadn't given a damn before.

His work had a powerful influence on the Depression-era photographs of the Farm Security Administration, on Ben Shahn (whom he taught to photograph), Helen Levitt, Harry Callahan, major photographers of the 1950s and 1960s, particularly Robert Frank, Lee Friedlander (who says he doesn't know how any photographer younger than Evans could not be influenced by him), and Garry Winogrand (who once said that Evans's

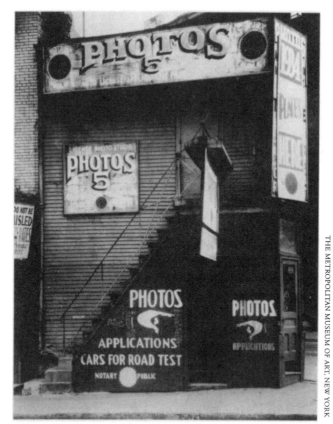

WALKER EVANS, *License Photo Studio, NY,* 1934

book *American Photographs* made him realize for the first time that photography could deal with intelligence). Evans has continued to exert an influence on photographers ever since—from Bruce Davidson and Joel Meyerowitz to Robert Rauschenberg, William Eggleston, and on and on, the street photographers and others who have adopted documentary as the vehicle for American Modernist photography.

He is sometimes credited with influencing Pop art too, and he laughingly referred to himself as its inventor, although it may be that the 1960s obsession with commercial culture was just waiting to happen, and artists took Evans's work as confirmation. Jim Dine and Andy Warhol were both fascinated by Evans; Warhol even titled his photographic homage to Rauschenberg *Let Us Now Praise Famous Men* after the landmark book that Evans made with James Agee. Evans had a strong impact on Conceptual art as well, even on movies that tried to adopt a documentary look, and he played a primary role in shaping our vision of the Depression. The note he struck has simply become the background music of our environment.

Yet "Walker Evans," at the Metropolitan Museum of Art, is the first comprehensive retrospective to include prints from every period of Evans's work, including his stint at *Fortune* and the SX-70 Polaroids he took at the end of his life. Jeff L. Rosenheim, Assistant Curator in the museum's department of photographs, has assembled 175 photographs plus a variety of previously unseen diaries, letters, family albums, magazines, postcards, and books from the Walker Evans Archive, acquired by the Metropolitan in 1994 (a catalog, from Princeton University Press, accompanies the show).

Evans (1903–1975) was a rebel in a Brooks Brothers suit. His father was an advertising executive, his mother a social climber. They lived in Kenilworth, a tony suburb of Chicago, and Toledo. Walker meant to be a writer, dropped out of college after freshman year but read his way through contemporary literature anyway, spent a year beginning in 1926 moping about in Paris, returned to New York and decided he didn't write well enough. He'd fiddled a bit with photography but didn't take it seriously until 1928 or '29. By 1930 he was so excited by the possibilities of the medium he said he sometimes thought himself mad.

Being a photographer was rebellion enough at a time when photography was considered a shabby excuse for a profession. "My poor father . . . decided that all I wanted to do was to be naughty and get hold of girls through photography," Evans said. "Of course, that made it more interesting for me, the fact that it was perverse."

When rebellion is needed, reasons can always be found. There were those who thought the boom years of the 1920s revealed this nation at its worst. "I was really anti-American at the time," Evans said. "America was big business and I wanted to escape. It nauseated me. My photography was a semi-conscious reaction against right-thinking and optimism; it was an attack on the establishment."

Determined to be an artist, he lived from hand to mouth during much of the Depression; at one point he was so poor he had to sell his books. All his life he yearned to be a millionaire yet despised capitalism, amused himself when he had a little money by spending more than he had on fancy hotels and waxed-calf Peal shoes. A friend wrote that Evans's initial interest in him "derived from one particular Savile Row suit—which he so coveted that I promised to leave it to him in my will." Evans was acclaimed a major artist more than once, although never by his bank account.

Primed on Modernist European practices, Evans first took photographs strong on design, odd angles, urban geometries, and montage effects; three in that vein were published in 1930 in Hart Crane's *The Bridge*. But Evans soon tried something different, taking pictures on the street that looked unpremeditated—individuals at rest for a moment in the welter of the city, signs casually scrawled on walls, insignificant subjects he looked at directly, plainly, even brutally, without flourish or embellishment or the traditional tactics of art. He was suddenly in rebellion against the photography of his time, working against what he thought was the dishonest use of the camera by the two reigning masters of the medium, Edward Steichen (too commercial) and Alfred Stieglitz (too arty).

Evans was more impressed by the succinctness and reality of newspaper photographs and newsreels, picture postcards (which he collected), reportedly even the pictures in realtors' offices. His photographic portfolio for Carleton Beals's book *The Crime of Cuba* in 1933 included a couple of anonymous news pictures of atrocities, audacious evidence of his faith in the power of news photographs as well as in the artist's prerogative to use whatever is at hand. Few American artists back then were inspired by newsreels and news photographs. Evans was.

The moment was right. This was a documentary era, and the camera was its star. Some movie theaters showed nothing but newsreels all day long. Certain sections of John Dos Passos's trilogy *U.S.A.* were titled "Camera Eye," others, "Newsreel." In *Let Us Now Praise Famous Men*, Agee wrote

that "all of consciousness is shifted from the imagined, the revisive, to the effort to perceive simply the cruel radiance of what is. This is why the camera seems to me, next to unassisted and weaponless consciousness, the central instrument of our time." Evans was exceptionally fine-tuned to the cruel radiance of what is.

In 1931, Lincoln Kirstein, who while still a student at Harvard founded a vanguard magazine and a contemporary-art society that influenced the founding of New York's Museum of Modern Art, invited Evans to photograph Victorian architecture in New England, which most people at the time thought really deserved to be ignored. Evans said: "This undergraduate was *teaching* me something about what I was doing—it was a typical Kirstein switcheroo, all permeated with tremendous spirit, flash, dash and a kind of seeming high jinks that covered a really penetrating intelligence" about "all aesthetic matters." (Kirstein, on the other hand, found Evans so perennially bored, so thin-blooded and easily tired that he thought perhaps he didn't get enough to eat.)

Evans loved the Victorian houses, their genteel decay, their quaint rectitude and decorative furbelows, their air of being solid and proper beneath their frippery, as if they were pilgrims wearing lace collars. In 1933, Kirstein arranged for a show of the photographs at MoMA, the first one-man exhibition of photographs in a major American museum.

In 1935 MoMA hired Evans to photograph African sculpture; John Cheever worked as his assistant. That year, while photographing architecture in and around New Orleans, Evans met Paul Ninas and his wife Jane Smith Ninas (now Jane Sargeant), both painters. Paul Ninas had a mistress who sometimes spent evenings with the couple; when Evans and Jane Ninas fell in love, the dinner-and-dancing foursome had some brittle moments. One night in the Ninas living room, Paul pointed a gun at Walker and told him to take Jane or get out of their lives. Evans got out. He wrote her a long, apologetic letter, and that was that.

Evans had been hired by Roy Stryker, head of the photographic section of the Resettlement Administration, created in 1935 and later renamed the Farm Security Administration (FSA), a New Deal bureau established to help farmers in trouble. Brought in to win public support for the program, thirteen FSA photographers made more than seventy-five thousand prints and two hundred thousand negatives over the course of eight years—unprecedented proof of the government's belief in the power of photography, as well as a vital record of the Depression.

Evans, who wouldn't engage in politics, wasn't about to take government directions, and didn't believe in social reform through photography, was nonetheless crucial to the FSA. Stryker later said Evans's pictures greatly expanded his notion of what photographs could do. Evans himself said that other FSA photographers (including Dorothea Lange, Russell Lee, and Arthur Rothstein) just stole his style and applied it to this propaganda project.

He remained aloof from politics—Jane Sargeant says he didn't even vote until sometime in the late 1940s and then was nearly hysterical, not knowing how—and he stubbornly resisted authority all his life. While many intellectuals in the 1930s were embracing Communism, Evans did not. "I didn't want to be told what to do by the Communist party," he said, "any more than I wanted to be told what to do by an advertising man for soap."

Or by the government. Stryker soon discovered that Evans seldom checked in, seldom could be located when out on the road, did not always take the pictures he was asked to, and, since he primarily used the time-consuming 8-by-10 camera, which gives far greater detail than a 35mm, wasn't sending as many pictures to the file as other photographers were. Stryker dismissed him after little more than two years.

Evans was violently opposed to anything that smacked of propaganda, no matter how good the cause. Because he took pictures of sharecroppers, he has been repeatedly misread as a social-reform photographer, a label he couldn't bear. "I would not politicize my mind or work. . . . The apostles can't have me. I don't think an artist is directly able to alleviate the human condition. He's very interested in *revealing* it." Evans was against suborning the camera to charitable causes, against bleeding hearts, special pleading, exploitation, sensationalism—against anything that inserted the artist's personality, feelings, and political agenda into the photograph.

There were some precedents for this willful removal of the artist from his work. Mathew Brady and some of his nineteenth-century American peers took photographs that were plainspoken, straightforward records rather than personal expression, but that was before photography took on the fancy airs of art. In the first quarter of this century, Eugène Atget had mined a vein of poetry in the unassuming doorways and shop fronts of Paris. Evans knew the work of both men, but said his primary influences were Baudelaire and Flaubert, who wanted the author to disappear in the work. Evans had also read Modernist doctrines of impersonality—writers like T. S. Eliot, who said: "Poetry is not a turning loose of emotion, but an

escape from emotion; it is not the expression of personality, but an escape from personality." Evans set out to meld art with the flat, impersonal rhetoric of documentary photography and to produce images that would be, as he put it, "literate, authoritative, and transcendent."

And deceptively plain. When John Szarkowski, Director of MoMA's photography department from 1962 to 1991, first saw Evans's book *American Photographs* as a sophomore in college in the 1940s, he was so baffled that for a minute he thought it might be a practical joke. Where in God's name was the art? It was mostly just *facts*, he said, and any self-respecting sophomore could tell you that just *facts* were certainly not art. Szarkowski changed his mind. MoMA's 1971 retrospective put Evans on the map in a big way.

In 1935–36, Evans, in a virtual blaze of creativity, produced one picture after another that was tersely and dazzlingly eloquent about America and its history, and sometimes about the history of time itself, as if everywhere he looked the world spoke to him of something profound. In Bethlehem, Pennsylvania, he photographed a graveyard in the foreground, workers' houses in the middle ground, and factories behind, his lens compressing the distances so the three realms jam up against one another. Here are whole lives—birth, work, death—in thrall to the factories and their owners. A woman came to the FSA and requested a print. Asked why she wanted it, she replied: "I want to give it to my brother who's a steel executive. I want to write on it: *Your* cemeteries, *your* streets, *your* buildings, *your* steel mills. But *our* souls. God damn you."

Evans photographed a building in South Carolina that was a veritable entrepreneurial index, with signs for an art school, a public stenographer, a fish company, and "fruits and vegetables," all in different typefaces like a smorgasbord of alphabets, topped off with a sign saying: "GENERAL LAFAYETTE SPOKE FROM THIS PORCH IN 1824"—the past and present life of a Southern town spelled out in commerce and placards. Evans was one of the first to realize that the decade's history was being written by advertising of one sort or another, with signs spreading over buildings like kudzu. He was plumbing the heart of America through its buildings, its faces, and its public notices.

He commemorated the endless grid of portraits in the window of a Penny Picture Studio, where ordinary citizens had exercised their right to be represented. In effect, they posed again for Evans, who re-presented them, making the studio photographer's art his own—years before that idea

occurred to the general run of artists. The picture is a riff on photography and time as well: the camera preserved these people in memory, and Evans preserves them doubly, yet only in representation after all. The babies and teens and men in suspenders in that window are different by now, or gone. Photographs are merely a stopgap with smiles.

With Puritan austerity, Shaker simplicity, and Protestant thrift, as well as a certain affection and occasional wit, Evans limned the implications in scenes and faces and postures. Here were the things of this world, things as they were, secretly broadcasting their histories of being built, lived in, discarded, of having had experiences that just might shine through the documented surface if you peered closely enough. A storefront is just a storefront, a street just a street, and yet they are not: they are the sites and evidence of human life and social history, influenced by tradition and commerce and necessity, inhabited by memory and expectation.

In the summer of 1936, Evans got leave from the FSA to go South with Agee for a *Fortune* article on sharecroppers. Evans was emotionally aloof, in person as well as in his photographs; Agee leaked guilt and confession from his pores. Agee conversed in a steady torrent, unstoppably, like Niagara, and in later years, when Evans sometimes staggered away from his monologues in the wee hours, exhausted, that inveterate talker would follow him into the bedroom to pursue his stream of thought. Evans once said: "I'm embarrassed by the subjective, I'm embarrassed by Agee's prose, great as I think it is. I could never imagine myself in a confessional mood or an exhibitionistic one."

The two of them spent several weeks with three sharecropper families. Evans took portraits, mostly letting his subjects pose themselves and arrange their faces for confrontations with the camera. One woman gives a shy, graceful fillip to a sack dress that betrays her utter poverty, another stares hard at the lens without a hint of either vanity or self-pity. A family assembles in a bedroom—bare feet, scratched shins, dirty clothes. The boy, half-naked, laughs; the rest are self-contained, even solemn, perhaps evaluating the photographer, all possessed of an obscure dignity as surely as any merchant family in a daguerreotype.

Evans's refusal to politicize, proselytize, or propagandize equalized the differences between a photographer with a salary and subjects without, between the looker and the looked at. He insisted that human beings in any circumstances whatever were valuable enough in themselves not to be

objects to him or to anyone else, and that they be taken on their own terms, not on terms of charity or prejudice or knee-jerk reactions to class.

Some say he exploited these families and made them look worse than they were, but William Christenberry, who first saw those photographs in the 1960s and recognized a family that had lived near his grandparents, says he showed the book to one of the children in the pictures, who said: "We loved Mr. Jimmy and Mr. Walker. They would send us Christmas gifts."

Evans photographed the sharecroppers' simple, hand-built houses and their raggedy interiors, framing the rooms so exquisitely and lighting them so carefully that they tend to look like Vermeer on a stringent diet. He photographed Southern towns too, the isolated stores and minstrel-show posters, the men on benches waiting long hours for nothing. These deadpan reports of buildings and streets and weary faces are history texts, cultural accounts, critiques of America, somber assessments of the human condition. Evans was highly aware of the camera's indissoluble marriage to history, and once wrote that he was "interested in what any present time will look like as the past."

Agee's text was so long and so late that *Fortune* would not publish it. In 1941, *Let Us Now Praise Famous Men* came out in book form, with Evans's photographs (as he had insisted) grouped before the title page without captions, wordlessly divulging secrets about the degree of order that can be wrested from the disordered existence of too little money and too much hard work. The critic Lionel Trilling called the book "the most realistic and the most important moral effort of our American generation," but with Europe at war and the Depression beginning to lift, no one was interested. *Let Us Now Praise Famous Men* sold just over six hundred copies.

In 1938, MoMA mounted "Walker Evans: American Photographs," a one-hundred-photograph retrospective accompanied by a catalog. The book was a poem at once epic and elegiac, its subject nothing less than American culture—the work of its hands; the dreams that sustained it (or didn't); its echoing history undergoing a slow, mechanical corruption; the quiet collapse of all things under the pressure of time. Evans grouped the photographs in the book into two sequences without captions. The opening series of pictures of photographs and portraits comments not just on the record before our eyes but also on the spread of images across the world. Then there are automobiles, an automobile graveyard with dead cars in a skeletal traffic jam, street people and lonely streets, Depression casualties,

a coal miner's house with boisterous ads proclaiming the good life on the walls, all set out in the quietest photography in the world, not a footfall or a whisper, only the inaudible sigh of time as it seeps away.

In the second section, nearly everyone has left, and empty streets and houses marching in rows wait to be waked. This section opens on a relic, a smashed piece of tin stamped with classical designs, the remnant of a tin desire for European class. The photographs advance through towns built around factories and railroads, a few fields and some industry swallowing them, then bare-board churches and houses that, as the pages turn, grow more elaborately decorated until the book ends with another tin relic— another bit of ersatz grandeur fallen on hard times—American culture, created by unsung builders and craftsmen trying to make the prosaic present beautiful before time unravels it. Evans once said: "I am fascinated by man's work and the civilization that he's built. In fact, I think that's *the* interesting thing in the world, what man makes."

Sequence was of the utmost importance to him. His photographs change meaning as they echo and interact with other pictures. Near the end of the first section, a poster for a Carole Lombard movie in front of a couple of ungainly houses suggests the illusory lures of Hollywood dreams, but when you turn the next page and the next, the dreamers are out-of-work men with no place to sleep but the street, and the last picture in the section is of a ruined plantation house blocked by an enormous, uprooted tree—a way of life built on an untenable dream that came at last to nothing.

The author who disappears in his work expects us to spend time making our own connections and conclusions as the photographs continue to comment on one another. Evans asks a lot of his audience. If instant gratification is the goal, he seems to say, there are always the picture magazines, like *Life* (which he hated), but the kingdom of poetry was not built in a day.

William Carlos Williams wrote about *American Photographs* that "it is ourselves we see, ourselves lifted from a parochial setting. We see what we have not heretofore realized, ourselves made worthy in our anonymity." Others thought the book jaundiced, complaining that it was unfairly critical of this country at a time when it needed boosting. Ansel Adams wrote Edward Weston about it: "I am so *goddam* mad about what people from the left think America is."

In New Orleans, Paul Ninas showed his wife the dedication page with her initials, J.S.N. She was astonished. It was the first sign she had had from Evans since his good-bye letter three years earlier. He began a clandestine correspondence, with missives no bigger than Chinese fortunes tucked into letters from one of her friends. She found an excuse to go East, refused to return to a marriage already in tatters, and in 1939 moved in with Evans. They were broke. After the MoMA show, Evans was indisputably a master, at least to the few who cared about photography then, but he could not get work. Sometimes Agee gave them ten dollars to get through the week. Jane and Paul divorced, and she and Evans married on the spur of the moment in 1941.

A complex man and prone to depression from early in life, Evans was equipped with a klieg-light charm that is said to have illuminated rooms when he came in the door. James Stern, a colleague at *Time* during World War II, described the multiple man: "There was Walker the intellectual, Walker the pedagogue, the hypochondriac, the man-about-town, the *boulevardier*—I was about to say lover. There were women, I know, who loved and admired him but considered him 'wicked,' a bit of a scoundrel." Bill Stott, Professor of American Studies and English at the University of Texas, who knew Evans late in life, says his talk was "generally brilliant and gaudy and full of aphorisms."

There was also the devilishly clever Evans. The artist Mary Frank says that one year when he had not received an expected invitation to Cape Cod, she received a letter from him that read roughly like this: "Dear Walker, It's so wonderful up here, the only thing wrong is I've been missing you a lot. . . . Please let me know when you could come," which he had signed "Mary"—and he arrived as if in grateful response.

Once when Richard Benson finished printing an Evans portfolio, someone asked Evans to sign three empty picture mounts in case one should get damaged and need to be replaced. An artist's signature is valuable, but Evans graciously consented; he signed one "Abraham Lincoln," one "Walt Whitman," and one "Ralph Waldo Emerson." (The epigraph to Evans's 1971 retrospective included Whitman's "I do not doubt there is far more in trivialities, insects, vulgar persons, slaves, dwarfs, weeds, rejected refuse, than I have supposed.")

In 1938 Evans had a new project, to photograph unsuspecting subjects in the subway. He hung his Contax about his neck like a tourist but

neither touched it nor put it to his eye, so no one realized he was photographing by means of a long cable release strung through his sleeve to his hand. He went underground to catch strangers unaware, with their guards down and their faces naked. The light was dim, the train lurched, his camera position was effectively fixed, and he depended on luck to put good subjects on the bench opposite his seat. He had purposely given up a large measure of control to photograph people who had unwittingly given up control over their own images; no one would tell them to "smile for the birdie." Evans had introduced chance into the photographic domain, where portraiture did not take chances.

These pictures were not published for a long while, but in 1966 MoMA exhibited them, and a book titled *Many Are Called* brought them a wider audience. Evans knew perfectly well how intrusive these pictures were; he once referred to himself as a "penitent spy and apologetic voyeur." The photographs were one of the higher-class signposts on the road to the general breakdown of privacy. Evans regarded them as a kind of inventory of "the people," that core identity the 1930s was so eager to find: "As it happens, you don't see among them the face of a judge or a senator or a bank president. What you do see is at once sobering, startling, and obvious: these are the ladies and gentlemen of the jury."

From 1943 to 1945, Evans reviewed movies and sometimes art and books for *Time* magazine. Gas and film were scarce, making photography difficult, and he had a full-time job, but he was always short on energy anyway and didn't seem charged up with ideas that would push him out the door with his camera. It must have added to his depression that no one was commissioning him to go out, either, and possibly he knew he had already reached his peak. At least he was writing, as he'd always longed to do. He had a taste for popular movies, rather like his taste for vernacular architecture. Reviewing *Coney Island* (1943, Walter Lang), he said: "The Technicolor cameras of this picture will turn many a spectator green with envy. They have been allowed a prolonged fondling of Betty Grable."

In 1945 Evans joined *Fortune* as the only staff photographer, and later became the magazine's Special Photographic Editor. He was always ambivalent about being an artist in a capitalist lair, but he managed to maintain his independence and do pretty much what he wanted to—which wasn't very much—for twenty years. He met with a higher-up now and again and passed some ideas by him, then took off with his camera and didn't come back for a couple of months. Evans must have been a master of manipula-

tion, having managed to persuade first a government bureau and then the Luce empire to pay him to do what he wanted in his own sweet time. Over two decades he published some forty portfolios and photo-essays in *Fortune*, including a couple of essays culled from his postcard collection.

He was still exploring, if not so often discovering. He pursued the issues of self-removal and lack of control by assuming a fixed vantage point on the street and photographing passersby. He photographed the passing scene through the window of a moving train. He claimed that color photography was vulgar, but he published several color essays. And he kept on looking for American life and traditions in the way that life was lived and constructed, on the streets of Chicago, in old New England hotels, old train depots, old office furniture.

He spent less and less time with Jane, and so much of his social life without her that some of his friends and colleagues didn't know he was married. All his life Evans had been certain he was an artist, and when he quarreled with her he would say: "I don't think you know who I am!" When she got a gallery show at last and a tiny taste of success, he thought she was competing with him and painting became so difficult for her that she almost stopped. She left him in 1955 to marry another man.

In 1959 Evans met Isabelle Boeschenstein von Steiger (now Storey), a Swiss designer, exceedingly pretty, worldly, and almost thirty years younger than he. A year and a half later, she had divorced her husband to marry Evans. His friends included literary types such as Lionel and Diana Trilling, Mary McCarthy, and Edmund Wilson, as well as a bohemian crowd of artists including Mary and Robert Frank, but Evans always kept his acquaintance circles entirely separate. Isabelle Storey says that when she met him he had recently become very social, spending a lot of time with people such as Jock Whitney. Evans the artist and rebel was a not-so-closeted aristocrat at heart. "He was an artist with a dinner jacket," Storey says. "We were invited everywhere."

He was invited to Yale, too, to give a lecture in 1964, and then to teach. He used some students shamelessly to help him out and lend him money, but they thought him a great man they were privileged to assist, and he was exceptionally generous to them too. He quit *Fortune*, where he had become a luxury. He and Isabelle built a house in Lyme, Connecticut, but the marriage was already in trouble. Evans began drinking heavily, and when his wife taught for a semester in Switzerland he accused her of deserting him. As attractive as Evans was to women, and as endlessly fascin-

ated as he was by them, he remained an Edwardian gentleman who could not imagine a woman equal to himself in any way. Isabelle Storey left him in 1971.

In 1973, just two years before he died, Evans bought a Polaroid SX-70 camera. He was frail, but the camera was so easy to use he became excited anew by photography. He worked at high intensity, in color, making more than 2,400 pictures in about eight months: close-up portraits, everyday architecture, interiors, signs. Little of this work has been seen until now.

He had become an obsessive collector, passionately gathering trash, ticket stubs, and shells, sometimes making collages with them, filling the back of his house so completely that half his bed was covered and he'd have to push things aside to slip his thin body between the sheets. Once he bought the entire contents of a yard sale, borrowed a truck and dumped them on a friend's lawn. He collected old signs too, inveigling young friends to help him steal signs in full view of heavily trafficked roads. On one such occasion, William Christenberry, stunned to realize what he had just pulled off, asked Evans what they would have done if the police had stopped them. "Aw, hell," said Evans, "we'd have told them it was a fraternity prank." He was nearly seventy years old.

In his photographs, Evans already owned the vernacular, the hand-painted signs, the ads, the crushed relics, the marginal crafts of American life. Late in life he simply brought them home. He had already lifted the artifacts into public consciousness and hinted that if you put them together in the right order they would sing a national anthem in a new key. And they did, and it had a mournful sound, and it kept time to the beat of American history. It plays throughout the land even today.

Vanity Fair, February 2000

CHAUNCEY HARE

According to Chauncey Hare, interior America is the loneliest place in the world. What few people are there are merely in attendance; by and large, they have given in and given way to their surroundings. Hare doesn't actually take their portraits anyway, although they may be in the picture. He takes portraits of the spaces they occupy and the lives they occasionally inhabit. Sometimes he focuses on empty chairs waiting for someone to settle down patiently for the next round of nothing. "Alienation" is the word Hare uses, a word that has been shockingly overworked, but which comes to rest in the bleak roomscapes of his book *Interior America* (Aperture, 1979).

Photography fuels our voyeurism—what an easy way to get the low-down on people who wouldn't otherwise have invited us in. The camera has intensified the hunger that makes us gobble up other peoples' lives, in magazines, books, and exposés, as if we were trying to add weight to our own. Photography's solid investment in how the other half lives has concentrated on the lower half; in this respect Hare's project is entirely traditional. He borrows a corner of the subject and even the look of some Farm Security Administration photographs. Moved, as he says, by Walker Evans, whose photograph of a cemetery opposite row houses he paraphrases, he was even more moved by Russell Lee, whose photograph of a couple seated on either side of their radio he also paraphrases, and whose stark use of flash he elaborates on.

But Hare's idiom is that of the 1970s. For one thing, the subject has shifted slightly. Hare's people are dispossessed only in spirit. Most of them appear to be blue-collar workers with steady jobs, struggling but afloat. Once postwar affluence had spread far enough, the classes once or twice removed from poverty began to seem equally foreign and fascinating, witness Archie Bunker, Rocky, and at least some of the people and places visited by Bill Owens and Lee Friedlander.

A more critical difference separating Hare from his progenitors is the decline of a kind of humanism, of a belief in the absolute significance of

CHAUNCEY HARE, *San Joaquin Valley, California,* 1970

This photograph was made by Chauncey Hare to protest and warn against the growing domination of working people by multinational corporations and their elite owners and managers.

the individual. When Evans and Lee photographed people, those people were both dignified and central. Drugs, crime, welfare fraud, and fear have made it unimportant, and at times impossible, to believe in the absolute dignity of the poor. Individuals have been so abandoned by the information retrieval society that one frustrated college student I know once gave her social-security number in class when asked for her name.

Hare's people are not central in any way. Even when they occupy the middle of the picture, he usually removes them to a distance that diminishes them. They have little more impact on the picture surface than the ornaments and appliances that decorate their lives. Hare's compositions rarely allow us to concentrate at length on the people in them; rugs, draperies, and toilet bowls keep pulling us away. Possessions define his people and send messages about them that are quite as potent as the messages delivered by their faces and clothes. Evans let interiors substitute for people but never swallow them.

Robert Frank, Friedlander, and Garry Winogrand have made their mark on Hare; he pushes their stylistic innovations one degree further. The frontality, symmetry, and order of Evans's and Lee's worldviews and aesthetics have long since been superseded by imbalance and disarray. Hare's combination of view camera (great detail), wide-angle lens (more objects, odd tilts), and flash (greater contrast, isolation of forms) produces pictures in which nearly every element is of equal importance. This in itself is a kind of disarray, since the eye does not see this way. The human eye edits selectively. It cannot focus equally on every object in its field and it has been trained to consider certain classes of objects, such as people, more important than others. The camera, capable of superhuman focus, has not been socially indoctrinated; unchecked, it will dwell as lovingly on vacuum cleaners as on housewives.

Historically, photographers generally fought this omnivorous impartiality of the camera, composing and focusing direct attention to the major elements. Then, in the 1950s or 1960s, the notion of spotty, divided attention, of concentration that could easily shift focus back and forth, gained ground in the arts. John Cage, the composer, was the most influential proponent of this outlook; his musical compositions acknowledged that people listen to records while also hearing babies cry and sirens scream. Robert Rauschenberg adapted the multiple stimulus to painting, and many photographers simply let their instruments perform as designed.

Still, in most photographs we knew where we were meant to end up, we knew what was *primary*, even if our eyes were continuously being seduced away. But some of Hare's pictures abjure judgment almost entirely; a carved chair leg or messy crib mean as much to the eye as the person in residence does, a floral rug fights a striped sweater for attention. Hierarchies, recognizable systems of values and priorities, have virtually disappeared. Hare's photographs come at us like the news on television. Because the TV reporter's inflection is the same whether the topic is a Middle East conference or a fire in Bayonne, and because the latter may be more visually beguiling, it is hard to judge the relative importance of events. Hare's style itself is a comment on the times.

His spaces are intricate, as demanding as the objects within them. Many photographers have loved the view through an open door to another space, but Hare makes a kind of conundrum of windows and doors that lead to competing spaces, views, centers of interest. Everything pulls in different directions; signs of stress have invaded the photographic figuration. In one vigorous shot of a hotel lobby full of openings that lead nowhere but manage to dwarf the unimportant concierge, the TV set in the center mirrors the photographer.

Hare, with an attitude he calls "stubborn, ironical, rebellious, yet empathic" (the last is less evident), dredges up detailed information from the interior to feed our ravenous curiosity. We see that rosaries decorated the pictures of young men who died in service, that there is a pervasive appetite for ornamental beauty even among those who do not understand it, that the signs of religion are strong in these houses. A curious detail: Leonardo's *Last Supper* turns up no less than four times in this volume, once as a carving that supports a picture of a group of Navy men, once in the company of a model airplane. Apparently art and religion survive, in whatever altered form, even under the pressure of industrial debasement.

The information we get about these lives is, of course, incomplete. The camera cannot deliver everything. Hare tells us that one picture is of his father, ill with an as-yet-undiagnosed malady. Another is of a one-armed man with his good arm toward us. In neither instance could we have discovered the truth unaided. The lives we take in by means of a stranger's report are fragmentary, and we tend to piece them out ourselves, to pick up on one detail or another, to imagine we understand how these people live or feel.

"These pictures carry a more complete message than I am responsible for," Hare writes. His rebellious attitude, his autobiographical journey away from similar rooms, must account in part for the atmosphere of lifelong displacement and ornamented depression that rises from these pictures. In a bleak autobiographical essay, Hare confesses that he never questioned what was expected of him, and therefore he got neatly locked into a corporate engineering career and a marriage. Once he took up photography, he discovered the question mark. This book is a harsh interrogation of the life he came from. Historical and social factors must account for part of the response he elicited; maybe the alienation Hare spies in all that Brooklyn Provincial furniture and insistent TV is really there. His photographs confirm the ambiguity of reportorial photography: packed with more details than the eye can assimilate, they report less than the mind can know and imply almost more than the imagination can bear.

American Photographer, June 1979

PETER
HUJAR

Peter Hujar stamped his photographs
with an uncommon sensibility that has not shown up often or consistently
in photography. It was a sensibility both emotionally removed and tender,
respectful of the compromised dignity of the least of his acquaintances, a
trifle solemn, alert to signs of death and ruin and constantly mindful of the
delicate sorrows of the human condition.

He died in 1987 at the age of fifty-three, one year after the first show
that covered the range of his work. He had been a fashion photographer in
the 1950s and 1960s, then gave it up to pursue his art. Naturally, he ended
up poor and little known except to friends, photographers (many of whom
he influenced), and a small group of staunch admirers. He deserved more
than the crumbs from fame's table.

A wider renown came to Hujar after he died, ironically enough for a
man whose work was so conscious of the end of things. In the 1960s he
took a number of pictures of the catacombs in Palermo, Sicily, where skele-
tons with sad faces or terrified skulls were fully dressed in garments and
gloves. Later he paid homage to ruin and decay mostly via inanimate things,
but mortality still haunted his pictures of the living, hovering just outside
the frame.

"Peter Hujar: Photographs 1980 to 1987" at the Matthew Marks
Gallery is a show of ninety-eight photographs from Hujar's estate, some
never shown before. The gallery says that in most cases Hujar made only
two or three prints, and according to his wishes no posthumous prints will
ever be produced. The prints themselves, on a particularly warm paper that
is no longer manufactured, are quite beautiful.

One would not use that adjective for the images, which are power-
ful and quietly, deeply disturbing, full of pain but resolutely refusing to
dramatize it, now and again touching, now and again amusing in an ele-
giac sort of way. There are portraits of friends, some nude, some in cos-
tume, some engaged in odd enterprises such as biting into a strawberry with

PETER HUJAR, *John Heys in Lana Turner's Gown*, 1980

excessive care, or posing naked with a boa constrictor. There are portraits—they cannot be called anything else—of animals. There are images of destruction: collapsed houses, the flayed carcasses of slain cows, a dead dog on a heap of trash. The photographs are intense and reticent at the same time. They are memorable.

In the 1950s, in his early twenties, Hujar took photographs of retarded and handicapped children that were never published until 1998. These preceded Diane Arbus's and Richard Avedon's images in similar hospitals by years and seem to have set a tone for his later work. His mature imagery deals, at least peripherally, subliminally, with the large and small ploys that human beings devise to keep afloat under the rain of damage that life distributes so liberally.

He grew up in a time when "the love that dare not speak its name" kept mum, when camp, not yet having been defined, was considered a lowlife taste, when cross-dressers stayed in the closet or under cover, and female impersonators did not dream that uptown financiers would consider it hip to come downtown and watch them perform. And he lived into a time when all that changed.

He was part of a camp entourage of performers, artists, and writers in the 1970s and he photographed it from inside, not as if he were a tabloid reporter getting the scoop on bohemia, but more like a philosopher in closed quarters contemplating the way things are, with a sense that if they are seen clearly enough, maybe even he might understand.

How large and serious the life in these pictures is. The atmosphere is not morbid exactly, for bravado breaks through, and dignity, and, at least in a couple of the dogs, nobility. A tenderness comes across, hard to define in the midst of Hujar's strictly controlled dispassion, but there nonetheless, expressed mostly as an acceptance of inherent human frailty and an unwillingness to take advantage of those who trust enough to let their vulnerabilities slip out.

Still, these pictures come trailing melancholy, the melancholy of being alive in the face of eventual death. Beneath the disguises is the body, heir to mortal ills, ineffectively protected by the taffeta dresses and high heels that either gender can put on for display. Everyone is alone, isolated, without the support of backdrops or props other than costumes, plus an occasional snake. Some make direct contact with the camera, but most are off in an interior world that no one will ever quite penetrate.

Even John Heys in Lana Turner's gown, dressed for a role he is not playing, foregoing the pleasure of vamping in favor of solemn concentration, looks not so much at us as inward. And when, naked and daintily holding out a shawl while assuming the pose of a slightly awkward ballerina, he stares at the camera with the look of a man thinking hard about something deep, he seems impervious to the moment, his body performing while his mind roams abroad.

And what is Jerry Rothlein doing, naked in a chair with his robe about his feet, puffing out his torso on display, raising his elbows to shoulder height and dangling his hands down before his armpits? What is he thinking, gazing off to the side, doubtless at nothing in particular unless it's an idea hanging out there in the air, his face all the while manifesting a sweet, vague self-satisfaction? And what about the fellow with one boot on and one off who bends down and studiously touches his bare foot as if he were doing something far too portentous to allow him to bother with the photographer or the camera?

Hujar photographed transvestites, female impersonators, and transsexuals late in Diane Arbus's career and early in Nan Goldin's. Like Arbus, he photographed in black and white, in a square format and a basically old-fashioned style, the subjects usually alone and centered in the frame. Unlike Arbus, he did not think his sitters any more peculiar than the rest of the world and made no efforts to make them seem so. He respected their dilemma, which was, in effect, the human condition.

Unlike Goldin, Hujar worked neither in color nor as a snapshooter, but slowly and contemplatively, as if every picture were a meditation, and he did not chronicle the lurching progress of the days or the knots and tangles of relationships except as those things were incorporated into personality.

If his languorous naked men and occasional masturbators were outré in subject (but not style) when they were taken, Robert Mapplethorpe soon made them look tame. Today Hujar's most startling image is of Jackie Curtis, the female impersonator, almost unrecognizable in his coffin in a man's suit and haircut but without lipstick or eye makeup. Almost no one knew him that way.

The animal portraits are quite simply wonderful. The dogs have personalities as individual as any of the human beings: a calm and regal Great Dane, a fluffy lapdog as convinced of its own glamour as any starlet in a

bikini, a shar-pei both distinguished and a tad disdainful. Horses and cows perk up their ears and thrust their faces close, quizzing us as if to say: "You're an unusual creature. Just who are you, and why, exactly, are we here together?"

For about half the show at Matthew Marks, the gallery used Hujar's notes and a checklist to re-create the photographer's 1986 exhibition as he laid it out himself, the pictures hung two-deep, with his own choices of what was above and next to each photograph along the wall. The result is a mournful blend of youth and death, trash and glamour, sex and ruin. The dead Jackie Curtis lies beneath leafless trees and next to the performance artist Ethyl Eichelberger in dangerously high heels, exaggerated eye makeup, and a ton of bracelets. A photograph of a *Communion Cloth in Ruins*, stained and hanging on a devastated wall, is placed above a mental outpatient who is also ruined; next to these is a self-portrait of Hujar above the severed head of a cow.

Everything ends—animals, cloth, trees, people. In the meantime, and until then, everything perseveres, whatever is alive looking for safety and pleasure and comfort, the people among them maybe even looking for beauty, seeking answers, and thinking of now in order to stave off then.

New York Times, October 6, 2000

JOSEF
KOUDELKA

Styles are not entirely easy to come by, but a clever photographer can find one without twisting his soul for it. A vision is more difficult and more rare. Style depends largely on surface components such as composition and contrast, on aesthetics, on a consistent eye, sometimes on gimmicks. Vision probably draws as much from the life as from the eye, from the heart as well as the brain, from the complexities of personality more than from ingenuity or mastery of craft. Alfred Stieglitz had a vision that persisted through changes of style, Cecil Beaton had a style but not what looks like an authentic vision, Richard Avedon as portraitist has both a style and a vision. Sometimes a style is developed, perhaps unconsciously, because no adequate way to convey the vision immediately presents itself; Virginia Woolf comes to mind in literature, August Sander and Robert Frank in photography.

Although vision obviously goes deeper than style, it is not necessarily better and certainly not always more likeable, for a style may be superficial but charming, whereas a vision can be sincere without being profound. Still, the muse of creative endeavor probably can't help taking more pride in her charges who win through to a vision.

Josef Koudelka has won through. That was made abundantly clear in the exhibition "Josef Koudelka" at the International Center of Photography in New York. Koudelka's style is derivative of Henri Cartier-Bresson's, although he has rung enough changes on the master to make it his own. Koudelka's vision is more clearly his personal creation—a distillate of the accidents of his birth, time, and place in the twentieth century. The photographs themselves are visual scraps cut out of the history of social and political displacements in Europe and America, scraps that have been rearranged to make a largely impenetrable but deeply resonant tale. (Aperture's fine, simultaneous publication, a selection rather different from the exhibition, is titled *Exiles*.)

In this country, Koudelka must be the least known of well-known photographers. He has won numerous grants and awards, including an

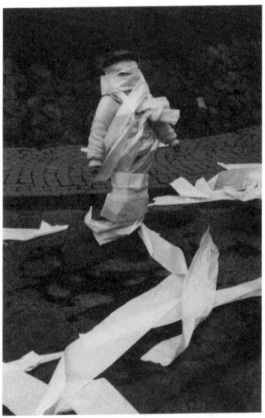

JOSEF KOUDELKA, *Carnival, Rhenania-Westphalia, Cologne*, 1979

NEA grant, and his pictures of gypsies were shown at the Museum of Modern Art in New York and published in book form in the 1970s. Yet his recent work has never been exhibited here before, his work of the 1970s only rarely, and none of it is often before the public. Lovers of photography respect Koudelka highly but do not know many of his images, and beyond the medium's core audience he generally goes unrecognized. This is in some part due to his refusal to contribute to the publicity machine. He is a member of Magnum but will not accept assignments. He rarely grants interviews, scarcely appears at his own openings. Apparently he distrusts words and prefers to let his pictures speak, for the captions in this exhibition give place and date but no other explanation whatsoever, although the pictures often lock up secrets only words could open.

The photographer himself lives the life of his pictures, a fact that does not account for their quality but does help explain his affinities, his sympathies, his access. Koudelka, who was born in Czechoslovakia in 1938, lived through and photographed the 1968 intervention in Prague. For a time, tanks were the center of his photographs, the central fact of life, always close enough to touch. Two years after the great machines ground down the streets of Prague, Koudelka was granted asylum in England. He now lives in France, in a manner of speaking; each year from spring to fall he travels and photographs, then prints during the winter in various darkrooms. It has been reported that he carries a sleeping bag and refuses to stay in hotel rooms. He has remained a photographic gypsy, a permanent outsider, at one with the peculiarly isolated urban dwellers he photographs. Czeslaw Milosz, the Czech writer in exile, says in his essay in *Exiles*: "To express the existential situation of modern man, one must live in exile of some sort." Interior exile will do.

Koudelka depicts contemporary life itself, especially urban life, as displacement, effacement, and isolation. A child stands on a paper-strewn street, its body and face wrapped round in paper strips, looking like a mummy, an icon, a symbol without referent. The graininess of another photograph turns a woman into the same substance as the wall behind her. Often in these pictures shadow eats away form and creates new, impractical realities. In one, a man stands with his back to a decorated cart in which painted figures ride. The carved figures are in focus, he is not; they are more *real*, more secure in the world, more lasting, while he is slowly being dissolved by time and light.

People in these pictures walk the streets like automata, the secret agents of some unbearable bureaucracy. Lack of connection, endemic to modern cities, seems to be calibrated in Koudelka's photographs, the physical and psychic distances marked off according to unwritten rules and then disrupted by some unlikely, even unseemly, circumstance. Four men stand with their backs to us in a narrow cul-de-sac mimicking one another's posture as if in an ancient ritual or a modern dance. It is, of course, the local pissoir. In a narrow street, three people, one with an amputated leg, walk away from us at precise intervals, while a lean dog threads its way in the opposite direction along the top of a wall. That life could be so regularized and yet so random in its encounters is mysterious and unsettling. The isolation, the fleeting and meaningless juxtapositions the city imposes, are familiar enough but pass by so rapidly that we can choose to ignore them most of the time. The camera makes the urban condition large, permanent, momentous, and sad.

There are amusements to be found amid the alienation. Sometimes in Koudelka's pictures connections are made according to some scheme that is not quite comprehensible. Either the camera has shamelessly trapped two unrelated moments together or it has found evidence of some plan at work, a plan so large it cannot be fathomed on such a small scale. In one photograph, a most unusual and bombastic ship, puffed up like a character out of Gilbert and Sullivan, huffs across the horizon directly above the head of a perfectly proper citizen. Elsewhere, a fully dressed woman in a hat wades out of the water flinging her arms about dramatically, while behind her a man in trousers soaked to the knees takes off his shirt and reveals a stupendous tummy. Street photographers have by now accustomed us to the improbable conjunctions and balletic choreography of daily life, but few have found dancers at once so recognizable and unlikely, or events so puzzling and so happily left unexplained.

Koudelka's compositions are pulled taut by a sense of unexpectedly active space, which seems to be as alive and demanding as the figures and objects within it. People move unaware through space that is as meaningful as they, assuming positions so significantly separated yet so oddly interconnected that they look like actors in *tableaux vivants*. Koudelka began as a theatrical photographer and has evidently never forgotten that all the world's a stage. He is an outsider speaking to outsiders everywhere,

a stranger reminding us how strange the world truly is, a photographer who can pierce the surfaces of our little moment in history with his dark and vigorous vision and find a world that is haunted by people rather like us.

American Photographer, August 1988

JACQUES HENRI LARTIGUE

Jacques Henri Lartigue thought that perhaps it was God who gave him his first camera. Or at least someone who might have been mistaken for him. "Papa," he wrote in a journal he reconstructed from childhood memories, "il ressemble au Bon Dieu (c'est peut-être même bien lui, déguisé?), il vient de me dire: 'Je vais te donner un vrai appareil de photographie!'" (As for Papa, he is like God [and may even be Him, in disguise?]; he has just told me: "I am going to give you a real camera!"). His father took photographs himself, and taught the boy how to develop them. This was late in 1901, when Jacques Lartigue was seven years old.[1]

A religious boy who became a religious man, he wrote in the same journal, apparently in total seriousness, that by the age of thirteen he knew that God had guaranteed his happiness: "J'aime le Bon Dieu et je sais que je serai toujours heureux grâce à Lui" (I love God, and I know that I will always be happy thanks to Him).[2] And all his life, from earliest boyhood on, he devoted himself with a kind of religious fervor to preserving the happiness God had guaranteed him so early, consecrating to that service the camera given him by God's surrogate.

The world through Lartigue's camera was composed of antics and inventions, fashion and coquetry, sun, wind, languor, and dreams—a place where cars were handsome and parasols gracious, and where people at leisure sported white trousers on the beach. No one cried there, for every desire was sated with delirious speed, amusing suspensions of gravity, and an abundance of feminine beauty. Almost the only reminder of ordinary sorrow was the vast and relentless loneliness of the sea.

Lartigue considered happiness both grace and goal. He elected himself conservator of the contentment he recognized as his birthright. When little, he invented what he called an "eye-trap," staring widely, then blinking to print a scene in all its liveliness on his brain. A few days after this great discovery, he woke up to find it no longer worked, and he immedi-

JACQUES HENRI LARTIGUE, *Kite at Biarritz*, 1905

ately fell sick. When he recovered, he resolved to reconstruct this wonder by other means.

He became the caretaker of his own felicity, in command of three means of preservation: photography, painting (or drawing), and writing. When the parent who so resembled *le Bon Dieu* gave him his first camera, he determined to photograph everything, *everything*, so he would no longer have to regret forsaking the joys of a country house for Paris, but could take them with him tucked into his photographs.[3]

His most fervent wish was to remain a child. By the time he was six, as he wrote in his memoirs, he was dismayed at the prospect of growing up and getting bigger.[4] It is not so uncommon for children, especially if they are cosseted and spoiled, to be reluctant to grow up. Lartigue, born five years after his brother, Maurice (better known as "Zissou"), seems to have shared with his mother a fantasy that he would always be her little baby.[5]

He was fortunate in many ways. He was born at the right place, at the right time, to the right family. The Lartigues had money and ingenuity—several of the men were inventors and engineers—plus a sense of adventure, and warmth. They scarcely bothered with his education but imbued him with a strong attachment to culture. The talents the boy was born with were encouraged, and the weaknesses he developed contributed in a peculiar way to his original enterprise.

When he did grow up he was evidently entirely charming—and also self-centered, emotionally detached (although often enough in love), a spectator who cursed his own inability to be involved, and so intent on a life of bliss that he excised earthly problems from his memory bank whenever possible.[6] In his paintings, photographs, and writings he ignored as best he could the hellish side of the history of his time. All of which contributed to a body of work that is, as he meant it to be, delightful, amusing, and at moments simply astonishing.

The right place and time: part of the enchantment of Lartigue's early photographs lies in the sparkle of a long-gone era and the nostalgia that clings to it. He viewed the end of the Belle Époque from a singular domestic vantage point, with a gleeful emphasis on technological changes in transport and speed, and with the preternaturally alert eye of an eager, curious, perceptive boy. His eccentric family itself fairly guaranteed that his pictures would be uncommon. His brother, like his grandfather and great-uncle, had a knack, indeed a mania, for inventions—makeshift cars, boats concocted from tires, homemade airplanes. Relatives and playmates ran at these

pell-mell, racing and jousting, jumping, tumbling, crashing. Jacques himself, too small, was kept from the play by the bigger boys and became a spectator for life.

In early 1902, with a camera too big for a little boy to carry, and excruciatingly long exposures, he took a few rather standard, posed family portraits. That same year, when he turned eight, his father gave him a Spido-Gaumont stereoscopic camera,[7] and Jacques soon learned to use it to stop action. Cameras had been capturing some movement since the 1850s, and emulsions and shutter speeds had been getting faster in the intervening years. Stereo cameras had succeeded in stopping slow movements, like men and women walking in the streets, as early as the 1850s, and by the end of the century, fast shutter speeds and emulsions had captured the horse at full gallop and made the snapshot a reality.

Lartigue, who never wanted to let the moment go, was especially entranced by moments that could not last. His cat cooperated by jumping, and Lartigue coaxed whoever was not already racing downhill, or defying gravity, to try out the air: tossing balls, sailing down stairs, jumping off walls. He turned their transitory shapes into lasting emblems: the spread-eagled cat, the perilous angle of legs leaving the ground with a runaway glider, the exploded zigzag of a woman in a long dress running down the beach with her veil and coat following on the wind. He relished the magical in-between instant when photography puts the laws of gravity on hold.

The right family at the right time: his father, who bought an electric auto in 1902 and faster cars in the following years, avidly followed auto races and early attempts to fly. In modern history there has probably never been a little boy who was not fascinated by cars and planes, but Jacques Lartigue came into the world just as technology began laughing at space and time.

At the Exposition Universelle in Paris in 1900, what struck the young Lartigue as the largest hall was the Galerie des Machines.[8] It bulked so large in deference to a revolution that was still in process; nonetheless he noted: "Ces choses compliquées ne m'intéressent pas du tout" (Those complicated things don't interest me at all).[9] That year a French Panhard won the first international championship automobile race, averaging sixty-two kilometers per hour on the road from Paris to Lyons. In the same year Kodak introduced the Brownie, the box camera so small that even children less dedicated than Lartigue could make pictures. A mere three years later Wilbur Wright would fly a motorized, heavier-than-air plane for fifty-nine seconds over the dunes of Kitty Hawk, North Carolina.

The world was in perpetual motion. Lartigue ran after every attempt, however whimsical or triumphant, to go faster, farther, higher on wheels or wings. In 1912, when he photographed *Delage Automobile, A.C.F. Grand Prix* (Automobile Club de France), everything moved: a narrow slit in his focal-plane shutter traveled rapidly across the plate like a curtain, so some parts of the scene registered a tiny fraction of a second later than others. Spectators seemed to tilt, and the wheel of the car elastically changed shape. Photographing another racing car that day, Lartigue initiated a new method, which consisted of keeping his camera still while moving himself: "Je la photographie (180 à l'heure) en pivotant un peu sur moi même pour la conserver dans mon viseur. C'est la première fois que je fais ça!" (I photographed it [doing 180 kilometers per hour] turning a little as I did so, to keep it in my viewfinder. It was the first time I did that!).[10]

The earth rushed by and the once-familiar, everyday sky was invaded by fragile machines; enthusiastically, the boy recorded the shift. A couple took their baby out for an unexceptional airing in a stroller, but the very air had changed: a plane hovering low to the ground interrupted the scene, while high in the empty space above, another one stained the sky.

Lartigue had an exquisite appreciation of the bizarre and complex shapes of his era: the extravagant confections and flightless wings women wore on their heads, the extraterrestrial architecture of great kites, the gliders and planes like fanciful and delicate cages meant to trap air.

But he also understood, or was lucky enough to register and smart enough not to delete, the odd outlines people assume as they walk, outlines the eye does not fully notice because it does not see isolated moments, stopped in time. He could trace the more complicated silhouettes that overlapping figures produce as well, and the even more surprising and marvelous incorporeal shapes that fill the spaces in between people and things.

And then his camera would note down figures or boats or trees that unexpectedly intruded on the scene and made witty comments on foreground shapes by echoing, inverting, subverting, or completing them. In short, Lartigue commanded a specifically photographic vision that had cropped up from time to time but had been neither explicitly worked out nor appreciated as a style.

The style entailed putting a high value on the momentary, the unstable, and the unbalanced; Lartigue's childish glee and the new century's inventions pushed this to a new level. In the ordinary life lived outside of

cars and airplanes, momentariness generally meant casual, unconscious, and unobserved (or at least uncelebrated) movements or expressions or relationships—the not-so-negligible events that occur between poses struck for public display.

The Realist painters in the third quarter of the nineteenth century had begun to put such momentary events on canvas as part of their radical attempt to depict contemporary life in all its irregular and haphazard forms. Manet had a feeling for it; Degas expressed it vividly. Photography probably influenced both these painters—Degas took photographs himself—and the qualities they sought to achieve in their art came naturally to a mechanical medium.

When photographers had stumbled on such things as a previously unperceived stage in the human gait or an awkward overlap as people crossed paths, the resulting images had been recognized as scientific discoveries or photographic "mistakes," but not as anything of artistic value. Indeed, the kinds of spiky hybrids made by adjacent parasols, the abrupt cropping of faces or figures seen too close, the elaborately outlined spaces between people, did not even begin to achieve full artistic status until the 35mm camera came along.

But the style was already in the making in Lartigue's infancy, principally in some early street photography and, more by mistake than otherwise, in the growing accumulation of amateur snapshots, for the camera in its voraciousness makes such decisions without any encouragement from the operator. Lartigue, when he started, was probably too young to be aware of artistic images, aside from his father's photographs and possibly illustrated books, yet he articulated a style that was only being whispered at the time.

A product of his family and his times, he recorded the playful, thrilling, suspenseful, and absurd aspects of both with rare ardor and discrimination. He was uncommonly focused in every way, and his eye was simply better than anyone had a right to expect at his age. History provided him with a cornucopia of inventions—including a camera with a fast lens—and he responded with the passions of a child and the eye of an adult.

He was in fact a photographic anomaly: a child prodigy. Although children are increasingly taught photography in schools and many produce good pictures, it is hard to think of another example in the history of the medium of someone Lartigue's age who consistently took remarkable photographs. The child was certainly lucky in his subject matter, but luck is

not gracious enough to sustain such a body of work. Some part of what appeals to us may be the reflection of a little boy's spirit, more rambunctious than his body, as he grew up protected in a world fairly bursting with exciting games and discoveries. But photography generally depends on perceptions, discriminations, and subtle judgments usually considered unavailable to one so young.

He was particularly alive in all his senses, highly attuned to sounds and smells as well as sight—"Seulement, moi, ce ne sont pas des pensées que je voudrais attraper au piège mais l'odeur de mon bonheur!" (Except that what I would like to capture aren't thoughts, but the scent of my happiness!).[11] Small, not strong, and sickly, he had a lot of time to cultivate his senses, practice his talent for drawing, and burnish his avid powers of observation.

He turned his eye toward women and female décor early. His journal says he began drawing pictures of women wearing hats and rings by the age of eight,[12] and by fourteen was "étourdi de plaisir" (dizzy with pleasure) at the mere thought of taking his camera into the Bois de Boulogne to find "*Elle*." "*Elle*" was "la dame très attifée, très à la mode, très ridicule . . . ou très jolie" (the very made-up, very fashionable, very ridiculous . . . or very pretty lady), whose picture he would snap despite the occasional wrath of a gentleman by her side.[13]

Here was another spectacle for his hungry camera to feast on. The women who paraded past his lens were dazzling, self-created displays, as carefully groomed and often as exotic as tropical birds. Lartigue noticed that some wore lip rouge as if they were on stage, a sign of changing ideas of feminine appeal. If the men felt called upon to defend them against photography, that was another sign of the times: since the 1880s, when hand cameras made outdoor photography simpler, women (and some men) had felt attacked by the legions of amateurs on the prowl for pictures.[14]

Lartigue caught all the nuances of high-heeled gait and swishing skirts: hats as big as architecture, pleated *fichus*, fringes, finicky dogs; womanly figures tailored to within an inch of flirtation. At least twice he snapped the appreciative and speculative glances that men who thought themselves unobserved cast at items on display.

He relished the clothes as much as the women, and their strategies for making women beautiful. A case could be made for calling Lartigue the first fashion photographer (*Vogue* did not hire Baron Adolph de Meyer, its first staff photographer, until 1914), although he neither knew that was what

he was nor published the pictures. When Lartigue's previously unknown photographs were finally discovered in the 1960s, Cecil Beaton drew on *Le Jour des Drags, 23 juin 1911* (Carriage Day at the races at Auteuil, Paris, 23 June 1911), that rhapsody of hips and stripes, for his costume designs for *My Fair Lady.*[15] (Lartigue had been a painter of some repute in France until his photography was discovered, almost by chance, and John Szarkowski exhibited it at the Museum of Modern Art in New York in 1963.)

Once World War I began, Lartigue withdrew, in a sense, from the history of his times (and remained outside it for the rest of his long life).[16] Too underweight to serve in the military, he was assigned to chauffeur officers around Paris. He seldom photographed the effects of war and the ugly episodes he saw. His journals retreated from the evidence, barely noting: "The war goes on. Friends die. Good weather. My first mistress (the most desirable woman in Paris). Good weather."

He explained to these private pages that his retreat was fully conscious. His reconstructed journal of 1907 attributes his happiness to the habit of effacing bad memories and embellishing the good.[17] Now he wrote: "La guerre, si ce 'journal' n'en parle pas, c'est d'abord que ce n'est *pas* un 'journal.' C'est mon petit jeu secret pour essayer de conserver des joies ou mon bonheur, mon immense bonheur tout parfumé de choses qu'on n'explique pas. Et en même temps c'est une protection. Une protection contre 'l'excès de bonheur'" (If this "journal" doesn't mention the war, it is first of all because this is *not* a "journal." It is my little secret ruse for preserving joys or my happiness, my immense happiness, all perfumed with inexplicable things. And at the same time it's protection. Protection against "too much happiness").[18] While the world burned, he tended his silken memories, thus avoiding the pit of lethargy, or perhaps the loss of control.

In 1919 Lartigue married Bibi Messager, daughter of the composer André Messager, and commenced the life of a millionaire without much money, painting Bibi and flowers; gliding about the Riviera, Paris, and London; going to the theater every night to see his close friends Sacha Guitry and Yvonne Printemps perform; photographing Bibi, the races, sunlight, and the sea—a truly perfumed life. It was still possible to make an art of living then, and he did.

Although Europe had lost its innocence somewhere east of the Maginot Line, and disillusion had seeped into daily life, Lartigue by now was intent on chronicling his own existence rather than anyone else's. Car and

bicycle races still intrigued him, technological advances did not. He had a son, and a daughter who died in infancy. Bibi left him for another man; other women came along, and a Depression, and fascism. He eked out a living as a designer of galas in the 1930s. He had a brief second marriage and a lasting third one. Steadfastly, he kept his eye on the garden of earthly delights.

The eye that had been so quick to grasp the possibilities of photographic composition when he was still a child had become increasingly sophisticated. The twin lenses of his Klapp Nettel stereoscopic camera, which took two 6-by-6-cm photographs, could be converted to a single lens format taking one 6-by-13-cm picture. Lartigue exploited this elongated frame with a balancing act of precarious juxtapositions, disjunct scales, mysterious figures hovering in the wings.

He held his camera less than a meter away from a racing car, disrupting the scale so thoroughly that a spectator on the far side might have strayed in from another space. A small figure of a man running before an incoming wave is overshadowed by a monstrously large fellow with no connection to him, in the foreground. The lively relations between figures in Lartigue's early pictures began to break down, and normative space now and then threatened to slip its moorings.

A faint tinge of melancholy lingers on some images: his beloved Bibi dwarfed by objects that expand as she seems to shrink, or her figure isolated and small in indifferent cities, or standing on a terrace with his mother before a vast, empty sea.

Lartigue was increasingly troubled by his own removal from life. "Mon égoisme m'effare. Il y a en moi un spectateur qui regarde sans se soucier d'aucune contingence, sans savoir si ce qui se passe est sérieux, triste, important, drôle ou non. Une espèce d'habitant d'étoile venu sur terre uniquement pour jouir du spectacle. Un spectateur pour qui tout est marionette, même—et surtout—moi!" (My self-centeredness alarms me. There is a spectator within me who watches, with no concern for specific events, without knowing if what is happening is serious, sad, important, funny, or not. A breed of extraterrestrial, who has come to Earth simply to enjoy the spectacle. A spectator for whom everything is puppetry, even—and especially—me!).[19]

Several images, one taken in the first decade of the century, focus on a lone man seen from behind, exactly the position the viewer is in, as if he

could be any one of us, watching the sea beat powerfully against rocks or walls. This is a Romantic theme: man confronting the indomitable force of nature, an image repeatedly explored in paintings such as Caspar David Friedrich's 1809 *Monk by the Sea.*

When he was very small, Jacques Lartigue worried that this was precisely the cost of growing up: "Découvrir tout à coup l'impuissance vertigineuse d'être un petit humain aux prise avec la vérité des choses, est-ce cela 'grandir'?" (To discover suddenly the staggering helplessness of being a little human being coming to grips with the truth of things, is that "growing up"?).[20] He remained a spectator all his life, and we are the beneficiaries. He tried to remain a boy and his spirit succeeded, but time could not be stopped—except, of course, in photographs.

NOTES

1 Jacques Henri Lartigue, *Mémoires sans mémoire* (Paris: Editions Robert Laffont, 1975), p. 34. He did not begin keeping a regular journal until 1911.

2 *Mémoires* for 1907, p. 66.

3 *Mémoires* for 1901, p. 35.

4 *Mémoires* for 1900, p. 24.

5 *Mémoires* for 1905, p. 58.

6 See Shelley Rice, "Lartigue, L'Empailleur de Bonheur," in *Jacques Henri Lartigue: Le choix du bonheur* (Paris: Editions La Manufacture, 1992), p. 262, for information on how he rewrote his memoirs. This essay astutely assays Lartigue's character and his lifetime project. Michel Frizot, "L'ombre et le reflet," in *Le passé composé* (Paris: Centre National de la Photographie et L'Association des Amis de Jacques Henri Lartigue, 1984), discusses the way Lartigue cropped his 6-by-13 photographs in the 1920s when making up his photo albums.

7 Florette Lartigue, *Jacques Henri Lartigue: La traversée du siècle* (Paris: Bordas, 1990), p. 24.

8 *Mémoires* for 1900, p. 26.

9 Ibid.

10 *Mémoires* for 1912, p. 127.

11 Jacques Henri Lartigue, *L'Émerveillé: écrit à mesure 1923–31* (Paris: Stock, 1981), p. 273.

12 *Mémoires* for 1902, p. 44.

13 *Mémoires* for 1910, pp. 80–81.

14 See Heinz K. Henisch and Bridget A. Henisch, *The Photographic Experience, 1839–1914: Images and Attitudes* (University Park, PA: The Pennsylvania State University Press, 1993), p. 263; and Vicki Goldberg, *The Power of Photography: How Photographs Changed Our Lives* (New York: Abbeville Press, 1991), pp. 113–115.

15 Florette Lartigue, *Lartigue: La traversée*, p. 40.

16 Rice, "L'Empailleur," p. 27, says that the year 1914 gave a double impetus to Lartigue's withdrawal into himself: his father was shot three times, not fatally, by a deranged man, and the younger Lartigue was rejected for service at the front. In neither case was he where the action was.

17 *Mémoires* for 1907, p. 72.

18 *Mémoires* for 1917, p. 273.

19 *L'Émerveillé*, p. 220.

20 *Mémoires* for 1900, p. 33.

From *Jacques Henri Lartigue, Photographer*
(New York: Bulfinch, 1998)

REINER LEIST

Photography's invention was peculiarly timely, occurring as it did just as the human life span was expanding and the prospect of an afterlife shrinking. In the Western world, life expectancy slowly rose throughout the nineteenth century, especially for the upper classes, but the promise of a life after death began to be nervously questioned as religious faith wavered and came under attack. Into this atmosphere of a simultaneously expanding and contracting future, the new medium of photography inserted both a visibly extended past and a visibly extended future.

After the announcement of Daguerre's and Talbot's processes in 1839, large numbers of people could know for certain, and for the first time, what they looked like last year, or (after 1849) what they looked like a decade ago.

Add a couple of decades, and new generations could know what their forebears looked like, although they were not kings and could not have afforded bronze or marble effigies. Photography magnified life's inherent poignancy, preserving the promise of childhood long after it was dashed, the loveliness of youthful good looks that age had long since stolen. The portrait of Dorian Gray served its owner's time for a while—a metaphor for the powerful identification of portrait and subject—but for the rest of us, no bargain with either the devil or the camera can ward off the years so effectively.

Yet childhood persists in photographs to delight and mock us and summon up regrets. There is history in our wallets and albums (and now on videotapes or disks), intensely individual histories, but inevitably framed in a larger story of time and place and circumstance. Reiner Leist's pairing of old and new, childhood and adult photographs is a novel means of setting out an idea that is common enough but not so often signified in pictures: that a country's history, character, even definition can be located not just in the look and activities of its citizens, but in their life experiences. These they relate in their own words, photographs being too limited to do the job well. Nonetheless, portraits here become points on the map of the

Left: *Heinz Kissinger, Fürth, Germany,* 1931. Right: *Henry Kissinger, Park Avenue, New York City,* 2000. From Reiner Leist's series "American Portraits, 1910–2001."

nation, keys, indices, signposts. The accompanying stories fill in the topography and the routes that run across it.

Here family snapshots (or occasional portraits by studio photographers), chosen by adults because they were significant in their lives, are echoed in portraits made by Leist of the people those children became. He then rephotographed the childhood portraits in an identical size, with the same camera, on the same paper, to achieve a kind of equivalence between the two. The resulting diptychs fuse and compress the lives as they have been lived to date.

The notion of comparative portraits made over time is hardly new. All family albums are just that. (One of Leist's subjects remembers that she and her brother and sisters were photographed every year and the results put up on the wall.) Biographers dig up baby photographs to show how a life progressed and, perhaps, how it was implicit in its beginnings.

Alfred Stieglitz thought he could make a true portrait of someone by photographing him or her over a lifetime. He started with his infant daughter, but stopped when his wife complained that the child couldn't have any fun if she had to hold still for the camera at each delightful moment. Later, Stieglitz photographed Georgia O'Keeffe over a number of years, unaware when he started that it would end up a portrait of her growing independence and their dwindling intimacy. Nicholas Nixon has been making yearly portraits of his wife with her three sisters since 1975; it has become a portrait of aging as well as of relationships. The documentary filmmaker Michael Apted has, in his "Seven Up" series, followed the same group of people at seven-year intervals, starting at the age of seven; some lives have been satisfactory, others have not. It is all very well for photography to stop time, but if it tries to track it, then time, as W. H. Auden put it, will say nothing but: I told you so.

Portraits are boring or compelling, partly because we think that we can decipher them. We tend to believe, rightly or wrongly but as a way of getting along in the world, that we can read something of character and experience in faces. This transfers to photographs, where we maintain a strange trust in their ability to convey some fact, some recognizable truth, despite all the ink that critics have spilled saying this is not so.

There is also a long-held belief that images of the citizenry will reveal the nature of the country. Genre pictures of costume and profession in the nineteenth century were a kind of bald introduction to the customs of the land. In the early twentieth century, August Sander believed he could

delineate the German character by photographing every profession and walk of life objectively, without comment. Maybe he came too close; at any rate, his results did not match the Nazis' formidable insistence on a pure "Aryan" state, so they stopped his project cold.

No matter how strenuously a photographer tries to eliminate his or her own personality from the picture, no one can avoid personal preconceptions and expectations. Leist made his the armature for his project. What would someone born in Germany after World War II have known or seen or thought of the United States when he was growing up? Leist had a kind of list, and asking everyone he met what "America" meant to them, he heard Americans and foreigners mention virtually the same things, as if the nation wore its CV on an identification tag.

What would that be? Internationally reported events, of course: the Nuremberg trials, McCarthyism, the Vietnam War, the civil-rights and feminist movements, student radicals, the moon landing. Certain facts and legends and words are probably automatically bundled with the country's name: cowboys and Indians, the Civil War, slavery and racial discrimination, Charles Lindberg's flight, JFK, immigration, Hollywood, Disney—and democracy, liberty, freedom, opportunity, capitalism, commercialism, violence.

And how would this history, these qualities, these dreams be transmitted? Through the news, of course, and then in massive doses through movies and TV, and movies in reruns on TV. The cinema is one of the most vital of all American exports and one of its chief means of propaganda. Hollywood still freely offers visas to its version of the United States, long after *Dallas* and *Dynasty* began granting theirs. American citizens, too, see their country through movie- and video-camera lenses and lift their heroic models from the screen.

So Leist came looking for James Dean and found a man who'd been raised with the star when Dean was a youngster. He found a woman who lives in Disney's boyhood home. And a man who was stunned to realize that New York taxis were yellow; they were always *gray* in the movies. As for Marilyn Monroe, that looming blond image, Leist located a brutalized boy who'd been saved by her infectious, available joy on the silver screen, and a woman who made a career imitating Marilyn in the burlesque theater, but had to give that up for a more standard strip act after Monroe died. Today, well into her seventies, this burlesque-show Marilyn happily shows off her legs and her panties, bringing the past bluntly into the present.

Leist actually had in mind a new world in a dual sense: a continent that Europe thought it had discovered, and the new world of adulthood everyone immigrates to upon leaving the homeland of childhood. The passage from childhood foreshadows the kinds of transitions that occur when war changes both inner and outer worlds, or disillusion sets in, or something like Marilyn's presence on the screen opens up possibilities unknown before. Life everywhere leaps, lurches, sidles from experience to displacement to accommodation, but America, a nation founded by immigrants and still a magnet for them (Leist himself moved here from Germany in 1994), and a country still constantly on the move, has transition embedded in its psyche.

All this would be a lot of baggage for photographs to carry—they could not manage much of it without the text—but it is impossible to look at pictures of the same person from two such different ages without thinking about the nature of life and wondering how much of its passage is visible in both faces. How hard Henry Kissinger the boy tried to be ingratiating in his photograph! He was still trying, less strenuously, for Leist's camera, although that had scarcely been his professional posture. How sultry the Marilyn of burlesque was at the age of ten, how disconsolate Flavin Judd both as a boy and as a young man. Benjamin Ferencz, dressed like a little businessman in 1926, looks exactly like one again in 1999, although he has spent his life prosecuting the Nazi Einsatzgruppen, negotiating treaties, and directing a program to obtain restitution for Nazi victims.

Photographs say more than one ought to expect. Sometimes they do not say enough. And yes, sometimes they lie. Studio portraits are meant to lie or flatter at the very least, and childhood snapshots may too. "If you'd just see that picture," one woman says, "you'd think I was a normal kid—but it was so far from the truth—it was really hell."

True, false, slanted, misinterpreted, photographs from childhood are sometimes the only basis for memories that have already slipped the traces, sometimes the basis for the stories we tell ourselves to fix a recognizable trajectory across our years. The past is not merely captured but created by old photographs.

Leist himself says that some of these childhood pictures are stronger than anything he can do. Old photographs, after all, gain force with the years. They have history in tow, clothes and poses and attitudes—the glum family posed in 1913 on a crescent moon that is much happier than they are; the boy in the Lindberg outfit in 1927; the boy in an embroidered cap

with a big, soft bow at his neck in the USSR in the 1930s. So many children, boys mostly, are got up as little adults—and nostalgia coats them all like a patina.

Of all the powerful photographs ever taken, of wars and disasters, celebrities, comets, the suffering poor, probably no photographs have quite the impact that family photographs have on family members. All of memory and personal experience, all longing and desperate disappointment, love and hate are bound up in images from the most personal past. Some small measure of this heavy investment can transfer to these strangers' images under the pressure of the comparison of now to then, which anyone can identify with, and the resonance of some of the personal tales.

And although this is at best a spotty history of America, a lot of that history clings to the edges of these pictures. There is a woman who grew up without electricity in Mississippi, among older relatives who kept the children whipped up about the Civil War. An American Indian whose great uncle was a scout for Custer, and a white man whose relative was killed at the Battle of the Little Bighorn. A man who remembers traveling with his mother early in the twentieth century, when it was unheard of for women and children to travel alone. A black man who recalls that in the 1940s only "preaching and teaching" were open to blacks. He had to find work early because his mother and father were dead, his grandmother a maid: "My family was not dysfunctional, it was just short of staff."

There are Jews here who left Europe, Russians who left the USSR, Vietnamese who left Vietnam. A number of Asians, a number of Hispanics, some of mixed blood: what we used to call the melting pot and would now call multicultural. The United States has been multicultural since the first white man encountered the first native on these shores, and the country has been in one degree of transition or another, acknowledged or not, ever since. In recent years the process has shifted to warp speed, as we repeatedly enter another new world, and yet another.

The pictures in Leist's book are like bookends supporting volumes of personal history, volumes that hinge on national and world histories as well. There is even a glance at the history of photography, with a portrait by Stieglitz himself and pictures of photographers like Robert Adams, Duane Michals, and Charles Traub, who write about the meanings of the medium. The larger history of photographs that played a major role in the life of the last two centuries creeps in here too, with people speaking of baby pictures that won prizes and pictures of parents who died young, with celebrity pho-

tographs and the borrowed fame of photographs taken with a star. Ultimately, there are the photographic media—magazines, film, and television—which have welcomed a few of the people here and evidently validated their achievements, if not their very existence.

When a parent takes a picture of a child, both a wish and a dream ride on the click of the shutter: a wish to record one's own offspring who will be someone else tomorrow, and the dream of a good future that this happy moment ought to portend. Portraits of adults have somewhat less of the dream about them (except in wedding pictures, actors' portfolio shots, and advertising) but plenty of wishes still. The adults in the New World, queried by the photographer, have a stake in the great American dream. Mostly, they love this country and are certain it is the best of nations. Many mention the freedom, the opportunity, the liberty it stands for. Enough freedom and liberty so that no one hesitates to criticize it either, and many say it has declined, sunk into the swamp of consumerism, where so much that was good about America has disappeared into the muck.

This may be correct. It may even be true (although every age has probably said something similar). The nostalgia that gathers like dust on old photographs gathers on recent history too. Both represent an unrecoverable past, as the photograph taken today represents an unrecoverable present. Somewhere between the past and the present you might find a picture of America, or a story about it, or a life that was lived in it and a face that grew old between its borders.

From *Reiner Leist: American Portraits, 1910–2001*
(Munich: Prestel, 2001)

DAIDO MORIYAMA

Daido Moriyama's vision resides in the heart of darkness, literally and figuratively. The world he records is black, stunned rather than illuminated by light, threatening, chaotic, incomprehensible, compulsively erotic, obsessed, eccentric, fixated on consumption, devastated by accidents, always off-kilter, sometimes ruined, sometimes empty—a world unaware of its own instability, a world in need of Prozac.

His photographic technique, all blur and scratches, bleach and dust, joins with his subject matter to conjure documents on the verge of disintegration. At times Moriyama tinkers with the limits of perception, which he makes look hopelessly narrow, and with the limits of photography, which he makes seem very limited indeed. This is a tough vision, even a fierce one, individual, authentic, and pursued to the far reaches of its own premises.

Born in 1938, Moriyama is one of Japan's most respected and influential contemporary photographers, but little known in America, although his work has appeared in group shows here, even in New York. The first retrospective exhibition of his photographs anywhere in the world (the Japanese not caring much for retrospectives of living photographers) is divided between "Daido Moriyama: Stray Dog" at the Japan Society Gallery, which includes 130 photographs from several of his major series, and "Daido Moriyama: Hunter," 40 photographs from a 1972 series, at the Metropolitan Museum. The joint show was organized by the San Francisco Museum of Modern Art (where it premiered last year) and the Japan Society Gallery. Sandra S. Phillips, Curator of Photography at SFMOMA, is the curator; an informative catalog accompanies the exhibition.

A late-1960s series of nudes by Moriyama, evidently sex workers, with an occasional male leg or two in the picture, are at once flatly explicit and softly romantic, the bodies thrown so far out of focus that little besides the dark circles of the nipples and the dark patches of pubic hair confirm the subject matter. In 1972, when he and others had already tossed over the tradition of polished photographic techniques, Moriyama pushed the medium into illegible territories, as if to say that photography could not

DAIDO MORIYAMA, *Yokosuka*, 1970

record what really mattered. In a book of the same year called *Farewell Photography* (Moriyama almost always worked with books in mind) not only are the photographs out of focus, scratched up, and marred by dirt and light flares, but some of the subjects are also indecipherable, and some are apparently about nothing, emptiness, the void. Later, he had a change of heart: after giving up photography for a couple of years, he returned to it in 1982 with colder but also clearer images, what might be called a more perfectly focused nihilism.

The eponymous stray dog appears in one picture as a shaggy beast, menacing, wary, a street wanderer looming enormous in the frame. At the Japan Society, an installation of 3,400 Polaroid images Moriyama took of his living and working space in 1997 (the only color in either show) centers on this image. The photographer recently told *Photo Metro* magazine that when he photographs, he walks down the main thoroughfare, diving into and out of alleys, like a stray dog.

He is indeed an urban wanderer, an outsider, feral in his way, often shooting from the hip, sometimes on the run, or from the shadows, through fences, from the windows of a moving car—snapping away on impulse and intuition in response to the crazy rhythms of modern life. He also likes to make images of images, particularly movie posters advertising sex and violence. It is not always clear whether a photograph is of a picture or of the thing itself; by the 1960s the two were already nearly interchangeable.

Sometimes, people pose for Moriyama's camera, like the suburban couple clutching a box of detergent. More often, he steals the picture. What he catches in his nearly random net is the peripheral vision of a city dweller, the bleary bits and fragments, the chance events and partially registered perceptions of our rapid daily rounds. "Chaotic everyday existence," he once said, "is what I think Japan is all about." When he has gathered sufficient chaos, he edits it into a detonating order all his own: pulsing, non-narrative, ambiguous, and textless pairs and sequences in magazines and books.

Attracted to outsiders and outlaws, Moriyama has photographed more than once where he is not welcome. A young woman in one picture races away frantically down a narrow, trash-filled alley. At a recent lecture, Moriyama said she was running because she had gotten in trouble with the Yakuza (Japanese gangsters), and that he was beaten up and forced to rip his film out of his camera after he took the picture. As this was not his first such encounter, Moriyama had devised a way to keep his film intact while

pulling a fresh roll out of the camera. The scent of something ominous that filters into his photographs begins to feel like a whiff of realism.

"I will go and take photographs," he told an interviewer, "as long as I still am capable of running away when someone tries to punch me. I can tumble." Moriyama is not the first who could make you think that a slight touch of craziness might be a valuable trait for those who want to be photographers; at any rate, he is obviously devoted to his profession and his subjects.

The catalog, with essays by Sandra Phillips and by Alexandra Munroe, Director of the Japan Society Gallery, fills in some background information on the zeitgeist that put this work in motion and the context that surrounded it. There is, of course, the inescapable fact of two atom bombs dropped on Japan. Shomei Tomatsu, whose work had a significant influence on Moriyama, documented the direct effects of the bomb on survivors. He is only eight years older than Moriyama, but generations are so brief today (and Japan underwent such rapid and overwhelming changes) that someone eight years younger saw another society altogether, shaped first by catastrophe but then reshaped by subsequent events. Americans were a major presence in Japan, and American popular culture a major import. Moriyama was fascinated by the driving energy, the sex, modernization, and liberal Western customs that were infiltrating Japan and forming new hybrids with the traditional culture.

While many Japanese were furiously resentful of the invading, occupying power, Moriyama was apparently less so. Demonstrations against the treaty that allowed American military forces to remain in Japan turned particularly violent in 1960. Strikes and student protests soon became more violent, too, the Vietnam War making a profound contribution to the depth of the dissent. As in other places, the 1960s were a time of public turmoil, experiment, and drugs, complicated in Japan by nuclear destruction, the miraculous economic rebirth of the country, and the bewildering atmosphere of transition between an old society and a new and foreign one.

Photographers, including Moriyama, needed a new way to respond to the wave of ferment and change that was engulfing their country. Magazines and books of the time make clear that Moriyama was not reacting alone, but was part of a photographic movement that sprang up in Japan, with obvious affinities to movements in Japanese literature and film, in reaction to what amounted to an existential crisis as the frenetic modern world transformed the country.

Other countries had been experiencing related changes and upheavals. Globalization was already on its way, and artistic ideas traveled between continents on the backs of publications. Moriyama was shocked and influenced by William Klein's book of photographs of New York (published in Japan in 1957), with its raw vitality and confrontation, grotesqueries of the street and fierce disregard for technique. He took what he could use, and moved on.

Later, a friend showed him a Warhol catalog that shocked him again with its emphasis on death and consumerism. Moriyama did a series of photographs of accidents, some of them details of a police safety poster. He also took pictures of canned goods on grocery-store shelves, even Campbell's soup cans. Where Warhol's repeated soup cans are clean, mechanically repetitive displays of forced cheerfulness—the alluring calculus of a consumer culture—Moriyama's are morose masses of identical labels rushing toward a numbing infinity of manufactured goods. By the 1970s, the economic boom had submerged the idealism of the 1960s in Japan as it had elsewhere, leaving frustration and discouragement in its wake.

An understanding of Japan's upheaval is probably crucial to an understanding of this work, and the influences count too. But in the end the artist is an individual with a mind and feelings and talent that nothing external can wholly account for. Different photographers using the same photographic language in the same places wrote different synopses of their times. Art continues to move in mysterious ways. Let us now give thanks for mysteries.

New York Times, October 3, 1999

SUZANNE OPTON

First of all, consider the title: "Loose Change." Loose change is what's left over at the end of the day; it makes a pretty jingle, but hasn't much power and doesn't go far. Here the subject is women's bodies, not the ripe perfection of improbable twenty-year-olds but *des femmes d'un certain âge*—middle-aged, to be precise, a stage of life that finally lives up to its name, for who ever lasted twice as long as forty-seven or fifty or fifty-five before? Okay, so bodies change en route, and well before old age take on a bit of flesh, relinquish their early, unearned tautness, relax, droop. Ultimately, everyone loses two battles: one with the ideal and the other with time.

Suzanne Opton plays a metaphorical and quizzical game with the feminine condition. Her naked subjects are anonymous, baring everything but their identities. They never looked like Brigitte Bardot or Sharon Stone anyway, but—like most of us—have had to live with and make what they can of reasonably attractive, hatefully imperfect, delightful, annoying, nagging, and hungry equipment imposed on them by genetics. Opton's models still have flesh pink and firm enough to remind us of what it once was; she assigns them parts to play, with the props of domestic ritual, in tableaux that are simultaneously strange, sad, vaguely disturbing, glancingly bitter, and ironically humorous. In these emblematic scenes, women who have doffed their costumes bow their heads or sprawl in ungainly ways over tables and between vases, which take on major roles. Tables, the sole stand-ins for furniture, are useful for kitchen work and dining (and, in an earlier generation that did not work, for afternoon games of cards). Vases remain the eternal symbols of the female principle, the receptacle, the vessel waiting for fulfillment. Here, a woman stretches over a tabletop that bites into her thigh; headless, armless, legless, she approximates some primitive sea creature or protoplasmic form. There, another woman, whose legs have been battered, prepares to dive off the table, whether into freedom or death, pursued by spray bottles from the cleanup brigade, lined up like a firing squad.

SUZANNE OPTON, *Ganesh*, 1999

One woman, clothed, sadly meditates on another, naked; possibly they are two aspects of the same person. The naked one's body is relegated to the floor; her head, detached, sits on the table amid vases with swelling shapes and open mouths, one of which takes the place of her face (and her identity). And, in a remarkably close approximation to German emblem book illustration of the sixteenth century, a woman whose swelling belly and hesitant walk might have come straight from a painting by Hans Baldung Grien carries a table on her head, the tablecloth entirely masking her face as if she were the blind, anonymous bearer of domestic service of every variety.

Yet another woman, grown heavy with years of overeating, hides her head behind a shopping bag from Balducci's, purveyor of fine, expensive foods: grocery shopping as life. Another's drooping breast is supported by a stack of wine and dessert glasses: can she still produce milk, or is this a household uplift of a sort that brassiere manufacturers do not acknowledge? A torso upon a table, cruelly sliced off at top and bottom and marred by stretch marks and ungainly pudge, is also mated with glasses, intact but notoriously fragile, that glitter in the light and then are radically changed by their own shadows. And in a final marriage of sex and kitchen, a stack of plates balances on the area that runs from the thigh to the breast of a reclining body.

Opton's palette is as odd, as sui generis, and as arresting as her imagery, beginning with off-greens and blushing sienna flesh tones that mimic the wood of the table, then shifting occasionally to skin that is virtually drained of color, and green-brown backgrounds that temporarily register as black. Sharply angled lights contribute to surfaces so smooth that flesh, wood, ceramics, and painted walls all seem to be made of the same material.

For many years, art scarcely dared consider the aging body, except occasionally in sorrow. Rodin depicted a poignantly ruined body that had once been a beautiful courtesan, and in the 1930s Erwin Blumenfeld photographed Carmen, formerly Matisse's model, as a miserably unhappy, aging nude. More recently, the not-so-young nude has been gaining ground in art. Late in the last century, Irving Penn photographed heavy and decidedly un-ideal bodies in sometimes awkward postures but superbly, exquisitely printed, and Anne Noggle traced the progress (if that's the word) of her own aging body with her camera.

Opton inserts into the tradition of the nude the concerns of this moment in history: feminism and an aging population. Middle-aged women, invisible in the blare of commercials and fashions, gyms and plastic surgery that promise everlasting, relentlessly beautiful youth, call now and then for acceptance, if only by themselves. A group of sixty-ish women in Britain, in an ingenious attempt to raise funds for a charity, published a calendar of themselves nude, and were startled to find their publication selling like hotcakes, no doubt largely to women like themselves who also hoped to be recognized as people who still had bodies. Opton begins in nearby territory, venturing more deeply into the difficult precincts of feminism, agism, metaphor, and art. These photographs confidently add what might be called a new wrinkle to the great corpus of female nudes in the history of photography.

From "Loose Change," exhibition catalog
(Milan: Il Diaframma Gallery), February 2001

MARTIN
PARR

Martin Parr is the emperor of bad taste. He tested the territory in the 1970s and planted his flag on it in the early 1980s, before most British photographers understood what a rich resource vulgarity was. Parr has been mining the territory so long, in such volume and detail, and with such voluptuous excess you might think he considered poor taste a luxury. The photographer Larry Sultan once told him that the shirt he was wearing was in the worst taste Sultan could imagine, to which Parr replied, with his usual modest and thoroughly pleasant bad-boy manner, that he considered that a great compliment.

Parr is at once the most successful and most controversial photographer in Britain. Some of his pictures have been shown in the London Underground system and at bus stops throughout the nation. He has been a member of Magnum since 1994, although he doesn't fit the usual humanitarian-documentarian Magnum profile, but practices an amusing, over-the-top, occasionally gross social critique or makes deadpan records of such mundane contemporary acts as cell phone use and falling asleep on subways. Henri Cartier-Bresson reportedly said, when Magnum was considering him, that Parr was from "a different solar system."

He also takes offbeat fashion photographs, makes films for the BBC, and gets his own work published in books and catalogs at a prodigious rate. *Martin Parr*, Val Williams's catalog of the show she curated for the Barbican, has proved so popular in Europe that last fall it was completely sold out in Paris, and Phaidon, the publisher, hadn't a single copy left in either London or Paris.

Parr really hit the controversy button in 1986 with the publication of *The Last Resort* (Dewi Lewis), a book that marked his shift to a medium-format camera and color photography, a shift influenced by his interest in the way William Eggleston and Joel Sternfeld used color to make the most ordinary scenes compelling or disturbing. After the switch, Parr claimed that his previous, black-and-white documentary work had been roman-

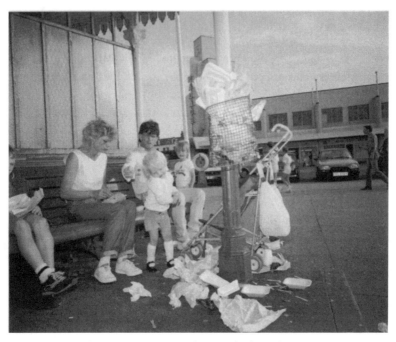

MARTIN PARR, *The Last Resort, New Brighton, England,* 1984/85

ticizing and nostalgic in its refusal to look at the ugly side of working-class life.

The last resort was New Brighton, a seaside vacation spot sadly declined from its glory days, but popular with people whose pocketbooks it accommodated. In Parr's photographs, garbage is taking over the world and people are crammed into the remaining space, babies play in brackish water, perfectly nice children have a rabies froth of food on their mouths, and their unhappy older sibs jostle each other at ice-cream counters.

Perspectives in these pictures could be abrupt and compositions finely disorganized, with car fenders and life preservers muscling in at corners and an appreciation for the complex choreography of happenstance. Parr has developed these ploys further over the years, as he looks at scenes from above or past the back of a head seen so close-up it becomes a major monument, or ruthlessly cuts off other people's heads and catches still others leaning precariously into the picture. Sometimes in the later work, angles grow so slanted it's a wonder everyone doesn't slide out of the frame, and incongruous juxtapositions rule the day. The photographs remain vigorous and appallingly funny, sharp enough to take a bite out of anyone's notion of a vacation with the kids or a four o'clock snack.

Many thought (and still think) the New Brighton pictures and the work since then are voyeuristic, exploitative, cruel jabs at a lower class. Parr has become accustomed to defending himself. He told Val Williams: "Photography is full of guilt. . . . And I accept that all photography is voyeuristic and exploitative." His supporters loudly proclaim that he tells it like it is and has exposed what Britain is coming to. To a certain degree both are right.

Even as he touched off controversy, perhaps *because* he touched off controversy, Parr was recognized as the most important documentary photographer in Britain, partly because he had discovered a new subject to document and partly because he had found a new way to document it. His no-holds-barred approach has since strongly influenced younger British documentarians—think of the family pictures by Nick Waplington and Richard Billingham. Parr's new subject was the changing life of the working and middle classes under Prime Minister Margaret Thatcher, a life in which ownership of private houses and the possibility of vacation travel became widespread for the first time and consumption in general began to occupy such enormous amounts of time and psychic energy that it became a central fact of existence.

Parr's earlier black-and-white pictures of prefab houses and lower-middle-class life were already tinged with irony as well as a fascination with lower-class life that probably was a reaction to his own suburban upbringing—but they were gentler than anything he has done since the 1980s. He claims that his color pictures reflect his own feelings of angst about the culture.

They are certainly full of angst: anxious color, thoroughly saturated and either dusted with a chalky overtone by fill-flash or, more recently, rendered eye-popping by a ring-flash; anxious crowds and spectators; anxious tourists and vacationers trying to squeeze the last ounce of info, sun, and fun out of the few moments left; anxious objects seen too close-up with a zoom; a general anxiety about the creeping sprawl of the worst parts of pop culture.

Parr's photographs, bursting with subversive energy and profound absurdities, elicit laughs, disgust, guilt, and discomfort. Should we be amused by lower-class kitsch when it is, after all, a way of life and no doubt as difficult as ours? (A 1992 book called *Signs of the Times: A Portrait of a Nation's Taste* [Charterhouse], pictures taken in conjunction with a BBC program about British taste in interior decoration, included this item: a couple stands apart, looking into the distance, with a caption that reads: "We're going to come to a nice compromise on every issue. I've already decided what colours we're going to have. He can just pick variations.") Should we laugh or weep to think that mass tourism has deteriorated into mere photographs or stage sets, like the Eiffel Tower in Las Vegas, or that cholesterol has conquered more territory than Napoleon ever did?

Parr is, in fact, transfixed by fast food. His camera homes in on grease and calories (squirming pink sausages, limp and oozing bacon, Reddi-Wip extravaganzas) with the unerring instincts of a bloodhound. He is equally fascinated by food that masquerades as cartoons: toothpaste-pink cupcakes with Porky Pig faces, icing-covered bagels on lollipop sticks, smiley-face pastries in an inedible shade of turquoise. If we are what we eat, all is lost.

But as usual, Parr is on to something: first of all, the globalization of the fast-food culture, which has altered eating habits and raised the obesity index. Second, the desperate need to catch the buyer's attention in the highly competitive quick-lunch and snack-food industry, as well as the spurious sense of luxury that sneaks in with an oversupply of ersatz goods. Fast food and overeating are pervasive ways of life; the stores and logos, ads, promotions, lures, and endless minor variations on the hamburger-French fry-

ice cream menu are meant to convince people that they have more choice in food (and perhaps in other important aspects of life) than they really do. If Parr prefers garish colors and revolting food, well, that's one way of commenting on the sorry state of the world.

The necessity for branding and conspicuous display in the fast-food culture is endemic in the rest of the culture as well, and Parr has turned his cool eye on all kinds of display, from manikins with furry lashes and parted, blood-red lips to fuzzy bears with pearl-button eyes and long platinum-blond hairdos; from someone's dog in jazzy sunglasses to women with patterned fingernails or sandals with fake flowers as large as jungle blooms. These are all means of calling attention to a product or to oneself as a product of self-manufacture and definition. They are attempts to use mass production to distinguish an individual commodity or person from the mass.

Parr is a dry cultural observer of the underobserved culture: people loading up on beer and toilet paper in big-box stores, bored couples in restaurants (including himself and his wife). Boredom so interests him he did a whole series of pictures in a town called Boring, Oregon, where the signs say things like "Boring Sewage Treatment Facility," and he collects what he calls "boring postcards," which live up to their name. He is indeed a passionate collector, whose photography book collection—he is writing a history of photographic books with Gerry Badger; the first volume appeared in the fall of 2004—and postcard collection (most of it not boring at all) reportedly rival those of the Victoria and Albert Museum and the National Museum of Photography.

He is of course a collector of sights and people with his camera. The son of a passionate bird-watcher, he was a train-spotter in adolescence but gave it up when he went to college to study photography. His work is full of pictures of people watching, observing, occasionally recording: watching outdoor shows, watching people on tour who are themselves watching a guide, watching sports, photographing monuments and groups, lined up to watch something we can't see outside the frame. All are metaphors for the photographer himself and for the society of display and window shopping, tourism, and television, that makes onlookers of us all.

Parr takes aim at photography too and at the reproduction of images, with pictures of the postcards that intrigue him so and of ranks of souvenirs or postcard racks that obscure the scenery to offer images of it. He has gone around the world having his picture taken by studio and street photographers—he poses just as they tell him to but refuses to smile—ending up in

a grass skirt and lei, with a bongo drum, in Italy; inside a shark's mouth in Spain; atop a bodybuilder's body in New York; inside a brandy snifter in Jamaica. This is self-presentation raised beyond theater to special effects; the "Autoportraits" crack wise about the ubiquity of photography and its role in establishing our ideas of ourselves.

Parr's view of life is not likeable but bitingly funny if you're certain you're not the one being bitten, and it is wise in its scurrilous way. There is sufficient energy in these pictures to electrify a third-world country, sufficient irony to electrify an entire university department of literature, sufficient humor for a late-night comic, and sufficient grease and kitsch, garbage, sunburn, and gaucherie to fluster anyone caught laughing at the cupcakes, tchotchkes, and foibles of our world.

N.B.: As an ethical matter, I feel I must confess that I bought two images by Parr from the Janet Borden Gallery in 1999, when Parr produced a show of laser prints that appeared simultaneously in forty-one cities, a Guinness World Record. All the prints were laser copies made by Xerox, but only one copy of each image was allotted to a city, a typical Parr comment on the nature of photography and reproduction. Mine cost me $40.00 apiece, and my dirty little secret is that I am writing this piece in the hope that their value will double and I can retire. But alas, I had them *laminated*, so I guess that's just another investment down the drain.

American Photo, May/June 2003

HERB RITTS

Celebrity is the jewel in the tin crown of pop culture. Famous names supply the material and motivate the market of that robust economy, for celebrity is not only a product but a remarkably efficient advertising medium as well. In a society as fixated on famous people as it is on what they do or make, the glitter of renown seems to grow ever more brilliant the further it spreads itself about. In the 1954 film *It Should Happen to You*, Judy Holliday starred as a nobody who rents a billboard to advertise her name and instantly becomes rich and famous. At length she learns that "it isn't just making a name. . . . The thing is making a name *stand* for something"—but that was only a movie.

You're nobody till somebody knows you, which is where photography comes in. A star needs a face, not to launch a thousand ships but to throng a million magazines. One of the most visible face-makers of the day is Herb Ritts, whose portraits are on view at Staley-Wise in a show called "Herb Ritts: Notorious" (and in a book of the same name from Bulfinch Press [1992]; he is donating his royalties to the American Foundation for AIDS Research.)

Ritts has made his name by giving fame an identity card, which he does with admirable technique, strong, rather old-fashioned design, sly and occasionally brazen borrowing from earlier photographers, and just enough naughtiness to make him seem up-to-date. He recently signed a contract with *Vogue*, which immediately reconfigured itself to look like *People* magazine.

The word "notorious" is supposed to whet the jaded appetite. It connotes a modern kind of fame, as when Macaulay, in the nineteenth century, spoke of a man raised to "notoriety, such as has for low and bad minds all the attractions of glory." For Ritts's camera Kim Basinger and Naomi Campbell strip, Axl Rose shows off his tattoos, and Vladimir, a circus performer, poses in a fancy leather jockstrap. If you want people to recognize your face (or your pecs and your abs), it helps to misbehave.

HERB RITTS, *Cher, Hollywood*, 1991

It was not always like this. In the 1930s, stars behaved so steadily for the camera you could navigate by them. George Hurrell and Clarence Sinclair Bull and the other mainstays of Hollywood portrait studios knew how much glamour meant to people with shabby lives. Dwelling in the realm of the ideal, those photographers did not indulge in flattery so much as in a kind of loving embalmment, manufacturing idols out of alabaster and cream. The graven images of Dietrich and Lombard and Gable were made up, dressed up, lit up, touched up far beyond the means of people who had not perfected the smolder or come-hither.

The 35mm camera had already introduced an element of apparent candor and the potential for awkwardness, even scandal, into portraits of the famous, but rules were rules back then, and the press believed in them. Hollywood studios made sure the glamour of their properties was not tarnished, much as Franklin Roosevelt's aides protected him from photographs that would have shown just how crippled he was.

But sometime in the 1950s that began to change. Irving Penn and Richard Avedon were already making portraits that were not exactly kind to their famous subjects. Sitters who showed up to have their status confirmed were assumed to be so famous they would benefit by looking any old way in the lens of so famous a photographer, so long as their names were spelled right.

Elsewhere during that decade, glamour began a long, slow decline, eventually to be moved out of the spotlight by ripe sex. There were some feints toward naturalness, which replaced the myth of unattainable perfection with the myth of a girl like I, only more so. Philippe Halsman made people jump in hopes of surprising them into letting down their guards. It did not always work. The Duchess of Windsor jumped without letting down anything.

As the Hollywood studios died off, paparazzi found a new market for pictures of people caught perilously off-guard. Biography, public confession, and photography all began to notice that the silken skirts and creased trousers of the famous were underpinned by clay feet. Then in the 1960s glamour failed to survive the frug and rock stars drastically changed the terms of celebrity.

The Doors, the Stones, and the rest of the gang were counterculture heroes, and their images were meant to be the same. They had a stake in looking scandalous, bizarre, deadbeat; they gave others license to do the

same. The great perk of fame (or the one that could momentarily make people forget how rich it was making you) was the freedom to look as undignified as any member of the great untalented masses.

In the 1970s, Helmut Newton introduced a dash of Weimar-era decadence to celebrity portraiture, photographing Paloma Picasso with one bare breast and Grace Jones in chains. When the decade ended, John and Yoko posed buck naked for national consumption, and John Irving soon showed up in his little red wrestling suit to be immortalized by Annie Leibovitz.

Celebrity portraiture had been tilting ever more steeply toward entertainers as the 1970s moved in. Heroes were in short supply. In Vietnam, the generals distinguished themselves by cooking the figures of enemy casualties. One president who excelled in erasing tapes was pardoned by another who had to concentrate either on gum chewing or walking. People needed someone to look up to; they settled for celebrities.

Television hastened this development. The little screen does not make heroes handily but cranks out celebrity status, even for those who merely read cue cards written by someone else. The thing about TV images is that they do not keep well unless refrigerated, so photographers were called on to preserve the fame of those who made it on the tube. *People* magazine moved into this territory in 1974.

Recent big-time celebrity photographers, including Ritts, Newton, the late Robert Mapplethorpe, Matthew Rolston, Bruce Weber, and Leibovitz, have no illusions that photography can picture the soul. Celebrities who step into a photographer's studio don't have much incentive to nurture their souls, which don't go into reruns in America anyway. The images, Ritts's as much as anyone's, are about surfaces, and the surfaces are described with enormous clarity, for basically the subjects are objects—sex objects, decorative objects, but mainly symbolic objects.

Fantasies of success, power, naughtiness, rebellion, irresistible sexuality get projected onto such objects. Richly printed photographs, borrowing the cool elegance of 1930s design and the authority of Art to lionize what passes for outrageousness, make the fantasies instantly available. The status of Ritts's subjects as objects is underscored at Staley-Wise by the large, heavy, elegant frames that turn his black-and-white photographs of Madonna grabbing her crotch and Stephen Hawking's sadly distorted face into precious and decorative items.

The mischief often suggested in such photographs adds to their value, letting you kid yourself into thinking you are like the stars, or better, and feeding a flattering sense of intimacy with the great. There is also the fantasy of identification: if someone that silly (naughty, neurotic, etc.) could make it, maybe you too could have been a contender.

Ritts has a peculiar specialty: obscuring the identity of his subjects. Here is a fairly new phenomenon—the celebrity who is so well known he or she can withstand temporary obliteration. Slash's face is totally covered by his hair, Prince's almost entirely by the chains hanging from his hat. Batman, already in deep disguise, is seen from the back and could just as easily be a dummy. Objects indeed. Stars and star photographers, spurred by repeated evidence of the finite and melancholy limits of human appearance, will go to great lengths for originality.

Even more peculiar is Ritts's penchant for the single feature as a portrait. He photographs Cher from the back in a violently abbreviated leather thong, mesh pantyhose, and high boots, so that the only possible area of interest is her derrière. Cheeky, you might say. Anyway, most people do not know Cher's gluteus maximus well enough to identify it without other clues. Hardest of all to name is the picture on the cover of his new book: the voraciously wide-open mouth of Sandra Bernhard, a picture that only an otorhinolaryngologist could love.

He is not the only photographer to use this gambit. A new book on Mapplethorpe has his portrait of his own eyes on the cover—one eye on the front cover, the other on the back, as if he were an owl. The few earlier photographers who used the single-feature ploy at least picked an unmistakable feature, like Joan Crawford's eyes or Marlene Dietrich's legs.

Has the camera at last worn out the human face, forcing photographers to try to reinvent the portrait? Has megafame so fetishized a few people that the audience will be content with a mere pound of flesh? Exaggerating a single feature is a technique of caricature or cartoon, and when celebrity becomes uncontrollably inflated, it does tend to distort the image of anyone wearing its mantle. Many current stars, needing attention, needing to pop off the page, needing to keep their fickle fans riveted, have willingly collaborated in caricaturing themselves through the lenses of Leibovitz, Avedon, and others.

Celebrity portraiture is basically advertisement, and the selling of a star in a form unrecognizable without a caption is the equivalent of those

BASTIENNE SCHMIDT

The Puritans thought that God had intended to shed his grace on America; in fact, most thought the Lord had already delivered it with a warranty. Long before we were a nation, the new land was referred to as "A City on a Hill," a shining city to be watched by all, not a utopia but a place where a society could be constructed on a plan, and humanity could stand a little nearer to the angels. No one ever thought it was perfection here, but most harbored the expectation that we might come closer than usual. And although we have never had a lack of critics and have probably been the most self-analytical and self-critical nation in the world, taken all in all we thought for a couple of centuries that the promise had been properly held out to us. The Depression put a crimp in that belief, but victory in World War II brought it roaring back.

And then success sent us reeling. Beats and intellectuals set out on the road in search of America, and if they loved what they found, they hated it too, and railed against consumerism and conformity. In the 1960s, students picked up this message and ran with it, while the civil-rights movement and the Vietnam War spread disillusion far beyond the gates of the universities. It wasn't just that the image of America was changing in people's minds. It was changing on paper and in the media too. It had become possible to look at the nation from another vantage point, where the promises looked a little ragged around the edges.

Among photographers, the telling event was the publication of Robert Frank's *The Americans* in 1959. (It was first published in France the previous year.) In the best tradition of the 1930s, Frank had gone on the road in search of America, but the only city he saw on the hill was dispirited and more than a little bleak. His abrupt, off-kilter style was unfamiliar, and his odd and lively affection for the loneliness, the mass-produced trash, and the fast-food joints he spied on his journeys was hard to fathom. But what struck observers hardest and upset them most was Frank's sense of the sad, tough, and tired heart of America the beautiful.

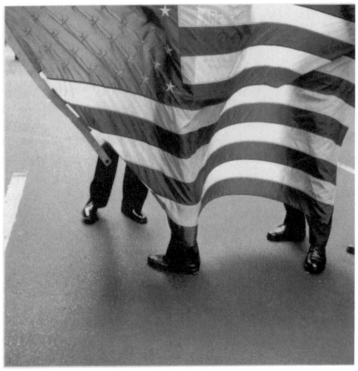

BASTIENNE SCHMIDT, *Flag Parade on 5th Avenue*, 1987

Frank actually made visible a cultural shift, a self-image in the process of transformation, that was already in the works, but he gave it such definitive visual form that his influence is still being felt. Bastienne Schmidt takes a cue from *The Americans*; her book *American Dreams* is a kind of offbeat commentary on that classically offbeat document. She is clearly in tune with Frank's spirit of brash and skeptical inquiry, and his willingness to look directly at the people, the places and moments that will never win trophies in a competitive land. Often she looks at the world from a tangent, at an angle, up uncomfortably close or cropping sharply, in line with Frank's influence on 35mm photography, though Schmidt generally shoots with a Rolleiflex, a medium-format camera.

She is more confrontational than Frank; her subjects often see her coming and regard her without fear. In byways and gathering places and quiet corners, she fastens onto a detail, a look, a gesture that speaks in a scene that would otherwise be mute. Curious about the occasions that bring crowds together, she sees America as a country in such constant motion that the still camera cannot keep up with it.

Hers is not everyone's America but an album of what few tourists and fewer residents have noticed, a land that takes both entertainment and death seriously, where singers smile without cease and watchers of every sort, even camera watchers, stare fixedly. This America, mourning some of its tattered dreams, is intent on having a good time but not altogether up to the task.

Both Schmidt and Frank were foreign born—she grew up in Germany and Greece—giving them the kind of outsider's perspective that an astute observer would take advantage of. Frank came from an atmosphere of postwar European anti-Americanism, but Schmidt says she was looking for something more tantalizing, the myth she knew from TV and American exports. Partly because Frank's images marked a change in the cultural weather, her view of grave young souls, cross-eyed cowboys, and ruffled-shirted ballyhoo artists won't provoke outrage, but her book too records a sharp-eyed foreigner's glance at surprises, incongruities, disappointments, and a few sweet moments in ill-fitting jackets. Most tellingly, Schmidt has a sharp sense of the times: she brings us smack up against her vision of the 1990s, when America, comprehensible or not, can only be considered in the light of the changes that have recently overtaken it.

Is it possible to picture a cheery America after Robert Frank? Well, that rather depends on who your audience is. Ronald Reagan insisted it was morning in America all the time. *Time* magazine, as recently as July of 1997,

had a cover story called "The Backbone of America" that mentioned some of the downside but kept the pictures pleasant. Most serious readers won't accept unmitigated good cheer after the civil-rights struggles of the 1960s, the Vietnam War, assassinations, Watergate, and subsequent revelations. Some consider us a nation that has gained the whole world and lost its soul. Serious photography watchers would probably be taken aback by a vision of happiness spreading coast to coast. Perhaps by now we look at our country as if we were foreigners too.

Both *The Americans* and *American Dreams* are road books—records of that great American place, the road—and documents of twentieth-century survey expeditions. Nineteenth-century expeditions brought back images of uncharted lands as a prelude to development; today, photographers go in search of social and psychic discoveries. Walker Evans's *American Photographs* of 1938 is the *locus classicus* for this kind of visual diary and strongly influenced Frank, but the road has also drawn writers and reporters from Jack Kerouac to John Steinbeck to Charles Kuralt. Frank memorialized the road in its endlessness, isolation, and invitation to fatigue, and Schmidt in her way does too, sometimes catching the mindless, half-melancholy looks of passengers watching the land roll by.

She repeatedly invokes the American flag, which for Frank was an organizing device. He saw it worn thin on July 4, or blotting out the faces of its followers. Schmidt sees it on a clothesline on July 4, or blown by the wind to hide three men in suits: their legs hold up the emblem of the nation, but only one leg of the central figure is visible, as if the country's support were unsteady, off, irregular at its center.

Both photographers are unusually alert to the signs of death. Frank went to a black funeral; so did she. He looked at car accidents, grave markers, cemeteries; she looks at mourners and commemorations. (Schmidt's first book, *Vivir la Muerte* [1995], was a moving study of the rituals of death in Latin America, where the end of life is more closely integrated into the living culture than it is in either Europe or North America. That book was Schmidt's attempt to come to terms with her own father's death—the mourning process as a photographic quest for understanding.) Frank presented the simple facts, as bare and stark as a grave marker or a mourner at a moment of sadness and perplexity. Schmidt looks at mourners too in all their sorrow, but she focuses on the changes that have overtaken the nature of death and our response to it under the pressures of recent history.

The signal event that opened the gates of disillusion and distrust in this country was a death: the assassination of President John F. Kennedy on November 22, 1963. Schmidt takes pictures of mourners visiting his grave three decades later, and photographing it to prove they have been there. She also snaps his brother Robert's grave, another index of assassination, and a more recent monument, a mural of Selena, the beloved Mexican-born singer who was murdered by a disgruntled employee in 1995. Assassination and murder serve as signposts on which to string the history of a country. . . .

There is one astonishing picture of commemoration here: a wax museum display of Jacqueline Kennedy, veiled, and her two young children about to march in JFK's funeral procession. The American flag hangs down beside the figures, in case we missed the significance. An image of these three at that moment in 1963 is still burned into the brain of every American who was alive at the time. Jackie and her children were on TV for what seemed like hours that day, and the black-and-white photographs of them have never entirely dropped from view. They fixed the national sense of grief and gave viewers someone to focus on and identify with, while Jackie Kennedy's sorrow, stoicism, and immense dignity raised her to heroic stature across the land. In the wax museum, improbably, she *smiles*. Death, which comes even to presidents, need not be too disturbing after all.

Though Schmidt makes no claim to document all of America, and indeed says she does not even understand it, her eye lights on evidence of some of the most telling issues of our time. The memory of assassination and the potential for murder are joined by a photograph of the AIDS quilt, with the mourners in anonymous silhouette in the distance, while a framed picture of a handsome man when he was still in good enough health and smiling casts a shadow over the signatures on the quilt. Elsewhere, a decorated veteran stands by the Vietnam wall: more names of the dead, lest we forget. And a black man with enormous, haunted eyes sits on death row, where so many more blacks than whites wait for execution in a country that embraces it more avidly than almost any other in the West. Even the prison's so-called Death Bed, which would be more aptly called an execution bed, sits—looms—for its portrait looking like some peculiar crucifix redundantly bound with belts.

Then there's the American preoccupation with guns, which account for too many of our death statistics. Here's a gun shop, here a gun club

where the rifles are laid out across the bedspreads with loving care and order-liness, and there three tough, pretty, and confident teenage girls posing with their rifles at a shooting camp, not every parent's notion of a summer camp for girls.

The race issue that Frank traced across America is traced by Schmidt too, but now it has a new slant, in line with historical shifts. Black history is today a subject of wide study, black ancestry newly venerated. A woman in African garb, knee-deep in the sea, performs a commemorative service for slaves who lost their lives. And race is no longer merely a question of black and white, but of many cultures and ethnicities in a society trans-formed by shifts in immigration patterns and ethnic awareness.

A young Latin American woman stands beneath two portraits of Elvis in a New York beauty salon. A man with the profile of a South American Indian rides a bus, or a train, across the West. An Asiatic singer greets his fans in a town made famous by country music. Schmidt's camera comes right up on the torso of a border-patrol officer, bullets gleaming at his belt, as he surveys the fence built on this side to keep people on that one from crossing over.

Then there's money. A young black man on spring break in Florida is cut off by the frame at nose and waist, so the dollar sign on a chain about his neck lies in the center of the picture. An East Los Angeles mural is pic-tured at such a slant that the dollar bills that float at one side of the paint-ing fly right out toward us. A Beverly Hills real-estate agent in tight white clothes works two phones at once; behind her are pictures of classical ruins that not even Hollywood agents could sell.

For all her references to Frank and his style, Schmidt's eye is all her own. She views American oddities and preoccupations with an unconven-tional intensity: Young children playing video games as determinedly as if they were adult gamblers. The Wigwam Motel's display of imitation tepees topped by electric lights. Gravely awkward children got up like lampshades and candy boxes for a christening. Obese older women isolated like monu-ments in the ocean shallows. A black woman having her hair braided in what might be a sacrificial ritual.

This being the 1990s, Schmidt plays with recurrent images of spec-tatorship in small towns and large. People watching parades or staring out windows at nothing in particular just because it is there. The photographer herself is a spectator, of course, and we, looking at what she offers us, are the audience for a foreign production of the American follies, or perhaps

of an American tragedy, or maybe America the beautiful without quite as much grace as promised.

Frank showed us a Hollywood starlet ogled by envious fans; Schmidt goes to a Miss Olympia Bodybuilding contest, where the goal of blond and lissome has been replaced by strenuous efforts to look like Hulk Hogan in a bikini. A tourist in Monument Valley trains his camera on the sky, others tour the valley with their lunches in plastic bags and unwrap them by the unlikely outcroppings where John Wayne used to ride. The stars and their fans bring their smiles, their guitars, and their patience to Branson, Missouri, for big-time country music year after year.

Schmidt takes a seat in the front row of the spectacle, so close she sometimes sees fragments or comes up against complexities that crowd in when backgrounds are cut out. The performers on stage—us—are often in motion, or the world is whirling past them faster than they know in blurs and streaks of light. Minor players, wanting a chance in the limelight, thrust a hand or an arm past the edge of the frame. Occasionally Schmidt bears witness to the almost empty stage of the American landscape, occasionally catches an actor off guard, waiting, watching: sad, wary, resigned, quietly alert for whatever comes next. The drama erratically unfolding before her camera is a sober one. Emotions at high pitch (or maybe just high smolder) crop up three or four times where you might not think they belong.

She came to the spectacle as foreigners do, on a ship passing the Statue of Liberty in the book's first picture. As the curtain comes down on her version of American dreams she is still looking at America, photographing herself now, this time with the Statue of Liberty behind her. And as she snaps a picture of Bastienne Schmidt with a camera to her eye, she looks for all the world as if she were photographing us.

From *Bastienne Schmidt, American Dreams*
(Zurich: Stemmle, 1997)

JOEL
STERNFELD

The sites of human tragedies have been marked for commemoration at least since tradition settled on the place where Christ was crucified. But artists cared more for the events, whether holy or secular, than for their locations; they painted crucifixions infinitely more often than the hill of Golgotha, just as they preferred martyrdoms or the deaths of generals to a quiet spot that once saw blood.

When photography first came along, it was too slow for most events and had to settle for the sites. In 1855, during the Crimean War, the English photographer Roger Fenton took a picture of the Valley of the Shadow of Death after the killing was over and nothing remained but spent cannon balls. During the American Civil War, photographers unable to stop the action recorded bridges, ruins, *The Scene of General MacPherson's Death* after the general's body had been removed. When faster lenses and films were devised, the event itself became primary again, but since photographers are not always in the right place at the right time, the site and its aftermath have been subjects often enough.

Now Joel Sternfeld, in "On This Site . . ." at the Pace/MacGill Gallery in New York, depicts a dozen and a half spots related to bitter events in contemporary America—the motel in Memphis where Martin Luther King Jr. was killed, the tree in Central Park beneath which Jennifer Levin's body was found (she was the victim of the so-called "preppy murder"). From flowers placed where the founder of an abortion clinic was murdered, to the beach where would-be immigrants from China struggled ashore from the Golden Venture, to the movie-theater seat where Lee Harvey Oswald was arrested, Sternfeld has devised a Baedeker to America in the age of anxiety, fear, and moral crisis. One could argue that American life has been shaped by the events that took place on these largely unsung spots, which form a contour map of contemporary angst.

Sternfeld writes rather regretfully that Italians put up crosses and small shrines where fatal car accidents occur, but Americans leave such tragedies unmarked. Yet inner cities have dedicated whole walls to graffiti of the

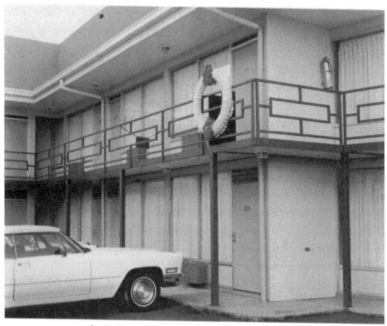

JOEL STERNFELD, *The National Civil Rights Museum, Formerly the Lorraine Motel, 450 Mulberry Street, Memphis, Tennessee*, August 1993

names (and sometimes the faces) of people murdered there: one of Sternfeld's own photographs bears this out.

A photographer who has demonstrated a knack for irony and incongruity, Sternfeld here produces a few fine images with his 8-by-10 camera, but even he cannot make a silk purse of a carport or a tacky meeting hall. Beauty is not his point, of course. The very banality of some of these pictures is a reminder of how indifferent brick, stone, and nature are to human tragedy. A tree does not wither because someone is raped and strangled beneath it; a road neither blossoms nor buckles in the wake of a fatal crash.

Behind these images is the age-old idea that places are imbued with the memory of whatever happened there, an idea that has given rise to both shrines and haunted-house stories. Photography helped boost Civil War battlefields to prominence on that list, and some of those fields have been preserved and are reverently visited. (Disney even considered re-creating the experience at Manassas for those eager to relive the Civil War—an idea that fortunately was shot down.) The issue of how much meaning inheres in a place has been chillingly raised by the slow disintegration of what remained at Auschwitz after the Nazis tried to erase the evidence. The question today is whether the camp should be reconstructed or allowed to crumble. What is a fitting memorial to unimaginable horror? What would the place mean if it were unmarked, and how would we read a photograph of it?

Here is where titles and text come in. "On This Site . . ." emphasizes their role, relying unusually heavily on words to provide a context, even a reason for looking at all. The surfaces of these photographs do not disclose their meanings. Because photographs can show but cannot explain, some images, particularly documentary images, are notoriously dependent on words. The face of an unprepossessing young man on a newspaper page, the kind of face the eyes slide over on the street, takes on significance when the caption reads "Serial Killer." Photographs are frequently open to multiple interpretations and easily redirected by captions. One well-known example is Margaret Bourke-White's picture of blacks with pails and baskets lined up for assistance after a flood of 1937. Nazi propagandists relabeled it an image of injustice and poverty in America, and no doubt Germans were convinced, for the picture could prove nothing by itself.

Art photographs too can be dependant on textual reinterpretation. Alfred Stieglitz's 1907 *Steerage*, often said to be a classic portrayal of immigrants, is not that at all. Stieglitz took this photograph while sailing to

Europe; it must be a picture of people returning home after being refused entry to the United States. Then again, Andres Serrano might never have come to Senator Jesse Helms's attention had he titled his infamous photograph *Yellow Christ* rather than *Piss Christ*. Today, some documentary photographers insist on written explanations to insure that their images are not misread. And some artists actually prefer words to images. (Think of Jenny Holzer.) Everyday language is often bonded to images, if only in the mind. Descriptions obviously conjure up pictures. When Sternfeld writes: "Lee Harvey Oswald was sitting in this seat when he was arrested by Dallas Police on Nov. 23, 1963, at 1:50 P.M.," the mind's eye instantly "sees" much more than is in a photograph of movie seats.

The relationship of words to images can be slyly exploited. Several years ago, Larry Johnson showed photographs of famous names printed on fields of strong color—"Marilyn Monroe," "James Dean." Viewers (or readers) immediately saw portraits in their minds. Glenn Ligon has photographed white words on a black ground: "A photo of a man urinating in another man's mouth." "A photo of a man with a bullwhip inserted in his rectum." Anyone familiar with Robert Mapplethorpe's photographs recalls the images described; the mind in effect develops the photographs.

The Sternfeld photographs may not call up other images, but the explanations do, for events like Rodney King's and Reginald Denny's beatings were massively recorded when they happened. Like stones dropped in the well of memory, the words "Rodney King" and "Reginald Denny" create expanding rings of visual associations—all of them from photographs or tape. When I see a place identified as the spot where Rodney King was pulled over by the police, I see the beating on tape; when I see the motel balcony where Martin Luther King Jr. died, I recall a photograph of people around him on that balcony pointing to the source of the shot.

So much of knowledge and experience is derived from the media that pundits and artists alike concede that contemporary life is a secondhand business. Memory is stocked with photographically generated reproductions, which sometimes have a stronger hold on the mind than firsthand recollections. The media contend not only with personal experience but also with one another for space in the memory bank, and more dramatic or more widely distributed images generally win.

Thus a feature film seen by millions, although its images are fictitious, has an edge over "real" images in the memory (which is why docu-

dramas are dangerous: they are both credible and memorable). In response to Sternfeld's photograph of the spot where Karen Silkwood's car skidded off the road, I have trouble recalling Silkwood herself, although I have seen many photographs of her. Yet I do remember what Meryl Streep looked like when she played the title role in the film *Silkwood*.

If visual fictions can replace documented realities, they can also crowd out the best efforts of the imagination. When I read Kazuo Ishiguro's *Remains of the Day*, I had an image of Miss Kenton in my head that the Merchant Ivory film never came near. But Emma Thompson, so vivid, so convincing and so large on-screen, muscled her way into my mind and just about erased the woman I had created on my own. My memories of Ishiguro's words are now welded to a celluloid vision, as are my memories of an actual woman named Silkwood.

When it comes to tense moments in the national experience, photographic images are all I ever had. A couple of words for a cue—"Rodney King," "Reginald Denny"—and brief segments of tape automatically unreel in the movie palace of the mind, where reruns play on short notice around the clock.

New York Times, February 13, 1994

WEEGEE

He went out into the night, stalking disaster, and he found it. He found it promptly and often, a talent that gave him his name: Weegee, as in "Ouija board." He was a walking diviner, a dousing rod for crime. It helped that he was the only photographer in town with permission to have a police radio in his car, but that doesn't explain how sometimes he got to the scene of the crime *before* the cops. The dead men always wore pearl-gray hats. Weegee said: "Someday I'll follow one of these guys with a pearl-gray hat, have my camera all set, and get the actual killing."

Not the first tabloid photographer, not the first to concentrate on crime, he was the first one with a name. He coaxed that name forward with a pitchfork. By reputation and default he became the godfather to the invasive journalism of our day.

In *Weegee's New York: Photographs 1935–1960* (Schirmer/Mosel-Grove, 1982) John Coplans writes trenchantly on the work and the man: "There is a frantic edge to Weegee's imagery. He worked at a point-blank range and at a desperate pitch, the better to catch people in the raw." And: "His own tawdriness led him to where few other photographers were willing to go, and gives a terrible edge of remorseless tension to some of his images." The book presents those images in a large format, on glossy paper, richly reproduced, handsomely designed—the tabloid as high art.

Press photography and photojournalism live with some ease in the present museum world; Weegee made his bow there early on, when things were different: *The Critic*, his famous image of two society women entering the opera in diamond armor, oblivious to the angry comments of a member of the much lesser classes, was shown at New York's Museum of Modern Art in 1948. As social comment, the photograph was more acceptable in an art environment than his pictures of murder could be. (Weegee really got there early this time. He plied "the critic" with too much drink and had her escorted to the scene.) It wasn't until a 1977 retrospective that Weegee's bleeding gangsters, stunned survivors, and furtive lovers were elevated to glossy paper status. Weegee himself seems never to have thought he was committing acts of art. His simplifications and heightened contrasts

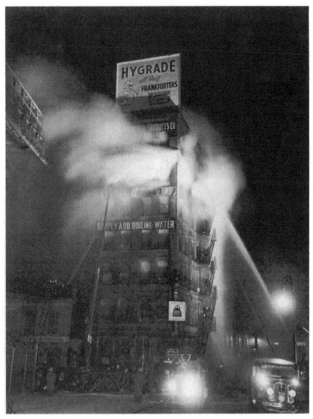

WEEGEE, *Simply Add Boiling Water*, 1937

were consciously designed to make his pictures carry in halftone repro-duction. "To me," he said, "a picture is like a blintz. Eat it while it's hot."

His subjects are beyond the traditional pale of art. *Weegee's New York* has sections on fires, on accidents, on crimes (corpses on sidewalks, under tables, under newspapers, under avid scrutiny), and on transvestites in the arms of the law. Weegee's parade is not mere news—the fires and murders all papers report—but true tabloid material, with a repetitiveness, an insis-tently hard stare, and a raunchy intimacy that are supposed to appeal to the great masses of the unwashed. Yet even the dry-cleaned classes, those who might deny reading the daily tabloids, admire Weegee's art. Some like their murder raw, some like it cooked—or, say, refined. History and reflection have cooked Weegee. His city editor would have been surprised.

Time acts as midwife at the birth of art from popular culture. The passage of a few decades delivers the vulgar and outrageous past to us as camp, kitsch, art. Weegee himself, with his tacky Hollywood career, his cigar, and his stamp that reads "Weegee the Famous," is a camp object. His photographs are not. They have too much power. They tell us too much about the portent of pictures, too much about ourselves. One or two mur-ders are news, and three might conceivably still be art, but ten amounts to sadism or titillation. The enjoyment of Weegee amounts to a cultural confession.

His camera tenaciously fastened on the common, involuntary fasci-nations, and we stare raptly at the results. It is no use to tell children, or adults for that matter, to look away from violence or sex; their eyes simply wander back.

Weegee never looked away. And much that he took he stole: using infrared, he surreptitiously photographed lovers on the beach and lovers in a darkened movie house—even darkness was not an adequate protection from his prying eyes. Other times he shot in the light or with flash, but his subjects were powerless to stop him. A fat man as pale as a termite lies nearly naked and fast asleep on a fire escape. (Weegee endlessly photographed sleepers, all those people imitating death, defenseless before his camera.) Or he turned his flash on the wife of a murdered man just as she collapsed. Again, a woman and her daughter watch in agony as a building burns; the other children are trapped inside. Weegee said he cried when he took the picture. That says he probably was decent. The picture says he probably was not. "But what can I do?" he said. "Taking pictures is my job." A voyeur by profession as well as by nature.

Indeed, he was preoccupied with voyeurism. He seems to have taken almost as many pictures of people watching fires as he did of the fires. In one of his most famous pictures, a group of (mostly) children are looking at a murdered man for the first time. Some are troubled, some elated to be privy to so dangerous a reality. We who are repelled by the children's glee are nonetheless vaguely aware of a similar impulse in ourselves. Weegee has seen the enemy, and it is us.

Many of the audiences in his pictures behave inappropriately because the camera encourages inappropriate behavior. In the well-known photograph of a drowning victim being administered oxygen, the man's girlfriend looks up, sees Weegee, and, unable to stifle the camera response, *smiles*. Bystanders at arrests and accidents mug for the camera, unwilling to let tragedy interfere with their chance to be in the paper. In one amusing photograph, two arrested men hide their faces behind a newspaper while three onlookers watch the birdy and say cheese. The camera demands good looks and offers much in return. "You oughta be in pictures," the popular song said.

No one works with such rank immediacy as Weegee. The situations in his pictures are always *here*, always *now*, often drastic. Motion is cut short in its progress. People turn, collapse, struggle, flee. Emotions are snapped as they burst: fear, anguish, shock, despair, anger. What a polite society keeps private spills out in emergencies, and Weegee unsparingly records it. The details his camera catches make the reality almost palpable. A man has fled a fire clutching two suit jackets, no trousers, and a dress. A cop-killer wears a bandage beneath what looks like a swollen eye. These photographs apparently don't have time to lie.

Although not artistic, they are constructed with artistry. Weegee cropped to improve his compositions. He used flash for what he called "Rembrandt lighting," in which the background falls off abruptly from the brilliant central subject. The backgrounds are inky black, not merely because Weegee preferred the night but because he burned in the darks. Even his kinder subjects, such as the night workers, exist in contrasts so strong that halftone could not destroy them. He created an extreme style for life in extremis.

But Weegee achieved art status not simply because he was a superior tabloid photographer. He also paved the way for profound changes in taste. His cruel and successful invasions of privacy influenced Diane Arbus and made a place for the newscasters who camp on the lawn of the murdered

girl's family, waiting for someone to open the curtains. Today we can accept Weegee's photographs as works of art partly because we have given the news almost unlimited permission; Weegee is less of a transgressor than he once would have been. Violence, even as it proliferates, has achieved a certain status. Clint Eastwood wins acclaim from intellectuals; wrestling becomes chic; Bernhard Goetz, the man who shot four black men on a subway when they asked him for five dollars, is lionized. Then, too, privacy as a value has become passé. The stage is set. Weegee enters.

The taste for his pictures also signals an uneasy change in our culture's world outlook and its expectations of art. It is generally assumed that art loosely mirrors the zeitgeist. In an era of mass reproduction and proliferation of images, all manner of imagery, including advertisements, news photographs, and music videos, must say something about our desires, fears, and philosophies. Weegee emerged from the tabloids at approximately the same moment young art photographers began to raid the media for subject matter. The attention paid him coincides with a widening artistic knowledge of the media's central position in our culture and a heady shift in artistic sources.

We live in a society that prides itself on loosening traditional restraints. The art world has declared that ideas of exclusion are infra dig, that art must embrace all comers. This inclusiveness has its good side and its bad. Weegee sits on both: the good side because of his undeniable power, the bad side because he reminds us of our dirty secrets—that we relish crimes, accidents, voyeurism.

The canonical photographic heroes of the American twentieth century, from Alfred Stieglitz to Minor White, Walker Evans to W. Eugene Smith, pictured a world that was orderly and meaningful, or one where order and meaning could be discerned by an intelligent eye. If photography didn't set out to establish goodness in humankind, then it sought the wisdom of the universe; if not the glory of creation, then the exaltation of the artistic vision. Not Weegee. He wasn't looking for the order in things: *disorder* is what sells. He tells us bluntly that the world is an unsafe place and that it is a photographer's business to add just a little twinge to the general discomfort.

We believe him. By now that is not news. We nod sagely, then happily if uneasily overdose on his pictures.

American Photographer, May 1985

PHOTOGRAPHY AND SOCIETY

BENETTON AND THE USES OF TRAGEDY

Slipping through the glossy pages of *Vogue* last month, readers passed a stuffed bear advertising Comfort Cream and were then plunged into calamity with the turn of the page. On the next three double-page spreads were a bombed-out car ablaze in the street, Albanian refugees climbing desperately into a packed ship, and a young man dying of AIDS in his father's arms. Then it was back to beauty without a pause. In *Interview* and *Vanity Fair* as well, Benetton sharply interrupted an idle, magazine-riffling lull with a nasty jolt of reality.

This month the ads appear in more magazines, and include an armed soldier holding a large bone behind his back, a couple wading through a flood in India, a crowd scrambling over a dumpster for food, and (in Italy only) a murdered Mafia victim lying in a pool of blood.

All these photographs were previously published in magazines as news. Two have been "colorized." Each is stamped with a small green logo saying "United Colors of Benetton" that fairly jumps out of the picture. Subjects and locations are not identified, although the world is awash with different varieties of refugees, terrorism, and illness. But all the images do have tiny captions—announcing that the latest issue of the company's magazine is available.

Opinion is noisily divided over the propriety of these ads, with older age groups reportedly much more opposed than younger ones. Since Albanians, terrorists, and bombing victims have no organized constituencies to argue their causes, the chief source of contention is the alleged exploitation of AIDS. Several European and British magazines refused to print the AIDS picture, and British ACT UP tried to organize an international boycott, but American ACT UP was divided on the issue and decided this was not the place to take a stand. No American periodical has censored any of the new campaign, though some balked at earlier Benetton ads with photographs of colored condoms and of a newborn baby still attached to its umbilical cord.

THERESE FRARE, *Final Moments*, 1991,
used in Benetton advertising campaign

No one fumed when the same AIDS photograph was published in a story in *Life*; no one minded any of these pictures before they were thrust into the arms of commerce. It comes as a shock when an advertiser claims ownership of today's most desperate news by branding it with the company name, but in fact news and advertising have been inching into each other's territory for years. All Benetton has done is to carry several current trends in image reproduction to their logical conclusions.

The company, which sells clothing in ninety-three countries, maintains that it is only trying to encourage awareness of social problems and of its own cutting-edge, concerned position. Yes, it contributes to charities, including some money for AIDS education in New York. But however pure or impure its motives (and although advertising keeps capitalism perking along, it has seldom been accused of purity), Benetton has given us what we should have expected and probably deserve: images of catastrophe as corporate ballyhoo. Political advisors who set up photo-ops already understand how photojournalism can be made to serve political ends amounting to unacknowledged advertising. Business moves in more boldly.

Besides, news photographs wander loose from their moorings all the time. This is partly because they really belong to everyone, copyright notwithstanding. This century's history is encoded in a set of photographic images filed in the mind: Jack Ruby shooting Lee Harvey Oswald; a Chinese man holding a hand up to stop a line of tanks. Whole populations have the same mental image files, which constitute a large part of the common culture. Flashing the key images guarantees instant connection and social commentary; witness Andy Warhol's paintings from photographs of civil-rights protests, or of Jackie Kennedy mourning.

News imagery is so strong that it does not entirely lose its meaning when radically displaced. Journalistic photographs have long been snatched out of journals to hang in museums. Some of James Nachtwey's war reportage at the International Center of Photography in 1989 was too bloody for most publications, but not for art audiences.

If art feels free to borrow news, so does entertainment. Billy Joel's music video "We Didn't Start the Fire" ran through a series of landmark news images. In *The Naked Gun 2½*, a nightclub that caters to miserable losers is decorated with pictures of such things as the Hindenburg explosion and the execution of a Vietcong suspect on a Saigon street. Art, music, film—Benetton asks, in effect, why not ads?

In fact, advertising has fed on news photography for years. Political contests take to it like cats to catnip. In 1964, Lyndon Johnson's presidential campaign ran a TV commercial with a little girl plucking flower petals and counting backwards—to a nuclear explosion. (Antinuclear groups like the explosion film too.) Bad news also sells insurance and protective organizations like labor unions, which before the current recession used Depression-era pictures to indicate how things had improved.

Manufacturers can turn the familiarity of dire images to their advantage by spoofing them. Kenneth Cole, the shoe company, ran a picture of General Manuel Noriega with the tagline: "One heel you definitely won't see at our Semi-Annual Sale." And good news sells anything. At Sherman Grinberg, a New York stock-film company, the story is told about a drug manufacturer that ran footage of George Bush Sr. shaking hands with Mikhail Gorbachev; the pitch was about the end of the Cold War. The White House snuffled a bit and said it was not amused; the drug company pulled the commercial. In December of 1989, Pepsi aired video footage of the Berlin Wall as it came tumbling down, with no text but "Peace on Earth" and the company logo.

Bad news might not seem like the ideal vehicle for selling casual clothes of the sort Benetton produces, but fashion knows how to cohabit with real-world horrors. *Vogue* published Lee Miller's devastating pictures of concentration-camp victims at the end of World War II and more recently looked at photographs on subjects such as homelessness.

And for a period in the 1970s, couturier-designed tragedies became high-fashion chic. Charles Jourdan advertised shoes with Guy Bourdin's photograph of the chalked outline of a body on the highway; a lone shoe lay forlornly beside the drawing. Helmut Newton's photographs of women murdering men illustrated a *Oui* magazine feature on men's suits—the last word in drop-dead fashions.

Real news, fashion, and advertising live in unnerving proximity anyway. To get to a Benetton calamity you may have to turn the page, but an inside page in the *New York Times*, as in any other paper, will have an article at the top headlined something like "Turk Warns of Religious War in Azerbaijan" above four photographs of a sultry model asking you to admire her brassiere. On the evening news, the anchor promises, in a sprightly voice, more information on the Lockerbie plane crash and nuclear dumps, followed by music fit for the Second Coming and a commercial for a miraculously responsive sports car.

Over twenty years ago, the photographer Robert Heinecken montaged opposites like these to make a political point. He superimposed upon ads for stockings and women's razors a picture of a Vietnamese soldier holding up two severed heads, then inserted the new images into fashion magazines on the newsstands. One aspect of Heinecken's message was similar to Benetton's: something terrible is going on out there while you're wondering whether your legs are sufficiently silky. But then, he wasn't *selling* silk.

Most of our news is commercially sponsored; the alternative is government, which most Americans trust even less than advertisers. Unwritten laws decree there should be some separation, however thin, between current history and commerce. Reporting and advertising, however, are becoming increasingly porous categories—*vide* that new staple, "infotainment"—and the independent identity of the news grows fragile. Sometimes, now, local television newscasts include interviews with the condemned criminal whose crimes provided a plot for the station's featured docudrama that evening—a public-relations campaign masquerading as news.

Commercials, on the other hand, may camouflage themselves as investigative journalism. Last year, Joan Lunden, cohost of ABC's *Good Morning America*, appeared behind what looked like an anchor's desk and delivered what sounded like a soft-news report on skin care in a commercial for Vaseline lotions. The only meaningful difference between the Benetton campaign and these attempts to fuse news and advertising is that Benetton is not pretending (except perhaps in its disclaimers). The bombed-out car, the ship, and the illness are undeniably news, the logo indisputably an ad.

The photographs do not hawk sweaters, but consumers are quite accustomed to fashion ads that haven't much to do with clothes. In the promotional minimagazine that Calvin Klein sent out with an issue of *Vanity Fair* last year, the models seemed much happier when they weren't wearing their Calvins at all. Supposedly, the consumer aspires to the lifestyles: Klein's pouty, pumped-up rock'n'roll; Ralph Lauren's ersatz pukka British; Georges Marciano's bimbo Western. Benetton abandons any pretense. This is it, kids: you really live like this, in the middle of an epidemic, with the news coming at you from all sides.

Counting on a newly active group of (mostly younger) consumers who prefer their corporations socially concerned, Benetton plunks down

its logo atop flood and fire to stress its awareness. This is not a departure but an uncomfortable compression of the goodwill-seeking news sponsorship visible on public TV every day. Logos like Pepsi's and AT&T's round off accounts of scandals and collapsing republics on shows like the *MacNeil/Lehrer Report*.

America is already afflicted with what might be called logolalia. Never mind the ads and packaging; people are also walking logos. Some years ago, women of a certain economic stratum stopped wearing their own monograms and started wearing other peoples'—Chanel, Yves St. Laurent—in large letters. The advent of the T-shirt as sportswear for the millions transferred a lot of brand-name product ads from the workingman's back to others'. How many young people have you seen lately whose chests hype the Hard Rock Café?

Now, images also carry logos. A good number of newspaper photographs of the Persian Gulf War or the William Kennedy Smith trial were marked "CNN" in the lower-right corner. On television, movie scenes suddenly and briefly sprout the letters TNT or TBS, and news footage occasionally blooms with a network trademark: name-brand clothes, entertainment, and news.

Will people now think Benetton the proper apparel to wear to a terrorist bombing? Whatever its sales potential, the new campaign has sparked intense discussion about AIDS and about the company itself. The company estimates that, with its ads running worldwide and the media covering the controversy, between five hundred million and a billion people have seen the AIDS image, far more than ever saw it when it first came out in *Life*. Conceivably, Benetton has created the most up-to-date news venue of all. A public that is reading fewer newspapers and believing fewer broadcasts might begin to swallow tiny doses of information between the ads for liquor and lingerie.

Name recognition counts. Luciano Benetton, founder of the company, ran for senator in the April 1992 election in Italy—and won.

New York Times, May 3, 1992

GETTING, SPENDING, AND PHOTOGRAPHY

Wordsworth thought that making money and buying goods damaged the spirit—"Getting and spending, we lay waste our powers"—and Wordsworth did not even live through the 1980s. Those who did without slipping over the poverty line either made a fortune in junk bonds or heard the basic capitalist commandment grow loud as a bass amplifier: "Thou shalt want more and more." The commodification of just about everything, a trend set long ago, swelled in that decade to a kind of Wagnerian climax. Art, far from being exempt, had already become an investment vehicle and went through boom and bust cycles as if paintings were the Nasdaq composite. Photographs tagged along for the ride.

Before there was even an art market for photography, the camera was deeply implicated in the commodification business. In the nineteenth century, photographs contributed to the translation of personality into consumer merchandise that came to be called *celebrity*. In the 1920s, when advertisers realized how effective they already were in whetting appetites, photographs became central to the selling of desire. Then in the 1980s, just as large numbers of photographers were deciding to critique the consumption of reproducible images, the market finally decided that photographs were worth money and turned them into commodities too.

The exhibition "Commodity Image," at New York's International Center of Photography Midtown, attempts an overview of photography's many-sided engagement with commodities in the decade when shopping was life. This is a smart and thoughtful show, a bit too ambitious—it lets some extraneous matter slip in—and a little dry at times, but saved by some clever choices and humorous artists. It puts plenty of irony and a few sweet paradoxes on the wall, which seems only fitting at a time when postmodernism keeps marching boldly through the galleries in the face of repeated obituaries.

JIM STONE, *Pricerise*, 1981

The show begins with the game of *la ronde* that art and commerce play with one another. While photographers and artists such as Richard Prince appropriate advertisements for their art, advertisers hire photographers to make their wares look artistic. The advertisers also appropriate artists' styles without asking any more permission than artists do when they do the borrowing. (When commerce takes a leaf from art it is usually called stealing. One would suppose that artists who hold to the theory that originality is no longer possible and authorship an outmoded concept should not complain if they are ripped off.)

Barbara Kruger's case is instructive. She appropriates images from advertisements and other popular-culture sources, then combines them with slogans that might be ads subverted. Hers is a strong and easily recognized graphic style, and she has designed covers for *Esquire*, *Newsweek*, and *Ms.* magazines, all on view here, thereby gaining a mass audience for a style that derives from mass media. "Commodity Image" also showcases a *New Republic* cover by an unidentified designer, published "with apologies to Barbara Kruger," that on first glance certainly looks like her own.

The signature style of the artist thus becomes a commodity easily knocked off at a fraction of the price. At least the *New Republic* apologized—a recent spate of blue-jeans advertisements on bus shelters had no fine-print gallantries addressed to Henri Matisse. Advertisers appropriate from everywhere, even from the news, as is astutely pointed out in the exhibition with a group of Benetton ads (although these images of floods, car bombs, and people with AIDS sit uneasily in a section called "Work and Labor" that itself fits awkwardly into the show's theme). The whole history of images and styles is available in one form or another—a kind of Salvation Army for the artless.

The commodification of art, troubling to artists for years, rolls quietly along like a steamroller. Site artists in the late 1960s traveled to remote areas to avoid the museum taint, yet their plans and photographs ended up on museum walls. Photographs joined the commodities list when their market began to resemble trading in pork-belly futures; this process is concisely traced at the ICP. A 16-by-20-inch print of Ansel Adams's *Moonrise, Hernandez, New Mexico*, thought to exist in more than one thousand versions, jumped from $1,200 to $16,500 between 1977 and 1979, went down to $5,500 in 1982, then up beyond $20,000 in 1991. The iconic stature conferred on *Moonrise* by critics and cash made it the subject of parody (an

earlier form of appropriation): John Pfahl's *Moonrise Over Pie Pan, Capitol Reef National Park, Utah*; Jim Stone's *Pricerise*, with a barcode on the famous image.

The market itself was a target for parodies, some not wholly intentional. Mitchell Syrop's *Junk Bond* was bought for the corporate art collection of a savings-and-loan association, yet another proof that the critical thrust of art today is generally dulled because collectors find it so charming. The bank went bankrupt, probably because it invested too heavily in the real thing, and was forced to sell *Junk Bond* at auction.

Andrew Bush lucidly lays out the rationale of the art market with color photographs of stacks of bills of different denominations. The $1 bill is a unique print and costs $1,000. The $1,000 bill, however, comes in an edition of one thousand and therefore costs only a buck.

The hottest items of all are the names—the artists themselves. David Robbins draws up a stock certificate that allows the owner to invest in "The Future of David Robbins." Lots of zeroes after their price tags turn artists into prestigious logos of themselves. There are "Artkards," a deck of thirty-two baseball-card-like images of artists, curators, and collectors. (Alas, no bubblegum.) Jean Pigozzi, on the other hand, awards himself an ersatz fame by taking his own picture with real celebrities around the world, as if he were a traveling restaurant and each star who dined with him gave him a photograph for his wall.

Photography having been complicit in the fame game, some of the perks of celebrity rubbed off on photographers themselves. One of the real kickers in this show is the press kit for Photo, Fragrance for Men: "The Lagerfeld Photo Man shoots and directs the scenes of his own life. Passion. Success. Energy. Challenge. Ecstasy. Conquest." You find that dubious? "The camera never lies." (This may be the last publication on earth to make that claim.)

When it comes to commodities, Cindy Sherman has the Final Word: a Limoges porcelain soup tureen that replicates a pattern designed for Madame de Pompadour, in a pink that would make toothpaste envious. La Sherman in a Pompadour guise, her eyes closed as if caught at the wrong moment by the camera, is reproduced four times on a tureen that must be meant for mock turtle soup: the artist as royal mistress and powerful arbiter of society; a photographic image inserted into a pattern that predates photography; a costly, prestigious porcelain made more valuable by a costly,

prestigious artist couching the whole enterprise in terms of a rather low-rent spoof.

Of course the faces of aristocrats and kings have often adorned china; the tradition of celebrity commodity dinnerware has been unfairly neglected by scholars. The most recent piece I know about boasted a tender image of Charles and Diana—perhaps a limited edition.

<div align="right">

New York Times, May 30, 1993

</div>

DOCUMENTING POVERTY

The poor are always with us, almost always visible, and yet not always seen, and it has repeatedly fallen to writers and photographers to bring them to public attention. Nineteenth-century novelists such as Dickens and Balzac captured the lives of those who were indentured to the Industrial Revolution and revealed them to those who had profited from it. At the end of the century, photographers stepped in, but in the aftermath of World War I, as prosperity rapidly advanced in America, poverty retreated from sight once more.

The Depression brought it roaring back, with photographers in its train. Another World War produced another period of prosperity and silence, then in 1962 Michael Harrington made the poor visible again by pointing out their invisibility in *The Other America*. Today, of course, the urban poor are always in view. Some say too much so.

Many of the well-off are willing, even eager, at least to look at images of the have-nots, so long as they are elegantly presented on museum walls. And certainly images of poverty, past and present, have been on prominent display in museums and galleries in Manhattan recently. Jacob Riis's slum dwellers, Dorothea Lange's Depression-era pictures, Sebastião Salgado's (poor) workers, and Andres Serrano's portraits of the homeless are all on view, and Ben Shahn's work was up until March. The great campaigns of photographing the poor—Riis, Lewis Hine for the National Child Labor Committee, the Farm Security Administration that employed both Lange and Shahn in the 1930s—were all efforts to alert those who were better off about the problems of the poor in order to alleviate them. Riis, Hine, and Lange believed that well-informed people would be moved to action, and the photographs of all three did in fact contribute to legislated change.

Photographers no longer have the luxury of this credo. Television, and films like *Hoop Dreams*, have the audience now, magazines have space only for celebrities, spectators have compassion fatigue, conservatives have the votes. Yet these shows, appearing together coincidentally, suggest real concern about the problem—and a wish to deal with it at arm's length.

JACOB RIIS, *Lodging in a Bayard Street Tenement—*
"Five Cents a Spot," ca. 1890

Social-reform photography moved into museums in recent years, as art has begun to absorb new categories, museums try out new roles, and documentary photographers adopt artistic modes. The august setting distances the work somewhat, and the repeated choice of photographers firmly lodged in the past sidesteps any need for action. (Salgado's photographs are quite current but literally distant: China, Rwanda, Bangladesh.) The question is: if hearts have grown indifferent under a barrage of images, do photographs in fine surroundings salve the conscience by stirring up just enough sympathy to assure us we have paid our emotional dues?

The camera's engagement with poverty mirrors the history of society's involvement—so it is not surprising if photography today shows signs of disengaging. Riis first united photography and reform around 1890, just as social-reform movements gathered strength in America and people grew nervous about the threat of crime and disease from overcrowded tenements. A crusading reporter who took up a camera solely to bolster his fight against the slums, Riis was instrumental in getting some of the worst torn down.

His pictures worked partly because people were beginning to realize that all of society was interrelated and to believe the citizenry had a responsibility for the poor. They also worked because his viewers had never seen anything like them. Nineteenth-century illustrators had always tidied up poverty; Riis's compositions were dark and cluttered and raw, like his picture of men crammed into grimy, unauthorized lodgings. Sometimes women fainted when he showed his slides. It is hard to imagine photographs having such impact today; photography's very success has undermined its power.

All the sins that documentary photography is heir to—its inclination to intrude, exploit, sensationalize, distance, and patronize—can be found in Riis's work. He burst into the lodgings of the poor without warning in the middle of the night. He promoted the cozy conviction that poor people were best avoided. "The beauty of looking into these places without actually being present there," he wrote, "is that the excursionist is spared the vulgar sounds and odious scents and repulsive exhibitions attendant upon such a personal examination."

Some recent critics have condemned Riis for appealing to middle-class fears of disruption from below. In fact, the progressive movement of social reform relied heavily on such appeals, and if the intentions .nd approach were impure (and they were), a good deal of reform was

accomplished for the first time, and there is no record of any poor person refusing better housing because the motives behind it did not come up to scratch.

Some of Riis's photographs, which he cropped, have been reprinted full-frame in this exhibition. They are even more chaotic. One is vertically bisected by a pole seen so close-up it has neither base nor top; photography would not consciously present such obstacles until the Modernist 1920s. Riis's inelegant rule-breaking gave his work power, but he knew this pole was "wrong." A century later, it stirs our admiration.

New art always forces us to see the art of the past differently, but our fascination with Riis's unwitting Modernism also betrays an attachment to style, which today has begun to edge aside subjects in importance. In his company, the five contemporary photographers whose work is on view with Riis's at the Museum of the City of New York (Martine Barrat, Fred R. Conrad, Mary Ellen Mark, Margaret Morton, and Jeffrey Henson Scales) often looked like formalists in search of distinctive signatures.

During the Depression, the nation was united in a sense of common humanity and social responsibility. Lange's photographs of migrants and rural workers, compassionate and moving, succeed in part because she was confident the audience shared her feelings. Nicely balancing emotion and discretion, she expressed a communal belief in pluck and endurance in the face of overwhelming troubles.

Misgivings about documentary photography crystallized in her day. When Walker Evans went south with James Agee to photograph sharecroppers for *Fortune*, Agee wrote: "It seems to me curious, not to say obscene and thoroughly terrifying, that it could occur to . . . an organ of journalism, to pry intimately into the lives of an undefended and appallingly damaged group of human beings . . . with a conscience better than clear, and in the virtual certitude of almost unanimous public approval." Agee charged on, bearing his guilt like a banner.

In hindsight, no photography of the time was entirely untainted by the sins of documentary. Shahn considered himself a worker like his subjects and identified with them; his photographs have a quiet humility of observation and a basic trust in the worth of ordinary people. His widow says he "could not tolerate the idealized figure of the 'worker' or the 'downtrodden' that in the early 1930s were becoming a distinct theme in the art world." (In this light, Lange's occasional use of a low angle and of figures silhouetted against the sky looks suspiciously stereotypical.) But Shahn him-

self often used a right-angle lens, the kind that lets you photograph people unobserved while apparently looking in another direction. Nothing could be more obviously exploitative, not to say deceptive, although in Shahn's defense it must be said that he did not catch people off-guard in order to belittle them.

By the 1970s, critics like Susan Sontag were excoriating documentary photographers and photography itself for exploiting the poor and turning them into objects of dubious beauty. Allan Sekula decried the cult of authorship, auteurism, and personal expression that had grown up around Diane Arbus and extended to art photographers and professional documentarians: "At the heart of this fetishistic cultivation of the artist's humanity is a certain disdain for the 'ordinary' humanity of those who have been photographed."

Not an entirely new complaint, this has a certain ring of truth. In Salgado's splendidly but repetitively composed pictures, his command of light, recognizable style, and relentless drive toward idealization take center stage, leaving the workers to play assigned roles in a drama where the photographer is the real star. Serrano, doubtless aware of the narrow line between advertising and polemic, balances on it and falls over. His large, jaunty, color portraits of the homeless look like advertisements for the newest grunge fashions, reminding us that advertising is becoming the culture's primary visual reference.

Photography in any form has an extremely limited capacity to convince those who do not want to be convinced, as the first Rodney King jury made painfully clear. It is also incapable of suggesting complex solutions without the massive assistance of text. By now the medium's power to provoke action has been somewhat dimmed, but it never did operate at all unless the proper response was immediately apparent and relatively simple, as Bosnia proved.

It is bad enough for documentarians to think that photographs cannot provoke action, worse to think they might be substituting for it. Even the museum audience might merely be paying lip service to compassion while hotly pursuing aesthetics. Museums do not do have exit polls on how many of their visitors are angry about welfare.

So, fewer people are documenting poverty. Some newspapers still report pretty diligently on the poor and photojournalists still provide a picture or two for the stories, but it is hard to shine a warm light in a cold political climate. The only real growth area in photographing the lower

classes lies in covering violence. Joseph Rodríguez's pictures of L.A. gangs at ICP include this caption: "The agency asked for more violence in my pictures. Violence sells magazines."

A few photographers seek alternative means and venues. Since the 1970s, some documentarians have insisted on extensive texts in their exhibitions to provide the context and explanations that photographs notoriously lack. Some show in labor halls and other places where art types seldom gather. Recently, New York photographer Mel Rosenthal's pictures of the homeless were displayed in the lobby of the Syracuse Stage while Dickens's *A Christmas Carol* was playing; close to sixteen thousand people saw both shows.

Some have even tried giving people who are always on the wrong side of the lens the means to shape their own images. Since 1985, Wendy Ewald has been teaching impoverished children from Appalachia to India to take photographs of their families, their lives, and their dreams. In 1991, Jim Hubbard published a book and organized an exhibition of photographs by children living in shelters; the children documented a more playful and upbeat life than their better-off elders did.

The 1980s are gone, when student photographers were so eager to forge their empathy credentials that sidewalk-dwellers in New York were more likely to get a decent portrait than a decent meal. Now the favored subjects are hotter, trendier, and safer artistic nudes—not so safe if they are underage—and the latest digital art, in fancy combinations. Right now, futures traders in photography are placing bets on the computer rather than on the poor. A shrinking cadre of documentarians soldiers on, trying to wrest information and meaning from pictures of poverty, while frost bites the toes of the poor and the hearts of the rich.

New York Times, April 9, 1995

REFLECTIONS
IN BLACK

When it comes to reputation, good images go down the drain fast. Ask Bill Clinton. Ask Gary Hart. Negative images are a lot tougher; they've got real staying power. Ask Michael Dukakis about the tank, or Edmund Muskie about his tears. President Ronald Reagan, who knew a lot about image power, had a habit of arranging important ribbon cuttings or attendance at charitable events whenever he had just done something unpopular, knowing the good image would be widely broadcast and thus upstage the mere words of executive orders.

Now that the media are assumed to be all-powerful, ethnic and religious groups immediately cry prejudice when negative public images come calling, but for the better part of history, that wouldn't have done much good. Most groups didn't have access to public forums where their complaints could be heard; others wouldn't have been listened to anyway, had they raised their voices. Ask African-Americans about *that*. The recent case of Amadou Diallo (a black man shot forty-one times by cops when he reached inside his jacket—for his wallet) still looked a lot like a moment when an image took over.

"Reflections in Black: A History of Black Photographers, 1840 to the Present," an exhibition at the Arts and Industries building of the Smithsonian in Washington, D.C., is a history with a provocative notion at its core: that at various times, but most pointedly in the first several decades of the twentieth century, American blacks used photography to resist the image the dominant culture imposed on them. Without a common program, perhaps even without a fully conscious intent, people all over the nation devised a way to see themselves as they were or wished to be, no matter what the white society had in mind.

This idea isn't entirely new, but it bears repeating. Nor is this the first historical show of black photographers in America, although it is by far the largest and most wide ranging. In "Reflections in Black," Deborah Willis, Curator of Exhibitions at the Center for African American History and Culture, has assembled more than 300 images by 120 photographers, many

C. M. BATTEY, *Portrait of Booker Taliaferro Washington
(1856-1915)*, ca. 1908

previously unknown or little known. Ms. Willis's book by the same name (W. W. Norton, 2000) is the first comprehensive history of its kind.

Shows based on ethnic or gender identity prompt the question: doesn't the photography matter more than the color (nationality, ethnicity, gender) of the photographers? Yes, but this photography was scattered, and it remained virtually unseen by the larger culture for years, because it too was segregated until after the civil-rights era. The black press printed the picture of fourteen-year-old Emmett Till's battered face after he was brutally murdered by whites in 1955; the white press didn't. The 1982 edition of Beaumont Newhall's *The History of Photography* did not include a single black photographer; the 1984 publication of Jonathan Green's *American Photography: A Critical History* did not either.

Earlier, the black image was distorted by ideas. In the nineteenth century, a theory got loose that dark skin was a sign of genetic inferiority. At mid century, even as black daguerreotypists in the North photographed black men in frock coats and women in elegant dresses, Louis Agassiz, the Harvard anthropologist, commissioned photographs of naked slaves meant to reinforce his ideas about the defects of their race. The best *Frederick Douglass' Paper* in New York could do was to write of a Cincinnati studio, owned by a black photographer and hugely successful with both black and white customers, that it was "one of the best answers to the charge of natural inferiority we have lately met with."

Cartoonish and stereotyped images of African-Americans, all of which took for granted subordinate status and intelligence, continued well into the twentieth century in minstrel shows, postcard pictures of lazy fishermen and watermelon eaters, films, ads, jokey salt shakers and cookie jars. Not to mention the dehumanized view of blacks that made lynchings possible—chillingly evident in the "Without Sanctuary" show currently at the New-York Historical Society, and in the book of the same name from Twin Palms.

This was tantamount to visual warfare against a group that could not fight back. Creating dignified images within that group was one means of defense. And cameras in black hands bestowed the precious gift of shaping one's own public persona rather than depending on others, or submitting to them—although it's still a pretty safe bet that more images of blacks have been made by whites than of whites by blacks.

Being able to shape one's own public (and private) image is the beginning of empowerment. Family snapshots are not included in "Reflections

in Black" for obvious reasons, but black homes were full of them, and as family snaps do, they constructed, sometimes concocted, stories about good families. Pictures of past generations must have a particular importance to African-Americans; they propose an alternative to the genealogy of slavery.

Control over the images of others exerts control over the way they are regarded and influences the way society treats them. During World War II, American posters pictured the Japanese as "yellow devils," encouraging a degree of generalized hate that made the heavy losses in the Pacific more bearable and the internment of Japanese-Americans more nearly acceptable. On another level, the Nazis repeatedly identified the Jews as *schweinhunde*, "filthy swine," a tag that branded them less than human.

In 1992, Roger Wilkins wrote that blacks were mistaken to believe that the power to segregate was the greatest power used against them. The real weapon, he said, was "the power to define reality where blacks are concerned and to manage perceptions and therefore arrange politics and culture to reinforce those definitions." "Reflections in Black" offers evidence that from the later years of the nineteenth century on, as more African-Americans were educated and financially successful, they worked at least within their communities to redefine their realities and manage their own perceptions.

By then, as images spread and gained power, photographs were a common instrument for mild self-aggrandizement and the kind of self-invention that pervades so much studio portraiture and so many family albums. But African-Americans had more than the usual reasons for wanting their successes commemorated, and fewer places to display them. If the white world did not see documents of black pride, the record was always visible to the people it depicted, and it must have been a silent support as well as a counterweight, perhaps even a gesture of defiance, to the postcards and salt cellars out there.

A wall text for "Reflections in Black" notes that most of the photographs are not about race, because African-Americans were not obsessed with race. Like everyone else, they were probably more preoccupied with earning a living, raising a family, and making a life within or against whatever limitations hemmed it in. Among blacks in the first part of the twentieth century, there was a division between Booker T. Washington's call for accommodation to the status quo and W.E.B. DuBois's appeal to struggle for equal rights, but just about everybody wanted the good life as Ameri-

cans saw it. It is one of the small ironies of history that a dominated people so often yearns to be like those who dominate; to judge by the photographs, the black community, withdrawn as it was from the white community and essentially invisible to it, still imitated it in many ways, at least in the externals of dress, possessions, rituals, even class structures.

By the 1930s, photojournalism had moved to the forefront, and the civil-rights movement in the 1960s made it an imperative for African-Americans such as Jonathan Eubanks, Joe Flowers, Robert L. Haggins, Moneta J. Sleet, Jr., and Ernest C. Withers. By then it was impossible *not* to be obsessed by race.

Many liberal, white photographers and a few blacks viewed that conflict from the black viewpoint in the early years, providing the press with brutal images of white attacks. After the mid 1960s, when the Black Power movement excluded longtime white supporters and African-Americans rioted and fought back, the camera viewpoint shifted to the position of whites facing attack from blacks, and blacks were pictured more as aggressors than as victims, a subtle change in news reports that must have influenced the way a changing reality was seen.

"Reflections in Black" includes very few purely artistic photographs before the 1970s, art photography being a poor way to earn a living, as even white photographers knew. Racism would have made a hard course even harder, so black photographers assigned themselves other tasks. Today, redressing racial grievances, or just bringing black life into the light, has become a primary task—heavy work, which has been known to produce art that is heavy too, rather than weighty.

But good images as well. Recent documentary photographs by people like Chester Higgins, Jr. and Marilyn Nance respectfully explore the role of religion among African-Americans. The art photographers are often feistier. Pat Ward Williams uses images, text, and objects to address the choices presented by light skin color; Amalia Amaki spells out the central role of photographs in black families by printing family snapshots on a cotton quilt; Albert Chong, who is half-black and half-Asian, attempts to reconcile his double heritage on paper. Carrie Mae Weems comments pointedly on art and artists' models in a five-part series of herself, sometimes naked, seen in a bedroom mirror. One caption reads: "It was clear, /I was not Manet's type/Picasso—who had a way/with women—only used me/& Duchamp never even/considered me." This might be a femi-

nist complaint about the way male artists regarded their female models—
or a black woman's observation about the place of black women in the early
years of Modern art.

"Reflections in Black" brings up a number of facts that will be little
known to whites. Item: Jules Lion, a black man who had emigrated from
France, was the first daguerreotypist in New Orleans, taking pictures
by 1840. (Unfortunately, none survives.) Item: during the 1840s, there
were fifty documented black daguerreotypists running galleries in Ameri-
can cities.

By the 1850s, African-American photographers showed in group exhi-
bitions and took home prizes. In the 1860s, as more African-Americans
moved from rural to urban areas, ads for black photographers and printers
(and for some white photographers) began to appear in black newspapers,
which obviously served a sizeable population that read the paper and could
pay to be commemorated.

J. P. Ball, a black abolitionist in Cincinnati, photographed the white
abolitionists in his city in the 1850s. In fact, although race is not always
identifiable from appearances, it is clear that before the Civil War and at
some points after it, black photographers had white patrons, and some-
times a lot of them. For Northerners who had abolitionist leanings, it might
have been a point of pride to frequent a black establishment; in other cases,
the African-American studio may simply have been the best one around.

African-American photography grew in stature, variety, and artistry
as blacks began to form their own societies late in the nineteenth century
in response to hardening racial attitudes and Jim Crow laws. Morehouse
College and Howard University had been founded two years after the Civil
War; other black colleges soon followed, and by 1897 black intellectuals
had founded the American Negro Academy. Three years later, Booker T.
Washington organized the National Negro Business League. A new elite
prospered in the first decades, and talented photographers like Addison N.
Scurlock, C. M. Battey, Florestine Perrault Collins, P. H. Polk, James
VanDerZee, and James Latimer Allen signed on to make them look good.

In 1900 the census listed 247 black photographers; in 1930 it listed
545, an increase of close to 225 percent. With their cameras, they docu-
mented not just men wearing boutonnieres, women in dressmaker gowns,
and children in lace-trimmed dresses, but typewriting clubs and high-school
cooking classes, college commencement days, businesses, Emancipa-

tion Day parades. (Emancipation Day was celebrated by blacks all over the country.)

They clearly believed Marcus Garvey when he said "Black is beautiful" back in 1910. They did not, could not, establish a good image for African-Americans in the culture at large, yet it is just possible they helped prepare the ground. It is easier to stand up tall if your self-image says you should, and easier to fight for your rights if you are standing up to begin with.

<div align="right">

New York Times, April 9, 2000

</div>

A DOGGED
ATTEMPT
AT HISTORY

Photography has gone to the dogs. Hundreds of them. Taschen has unleashed a book that the press release calls "a completely original history of photography told through images of canines."

Now, a canine history of photography is indubitably unprecedented as a means of tracking photography's long run through the swamp of disdain to the high ground at Sotheby's. We have had photo-history as a branch of art history, as a progression of masterpieces, as social history, Marxist history, and capitalist history in disguise. We have had histories of the photography of this or that country or continent, of women photographers and black photographers and many another category, all illustrated with photographs of great men, naked women, railroad bridges, and starving sharecroppers. We have even had collections of dog photographs, but never, ever a history told through images of canines.

I hope I do not shock you, gentle reader, if I reveal that the press release exaggerates a bit. *A Thousand Hounds: The Presence of the Dog in the History of Photography, 1839 to Today*, edited by Raymond Merritt and Miles Barth, is not much of a history of photography. Oh, after every twenty or thirty years' worth of pictures there are two or three pages relating several decades' worth of the history of photography, the history of dogs, and the history of world events and culture, but really, it would be a bitch to learn photographic history this way. However, smart readers will probably notice a historic progression of sorts from the nineteenth-century dogs befriending either dressed-up children or undressed women to a Soviet dog in a spacesuit and a pink poodle with orange eyes photographed in 1986.

Even the title is an exaggeration. There are no more than four or five hundred animals here, though admittedly that is a goodly pack of pooches. Most of them you have never met before, but now you should, especially if you are dog tired of cats. Indiscriminate in their tastes, dogs pose happily with Jayne Mansfield, John F. Kennedy, or the homeless. They dress

ELLIOTT ERWITT, *New Jersey,* 1971

up like spiffy Edwardian gents. They walk tightropes, suffer war wounds, jump over vacuum cleaners, look soulful, do impolite things in the street. Some are shaggy dogs and some are dirty dogs and some ain't nothin' but hound dogs, but all are more photogenic than thee and me, and more immediately lovable.

They are accompanied by quotes from philosophers through the ages. "Some of our greatest treasures hang on the walls of museums, while others are taken for walks" (Anonymous). "Outside of a dog, a book is a man's best friend. Inside of a dog it's too dark to read" (Groucho Marx). "Yesterday I was a dog. Today I am a dog. Tomorrow, I will probably be a dog. There's just so little hope of advancement" (Snoopy, whose motto should be *Semper fido*).

Reader, *cave canem*. You are likely to be either bitten or smitten.

If I may interject a personal note, I am working on a history of art that is similarly thematic, although mine will be told through images of mollusks. This history is of course far more extensive than anything that can be compassed in photography alone. For instance, in classical and medieval times, Venus and St. James were both identified by shells (although the iconographic meanings do diverge somewhat). The seventeenth-century Dutch still-life painters lavished an inordinate amount of expressive brushwork on oysters, which connote not only the robust economic condition of their patrons but also the transient nature of life. Chardin's painting of a pussycat tempted by glistening bivalves is emblematic of the deadly sin of greed. In the twentieth century, as the simple pleasures of the table were replaced by complex fears of clogged arteries and polluted beds, mollusk as food was replaced by mollusk as form (cf. Georgia O'Keeffe's empty clamshells). Anyone with other pertinent examples kindly get in touch.

New York Times, December 17, 2000

THE BODY
OF OUR
DESIRE

T he body is the heart's desire, and the eyes'. Eyes have never been monogamous; together with the imagination, they can generate more desire than the limited body in its meager lifetime could hope to satisfy. It is curious that, although the real article is certainly best when it comes to desire, the eyes can cause men to go mad over substitutes. In ancient Greece a citizen fell so in love with the marble Venus of Cnidos that he stole into her precinct to embrace her and had to be pulled away. Nor is realism necessary to spur temptation. Ingres in the nineteenth century and Gaston Lachaise in the twentieth depicted women as seductive as the promise of bliss, yet one endowed the female form with too many vertebrae and the other with the pneumatic heft of a balloon. The eyes demand neither reality nor realism. They remain enchanted, loving a fairy-tale as easily as an actual document.

In fact, eyes tend to require more beauty than mind or heart or hands do. Until the invention of photography, bodies in art were made to conform to one ideal or another, whether the tapering grace of Mannerism or the rosy delicacy of the Rococo, but they were rarely shown as nature had decreed them. The camera, which early focused on the nude, came into immediate conflict with the ideal. People complained that the bodies photography offered them were inferior. It was an age that thought real bodies indelicate anyway. In England, discreet people went so far as to cover the legs of their pianos. In France, the emperor was so offended by one of Courbet's paintings of an overnourished nude that he struck it with his riding crop. A society that was having realism thrust in its face was not ready to look at it.

Yet the camera did not hesitate. If *Nude: Photographs 1850–1980* (Harper and Row, 1980) is any indication, it started out strong with pornography. This would not be surprising. Pornography reduces the human being to an object with an exclusively sexual function, so that it can be possessed in fantasy. Hand-colored daguerreotypes and stereos seemed to give flesh

WAH LUI, *Untitled*, 1980

to fantasy, scaling down the object of desire to the size of a bauble. Several of the most openly sexual pictures in this book are of bodies that do not quite meet the standard of their day. In matters of sex, if not in art, men were willing to settle for the real in place of the ideal. (Oddly, in our own time, when sex is no longer secret, the magazines that sell sexual arousal to a large male audience insist that the women conform to a single body type.) The camera has recorded changes in type that fashion legislated for female bodies, and even for males. One of Thomas Eakins's slim art models has the exaggeratedly incurved back and outthrust rump that corsets and clothes imposed in her day.

There are other changes visible in these pages. The most profound is the radical new attitude to the body that modern thought and Modernist art effected. In a minor way, it was set off by Degas. Two beautiful photographs attributed to him follow his stated principle of seeing women as if through a keyhole. "The nude," he said, "has always been represented in poses which presupposed an audience, but these women of mine are honest, simple folk, unconcerned by any other interest than those involved in their physical condition." These women are caught unaware, with neither presumptive glory nor expectation of admiration. No longer is woman a goddess in perfect poise; the ideal human being as exemplary image begins to edge away from the center of the imagination. Darwinism and Freudianism, which undermined man's kingship over the animals, plus related developments in thought and science, eventually dethroned mankind from the traditional, supposedly central position in the universe. The consequences were boldly stated in art by Picasso and the Cubists, who broke apart the integral figure, rearranged the creature made in God's image, and insisted that backgrounds need not stay back but could be equivalent to human beings. Ideal humanity and the ideal figure were cut loose from their moorings.

Photographers were slow to follow the lead of art in this as in so many other respects, but in time they did so. In the 1920s, Margrethe Mather snipped the body up into a pattern no more important than the robe it wore. Hans Bellmer, that malevolent Surrealist, concocted an insectoid doll with four female legs, no head, and a navel for center. Even Edward Weston, so hotly pursuing an ideal, no longer looked for a purely human reference. He forced the female body to assume perfected shapes that had little relation to the body's natural states or performance. That is one reason some

of Weston's nudes are so cold. It takes rampaging fantasy to imagine making love to a polyhedron, no matter how firm its flesh.

André Kertész, with his wry comments on the female form, and Bill Brandt, with his serious regard for the individual, both consider the body with such affection that they depict it in tender human guise despite their Modernist displacements. Appropriately, there is a good deal of loving sensuality in this book. It is most handsomely printed and designed, with good essays by Robert Sobieszek and Ben Maddow. There may be a few too many pictures we have seen before, but there are good surprises, too: a demure and serene Roger Fenton, a Brassaï *poule* in a state of illogical undress, a ripely witty František Drtikol, which combines pears, juicy cutout curves, and a nude in a cloche who holds her own against the competition chiefly because the photographer and every element in his picture are so devoted to her body.

Constance Sullivan, the editor of *Nude: Photographs 1850–1980,* has diligently searched out a large number of male nudes. Many in the last century were entirely documentary, for medicine or the military. Attitudes have shifted so fundamentally that the most traditionally beautiful and ideal body in the later part of the book belongs to a young man photographed by David Hockney. One major surprise in these pages is the number of children's bodies photographed in the last sixty years, from Imogen Cunningham's twins and Weston's son to Dorothea Lange's young adolescent, George Platt Lynes's niece, and Sheila Metzner's girls. There is no denying the sensuous, if not sexual, appeal of these children, strong enough to make me recognize, uneasily, some of the allure of child pornography. The children are viewed directly, without the obscuring overlays of Modernism, but with an old-fashioned delight in the beauties of flesh and form. That could not be said about the more recent examples of the adult female nude. It's almost as if photographers today weren't sure how to approach a grown woman. Could the female nude be a worn-out subject?

New American Nudes: Recent Trends and Attitudes (Morgan and Morgan, 1981) whispers a tentative "yes." The book, edited by photographer Arno Rafael Minkkinen, enshrines the postmodern body, which is no longer pure and seldom beautiful. Among the photographs in this book are some that still assume that bodies are good to look at and live in, but sex and beauty have become decidedly secondary. The nude itself may not be the point of the picture but only nominally the subject; the real subject is the photographer's aesthetic allegiance. Bodies exist principally as excuses for

tableaux, for obvious symbolism, rather uninventive abstraction, elaborate light play, or color experiments. It is style, rather than substance, that has become truly polymorphous perverse.

In the age of liberation, we might expect to have more nudes served up in more different ways. The body is almost overexposed in the popular press, what with playmates dimpling between the magazine staples, the Maidenform woman getting out of a taxi in her undies, and famous athletes strutting in their Jockey shorts. A photographer might well feel pushed to the limits of inventiveness, but these are not necessarily the borders of art.

Degas said some time ago: "The novel captivates and bores in turn." Whatever photographers seek, a new way to view an old subject is simply not enough. Happily, there are photographers here who come up with fine pictures, both of an old-fashioned and a newer persuasion. I wish there were more of them. Among my favorites were Dianora Niccolini's complex, shimmering, black male nude, Levon Parian's eccentrically posed and colored image of a bad sunburn, and John Gintoff's pattern painting gone sexy.

It may come as something of a relief to the majority of humankind to see that certain photographers find the less-than-perfect body perfectly acceptable. Indeed, the taking of nude portraits, in which the subjects wear their everyday bodies, almost amounts to a movement by now. (Bill Brandt's sympathetic nudes lie behind this trend.) Minnette Lehmann penetrates more than clothes this way; Wah Lui makes a pointed comment on a woman standing next to her bridal picture. Once upon a time, nude portraits were the prerogative of the rich and royal, who compared themselves to gods by having their faces painted atop ideal bodies. In our confessional era, uncelebrated and unwealthy strangers bare their bodies to us as some of them tell their lives on first meeting. We end up aware of their secrets, but knowing them not at all.

What is most surprising about this book is that in more than one hundred pictures there is so little sexual charge. It lurks there, gleaming from flesh and curves, but hemmed in by the arty, the intellectual, and the dispassionate. It's as if the permissive society had granted us easy nakedness but made sex more elusive. The nude as a means alone is either pornographic or incidental. Where is the body of our desire? Covered, alas, by the earnest trappings of forced originality.

American Photographer, October 1981

LEE FRIEDLANDER'S NUDES

Lee Friedlander's career has evolved more by changes in subject than shifts in style; that's true for most photographers. Friedlander's vision was established early; he merely elucidated it and elaborated on it over time. It is a vision that has absorbed the lessons of Cubism, with its overlaps, transparencies, and fragmentations, its simultaneous views of what is in front and what is behind, its use of letters and patterns to insist on the two-dimensional surface. Yet Friedlander's work is pointedly, resolutely photographic. It is not so much about what the eye sees as about what a handheld camera with a fast shutter speed sees—transitional movements, momentary reflections, odd bits of cityscapes viewed from angles seldom lingered over, and the ironies of chance juxtapositions.

Friedlander carried this style with him when he went to look at American monuments and factory workers and to an extent when he stared at landscape as well. The style lends itself more readily to some subjects than others, and can too readily grow diffuse, but it flourishes in a new show called "Lee Friedlander: Nudes" at the Museum of Modern Art in New York, and in a book, *Nudes* (Pantheon, 1991). This last show under John Szarkowski's aegis celebrates an aesthetic so identified with his directorship, from the 1967 "New Documents" show (which included Friedlander) to the present, that the choice seems foreordained, and it is fitting that Szarkowski should bow out with this surprising variation on a style that has become a near-classic with his support.

A classic in the sense of a touchstone, a source, and a standard, the Friedlander style is anything but classical. Many of the nude images are rather stridently anticlassical, replacing wholeness, grace, and the accepted ideals of bodily perfection and beauty with ungainliness and rude detail. Often they refuse to offer even the classical excuse for looking at naked women: erotic enticement. Neither sex nor sensuousness has figured prominently in Friedlander's work, which is more at home in the realms of intellect and wit than in the territories of passion. He is a cool, detached,

LEE FRIEDLANDER, *Nude*, 1979

infernally clever observer. His eye and mind light up when the right elements converge, but he does not visibly lust for the life around him—not for women on the street (as Garry Winogrand did), nor for a man's scowl or a child's smile (as Henri Cartier-Bresson did). *Like a One-Eyed Cat*, the book that accompanied Friedlander's recent retrospective, began with sleeping musicians and ended with a nude with her back turned. *Nudes* begins with a nude seen from the back and ends with one sleeping. Friedlander is ever the unobserved observer, whose subjects slumber while he envisions them.

The nudes manifest all his stylistic traits, including his dispassion. There are plenty of Modernist lessons here, including some post-Cubist distortions, several poses that come about as close as human beings can to exhibiting the front side and back at once (so much simpler for Picasso), even a couple of instances where light and shade break up the body into fragments and planes. Several pictures put an object—in this case a body, or a body part—on the foreground plane where it divides and blocks the view of the room much as poles and streetlights section off Friedlander's city streets. The puzzling and eloquent fragment at the edge of many earlier photographs is now most likely a foot or a breast that has strayed into the frame.

In his street work, monuments, and factory pictures, the human form was merely part of a pattern, perhaps the most prominent part because of our identification with and attachment to bodies, but with no more *meaning* and little more importance than the signs and machines that had an equal claim on the photographer's attention. The nudes generally follow this prescription. Friedlander's all-devouring eye and his delight in the peculiarities of clutter he can frame in his viewfinder set up a near parity between nude bodies and patterned bedspreads. The models, who were paid, posed in their own homes, and we become as familiar with their lamps and radiators and lace curtains as with their ankles and belly buttons. Consider their hair. Friedlander's nudes add up to a kind of disorganized treatise on hair—armpit hair, leg hair, pubic hair, even head hair—in which bodies may be as scribbled over and textured as fabrics. Put a nude in a picture and she (or he) will hold your gaze, but these women, like some of Henri Matisse's more anonymous odalisques, tend to merge with their surroundings. They could be said to be reduced to objects, but not to sex objects.

Friedlander is clearly knowledgeable about art, whether consciously or not. Matisse lives in many of these compositions, as does the memory

of Jean Arp's swelling sculptural forms, and occasional homage is paid to Gustav Klimt and Egon Schiele, Edward Weston and Bill Brandt. The closest Friedlander himself has come to an extensive investigation of nude form before this was when he bought E. J. Bellocq's plates and printed them: pictures of prostitutes, taken around 1912, apparently for the photographer's private delectation. Bellocq's prostitutes are just as comfortable, just as enmeshed in their settings as Friedlander's; they loll and pose on flowered chaises and oriental carpets in the pseudo-bourgeois elegance of their New Orleans bordello. They present themselves to the camera, however, as to a customer, some tempting, some displaying, in black stockings and scanty shifts or masks. Bellocq's gentle Edwardian pictures about sex for money are in some ways more loving than the faintly clinical, strenuously experimental examples of the uninterested undressed in Friedlander's book.

The way this book is laid out (very nicely, with fine attention to the relation of the facing images), makes it look as if Friedlander began with Weston in mind and soon fell back on his own complex, disjunctive aesthetic. The project took twelve years, off and on, but has the coherence of an accomplished style and a unified vision; a key to the achievement of these pictures is that whatever their references, they end up looking like Friedlanders. His essential detachment overrides the effects his concentration on rarely seen parts of the anatomy might have produced; many images are unlikely blends of intimacy and detachment. Most strike me as much more passionate about the way the lens can record forms in their surroundings than they are about flesh.

For all his curiosity about female genitalia, Friedlander maintains his emotional distance. The models not only are totally unembarrassed before him (and us) but some are so relaxed they have fallen asleep. Almost no one looks at the camera, and many are faceless or headless. Despite arduous efforts to spread their legs they make no effort to entice; they seem indifferent to the male regard. Friedlander goes to great lengths to lower the temperature by contradicting the standard sexual appeal of the nude and ends up making photographs that are not so much about sex as about anatomy.

Unlike the male nude, the frontal female nude has genitalia that are still effectively hidden from view, and for most of our history art took pains to keep them so. Greek sculptors not only made the *mons veneris* hairless—for Greek women burned off their body hair with a mixture of spices—but eliminated the central cleft, so that even a woman's visible privates were

reduced to a pure blank geometry. From the Renaissance onward, propriety demanded that art suppress female pubic hair; the ideal woman had neither genitalia nor any disruptive traces of adult sexuality. The story is told of one highly educated nineteenth-century gentleman who was so stunned by the sight of his wife's body on their wedding night that he sued for an annulment.

In the twentieth century, both art and photography acknowledged the existence of pubic hair, but except in hard- and soft-core pornography, the vulva usually remained hidden, as indeed it does in most of life's ordinary postures. (Rodin exposed it rather ingeniously: Iris, the messenger goddess, raised one leg with her hand as she flew.) Friedlander fully indulges his curiosity about women's secret in these pictures, which are so explicit that some men have professed embarrassment at seeing them. They don't embarrass me, nor do I see anything wrong with male curiosity about female anatomy, but no doubt some will think these pictures exploitative and/or pornographic, two words that increasingly elude a consensus definition. The line between art and pornography is extremely thin, as Robert Mapplethorpe made clear, and there are the double issues of the photographer's intention and the viewer's reaction. As to intent, Friedlander's art credentials were impeccable and his models were consenting adults, fully aware of what was visible between their legs when they parted them, and so far as I can tell entirely undamaged by the images. As to reaction, my aesthetic pulse reacted more strongly than the one in my wrist; yours may react differently.

Although I have no moral qualms about Friedlander's preoccupation with women's private parts, it has produced some of the least successful images in the book, images of women putting themselves into improbably acrobatic postures to expose the pudenda. Bending over to touch the floor and raising one leg in the air, or lying on one side with the legs stretched out at right angles from the body—the positions are forced and the aesthetic gain nil. Friedlander may have reinvented the nude, but in these instances and some others he tried too hard, and the machinery of invention creaked.

Poses and composition upset the expectations set down both by art and by titillation magazines, and every suntan mark, every scar and bruise and Band-aid, each mole and trace of arm and leg hair is carefully preserved, so that even the headless figures remind us we are looking at pictures of real women, not sex goddesses or airbrushed fantasies. (The book has four pic-

tures of our latest sex object, Madonna, in an earlier incarnation when she supplemented her income as an artist's model. The new parlor game consists of trying to identify her.) One of the most refreshing aspects of the work from my (female) point of view is that, even though all the women are relatively young, several have a bit too much flesh or fairly small breasts, and would never make it in *Playboy*, yet the photographer apparently finds them all equally interesting. The best images prove to be adventurous reprisals of the female body (I especially liked two odd views of a breast and part of a face).

The mere fact that the clothed photographer coolly dominated his naked subjects makes one pause, but I for one am unwilling to renounce even for a worthy principle such beauties as Titian and Goya and Ingres created. I think Friedlander's insistence that women are both real and various, subject to banging their shins and eating too much, neither made of plastic nor modeled on Barbie dolls, is a step in the right direction. As formal explorations, these pictures work ingeniously; as nudes they often present the body in an unexpected aspect, and they add a new dimension to the work of a man who has not always photographed the human element as revealingly as the manufactured one. Friedlander's career has had its dull moments, but this is not one of them; you might not like these pictures, but I doubt that you will be bored.

Aperture 125, Fall 1991

SEX
AGAIN

Sex again. Sigh.

After Jeff Koons (sex in marzipan heaven), Cindy Sherman (sex in prosthesis hell), Robert Mapplethorpe (sex as 1930s car-radiator ornaments), and Nan Goldin (sex as depression on Avenue B), what's left? Not much, but art and photography are still game. Or gamey, anyway.

Never mind advertising, movies, or memoirs; just about the most explicit sex in town recently has been in the galleries. Last month the Paula Cooper Gallery showed Andres Serrano's large color photographs of kinky couples (perhaps the kinkiest—but that's arguable—was a woman with a horse); Deitch Projects had a whole room full of Beth B.'s photographs, manipulated to look like etchings or drawings, of vaginas; Stux Gallery decked its walls with racy shenanigans in a show called "Sex/Industry" (which did make some maneuvers look like hard labor). A glimpse of stocking it was not.

"The Sex Show: Sex and Eroticism in 20th Century Photography" at Yancey Richardson Gallery in SoHo is a reminder, in case anyone needs reminding, that photographers did not discover sex only yesterday. The show of fifty-one photographs includes pictures from the 1920s and 1930s that may look a bit tame today next to such pictures as Larry Clark's naked teenagers fondling one another (1972) but did not seem so tame back then. Brassaï's 1930s pictures in brothels could not be published when he took them, even in Paris. In 1939 Manuel Alvarez Bravo wanted to put his photograph called *Good Reputation Sleeping* on the cover of an international Surrealist exhibition catalog but could not because censorship did not permit the display of pubic hair.

"The Sex Show" ranges from rather decorous shots of nudes from the back by Edward Weston and George Platt Lynes to Hans Bellmer's disconcerting female doll with two pairs of legs, one upside down atop the other, and no arms or head, to Mapplethorpe's reverent portrait of an erection. If the more recent work seems, well, raunchier, it is worth noting that photography has been pretty explicit about sex practically since the

MERRY ALPERN, *Dirty Windows #28*, 1994

invention of the medium. After portraiture, probably the most successful commercial photographic enterprise of the nineteenth century was pornography. Then it was under the table; now some is on the wall, and sometimes off the wall.

This show has a number of good pictures and more sparks of interest than most of its kind, but it does point up one of photography's (and art's) more astonishing accomplishments in the last several years: they have made sex boring. A couple of decades ago you might have had the romantic notion that that was truly impossible, but the image culture has amazing resources.

Sex and voyeurism have many uses and rationales: procreation, recreation, titillation, and what-can-I-do-for-fun-that-costs-less-than-a-ticket-to-a-Broadway-musical, to name a few. But by now we have practically been force-fed delight, desire, and perversity, all ladled out so liberally by the media, and the art galleries, that torpor has set in. More frontal nudity? Yawn. Another homosexual couple coupling? Puh-leez. More flashers, miscegenation, whips, and pierced body parts? I think I'll go to the market.

Photography has done a number on us. It is edging closer to considering voyeurism a right. Pornographers, *Playboy* photographers, and men like Brassaï who worked with a big camera had to have the cooperation of their subjects, but Merry Alpern photographs transactions in a lap-dancing club bathroom from an unseen perch in a neighboring building, and Jean-Christian Bourcart photographs in brothels with a hidden camera. Privacy? Forget it. Who is going to sue?

A related and astounding change photography has contributed to as heavily as a lobbyist to a political campaign is the near disappearance of shock. It was still within the realm of possibility to find Mapplethorpe's "Portfolio X" repulsive, to feel uncomfortable at the Nan Goldin show at the Whitney Museum last year, and to feel infinitely happier leaving the Serrano show than entering it, but it took some effort to feel shocked, and it was almost impossible to admit it if you did. (Well, not with Mapplethorpe. Jesse Helms was shocked, *shocked*, and in Cincinnati in 1990 outrage was so intense that the photographs were hauled into court, but the art world calmly polished off the last of its margaritas and came to his defense.)

A joke making the rounds says that Southern fundamentalist preachers disapprove of sex standing up because it might lead to dancing, but in all seriousness there is little left that can either rouse the ire of gallery-goers

or startle them. The urge to shock has had so long a run among artists and photographers in this century that urinals and self-portraits as the crucified Christ will not do it anymore, and *le bourgeois* is no longer *épaté* by body hair or parts.

After all, two years ago the Guggenheim Museum displayed Joel-Peter Witkin's painterly photographs of armless, handless, legless, or hermaphroditic nudes and two halves of a corpse's bisected head kissing, so some little old nude with all her appendages intact is not likely to send an art lover screaming to Jack Valenti for a new ratings code. And shows like the two last fall devoted to Pierre Molinier's 1960s fetishistic montages and his photographs of himself with a woman's breasts, hair, and makeup have made cross-gender representations so common that by now they are (forgive me) rather a drag.

When the art kids decide that the best way to get a good grade is to take off their clothes and their inhibitions in front of the class, they may only be taking the easiest way out of photographer's block. Some might have done better to bare their souls.

In fact the show-and-tell antics in the galleries are so naughty these days you wonder if the grown-ups are not asking to be sent to the principal's office. Children do that sometimes when they are distressed: try out everything they believe is bad so that when Mom finally stops them they know what the rules are, which is a lot safer than not knowing. Maybe photographers, like most of the rest of the world, are adrift without a moral compass in their kit bags, secretly longing for a navigational map for the sea of unlimited permissions.

One popular gambit with the let's-be-naughty crowd is bondage, and the infliction, at least implied, of a certain amount of pain. Nobuyoshi Araki's new book, *Shikijyo—Sexual Desire* (DAP, 1997), has a slew of photographs of women trussed up tighter than Thanksgiving turkeys. The publicity sheet, which bills him as one of Japan's leading photographers, says women practically line up to pose for him tied up in knots. Even toys apparently need to be dominated. David Levinthal photographed a naked female doll with her arms bound behind her; she shows up in "The Sex Show." Beth B., once she finished photographing the female anatomy, installed a number of dear little dolls and teddy bears tied up or strung up and attached to menacing machines.

The "Sex/Industry" show had Joanne Tod's painting of a fully clothed woman suspended by various ropes from the kitchen ceiling with her hands

tied. The artist says that is the way she sometimes feels in the kitchen—she is not alone—but in a gallery full of restraining devices these acrobatics looked pretty perverse.

Is bondage so delectable right now because men have lost power elsewhere and women are guilty enough about sex to have to say "Look, Ma, no hands"? Whatever the psychological implications, it's certain that photographers, and other artists, want to show off their familiarity with transgression. Almost any variety will do. Earlier this month, the Andrea Rosen Gallery's show of Miguel Calderón's staged photographs included two of a man lifting a schoolgirl's dress to look underneath.

Oh, and suffering ranks quite high on the popularity list. Joy, on the other hand, does not. It just might be the last off-limit subject.

The peculiar thing about this relentless artistic attention to sex is that these too, too wicked photographers have got it all wrong. The really up-to-date obsession is not sex but consumption, the locus of lust having shifted from the bed to the shopping mall and the superstore. Shopping malls are larger, more continuously populated spaces devoted to the incitement of desire than topless bars will ever be. Attraction is more powerful at the mall, hearts beat faster, boredom is less common, action more likely, fulfillment of desire more frequent, and every man there is potent by virtue of having a few bucks in his pocket.

Art photographers have done their bit to kill off interest in sex, but commercial photographers have been far more instrumental in effecting the shift to possessions. Advertising photography long ago put a good face on object fetishism, turning perfume bottles and alligator purses into magical items of worship, as dramatically lit, magisterially isolated, and lovingly presented as Hollywood stars. Advertising and fashion photography are the safest sex of all: the merchandise comes with implicit promises, there is always the hope that the photographic aura is included in the price, and if it's all a lie, at least it's not life-threatening.

Meanwhile, art photographers peruse the pages of Krafft-Ebing and trot out scenarios that used to guarantee titillation and dismay but now produce something closer to the effects of melatonin. The question is: are we having fun yet?

New York Times, April 20, 1997

DEATH TAKES A HOLIDAY, SORT OF

THE DECLINE OF DEATH
AND ASCENT OF ITS IMAGE

In eighteenth-century Europe and England, death was everyone's intimate acquaintance, constantly on view. Child mortality rates were hideously high. Crowded living in unsanitary conditions, malnutrition, famine, disease, and accidents ensured life's unpredictability from day to day. Anyone with a little money then died at home, but the poor, who could not spare a hand from work to tend the sick, sent their relatives to hospitals where atrocious care and rampant infection killed them fast. The body then went home for washing and laying out, so if you missed the dying you still saw, and most likely handled, the dead.

A Christian death was a public occasion marked by religious ceremony and meant to set an example that would bring the spectator closer to God. Madame de Montespan, who died in 1707, was not so afraid of dying as she was of dying *alone.* Most likely she died in a crowd. The last sacrament was ordinarily borne across town to the dying in religious procession, and everyone on the street, of whatever station in life, was entitled to follow the Eucharist into the room of the dying, and indeed was granted an indulgence for doing so.

Executions were also public. Well into the nineteenth century, an execution day was a holiday, and schools were let out; it was commonly believed that the sight of punishment would deter future criminals. The bodies were often displayed for a long while, the flesh decaying before people's eyes.

The more innocent dead might also be on view. Cemeteries had been attached to churches in residential areas of big cities for centuries, and by the eighteenth century they were literally overflowing. Bodies were tossed into common pits and covered with only a couple of inches of dirt; the process was repeated until the pit was full. When new trenches were dug where corpses had wholly or partially decomposed, bones turned up all the time. These would be arranged in the galleries about the churchyard.

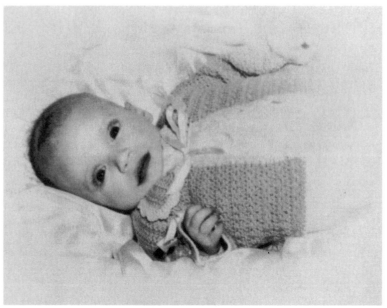

FRANCIS J. SULLIVAN, *Untitled (Deceased baby with "eyes" glued on), New Hampshire*, early 1950s

Hamlet would hardly have been surprised when a gravedigger came upon Yorick's skull. Although the burial grounds sometimes stank, people frequently played games and hawked merchandise right beside or even atop the dead.

Late in the eighteenth century, death actually began to recede in many Western countries, if imperceptibly at first, and attitudes to it changed. Life expectancy had in fact begun to increase, in increments too small to be noticeable but possibly intuited nonetheless. Between 1740 and 1749 in France, average life expectancy was 25.9 years; between 1790 and 1799, it was 32.1. No one knows exactly why, only that it was so. Possibly climate had shifted sufficiently to improve food production; perhaps certain diseases had run their course and become less devastating. Edward Jenner's introduction of the smallpox vaccine in 1798 offered the first real hope that disease might be conquered.

Over time, social, religious, and medical changes made dying and death gradually withdraw from view; by the mid twentieth century they became virtually invisible in most large metropolitan centers, especially in America and England. An odd and suggestive aspect of this process is that it roughly coincided with a long increase in depictions of death, some driven by new technologies. Although hard proof is lacking, circumstantial evidence strongly suggests that these two phenomena are related. The diminution of the visible presence of death was not the primary cause of the expansion of depictions, but history and psychology indicate that representation rapidly supplanted actual experience as a new and newly anxious audience sought novel ways to cope with its fears.

The increase in representation is more sudden and pronounced and a bit earlier than the most obvious decreases in death's visibility, but appears to have received an extra impetus from changes in life expectancy and the vicissitudes of death and dying during the nineteenth century (changes that became more evident as the century progressed), and it both responded to and aggravated new tensions and doubts brought on by these shifts.

As portrayals of death multiplied, the nineteenth century gradually turned its attention away from the religious, moralizing representations of the death of Christ and saints and the lessons on how to die taught by the *ars moriendi* books and focused instead on the secular subject of violent death as news and/or a matter of entertainment. These newer accounts and images of death became so numerous in the nineteenth century that some found them troubling, and many of the difficult issues raised about

the media in our time turn up, at least in miniature, in the infancy of the popular press.

The waning and waxing of death and representations of it were not on precisely parallel tracks nor by any means perfectly synchronized, and one cannot be held strictly accountable for the other. Yet there they are, doing a slightly out-of-step minuet across time: as the dead leave the realm of transcendence to become beautiful dreamers and tame objects, as executions retreat behind prison walls, as the mortal coil gets shuffled off in isolation wards and eventually in far-away nursing homes, the new reproductive media offer more and more realistic or exaggerated visions of how we die.

DEATH IN THE AGE OF MECHANICAL REPRODUCTION

In the eighteenth century, the popular print, still limited in number, came into its own. The last years of the century saw new and revived graphic techniques, including wood engraving and the invention of lithography. Both soon permitted much larger illustrated print runs. By the early nineteenth century, steam-driven presses and machine-manufactured paper made it possible to produce journals by the tens of thousands—within decades, by the hundreds of thousands—and more cheaply than anyone could have imagined. The introduction of photography in 1839 riveted the eyes of the world on pictures, and by 1851, an easy means of duplicating photographic prints made them cheaper and readily available.

These developments came along as industrialization, capitalism, and social change created a widely expanded audience that was literate, financially comfortable, and had a certain amount of leisure time. An enormous working class was newly concentrated in metropolitan areas, literate to a degree, and eager for news, human interest, and entertainment in written and visual—especially visual—form. The makings of a mass audience were at hand.

When executions attracted huge crowds, picture-makers came too. Broadside ballads, illustrated with woodcut pictures of crime and punishment, sold well. The images were crude, vigorous—men stabbing women, a woman dashing out a child's brains—and in effect interchangeable. Around 1840, when there was a series of suicide leaps from the same English monument, one resourceful publisher kept on hand blank pictures of said monument so he could drop in a falling male or falling female body. Often the up-to-date, on-the-spot image of a condemned criminal or a

crime was actually a picture made decades earlier to illustrate another dastardly deed.

The broadsides, which had a brief but powerful flowering in the first half of the nineteenth century, sputtered out under competition from the illustrated press, which began in the 1840s. Papers such as the *Illustrated London News* advertised for sketches from the scene and sent their own artist-correspondents to cover wars and revolutions; sometimes they copied photographs. (Until the late 1880s, there was no practical and inexpensive way to print text and photographs together.) Truthfulness, accuracy, and similitude were implied by pictures from photographs or sketches made on-site, although they were not always supplied. When it came to matters of death, people who were no longer seeing quite so much of it up close learned to accept representations that looked real as a substitute for experience.

Even as death seemed to die and be properly buried, it leaped to life on the printed page and in various visual spectacles. Illustration moved in as death moved out. Although the deathbed had ceased to be a public occasion for the community, the deathbeds of great men continued to be so in engravings. Photographers took deathbed pictures of many of the important cultural figures of the century, and these were sometimes copied in the journals.

The serious illnesses of monarchs and major figures had for centuries been closely followed news, and their bodies had lain in state for visitors to pay tribute to, but there were severe limits on what anyone at a distance could see or participate in. Now Lincoln, Grant, Lord Nelson, and any number of nineteenth-century statesmen were drawn on their deathbeds before or after their actual deaths, with careful attention to the features of the people in attendance, and the pictures were reproduced in a short time for a large audience that in some sense became present at their leader's side. After Lincoln died, his body traveled by railroad to several cities; if the public could not come to the monument, the monument could now come to them.

The community of mourners who felt in some sense present was greatly enlarged, although the immediacy of the experience was diminished. This removal-by-representation prefigured the worldwide attendance at the funeral of John F. Kennedy via TV, as well as the tabloid "slab shots," taken in the morgue, of the bodies of Steve McQueen and Elvis Presley.

It was already understood in the mid nineteenth century that newspapers were replacing the immediate, in-person experience of death. On July 25, 1857, *Harper's Weekly* wrote:

> *The policy of private executions in an age when the thrilling rhetoric of reporters photographs the details for millions of readers* [note the use of *photograph* as a verb to describe realistic visualization before photographs could be reproduced with text], *who become spectators in effect, can not now be doubted. . . . The jurists of all countries may well arrive at the conclusion, that the example pondered upon by millions of readers is more powerful than the one gloated over by a few curious thousands of spectators.*

Pictures would heighten the power of the press and compound the issues of public display. The same journal, two years later, trumpeted its own importance and the importance of illustration in general: "The value of the paper can be best realized by supposing that it did not exist, and by trying to conceive how little people would really know of passing events if they had to rely on written descriptions alone."[1]

Death was not the only experience that was gradually becoming more mediated than immediate. The postmodernist insistence that real life was being replaced by reproductions gathered force and recognition in the nineteenth century. In 1843, Ludwig Feuerbach, speaking of religion, wrote about "the present age, which prefers the image to the thing, the copy to the original, the fancy [sometimes translated as *the representation*] to the reality, appearance to the essence," and added that the era was perfectly well aware of doing so.[2]

The dominion of illustration was so overpowering that Wordsworth wrote a sonnet in 1846 (published in 1850) inveighing against illustrated books and newspapers in general. He feared that pictures would destroy the hard-won human capacity for thought:

> *Now prose and verse sunk into disrepute*
> *Must lacquey a dumb Art that best can suit*
> *The taste of this once-intellectual Land.*
>
> .
>
> *Avaunt this vile abuse of pictured page!*
> *Must eyes be all in all, the tongue and ear*
> *Nothing? Heaven keep us from a lower stage!*

In 1896, an editor added a footnote: "Had Wordsworth known the degradation to which many newspapers would sink in this direction, his censure would have been more severe."[3]

Photography explosively heightened this dependence on images. Oliver Wendell Holmes was peculiarly prescient in 1859 when he wrote:

> *Form is henceforth divorced from matter. In fact, matter as a visible object is of no great use any longer, except as the mould on which form is shaped. Give us a few negatives of a thing worth seeing, taken from different points of view, and that is all we want of it. Pull it down or burn it up, if you please. . . . We have got the fruit of creation now, and need not trouble ourselves with the core. Every conceivable object of Nature and Art will soon scale off its surface for us. Men will hunt all curious, beautiful, grand objects, as they hunt the cattle in South America, for their skins, and leave the carcasses as of little worth.*[4]

The replacement value and the dominance of the simulacrum were already acknowledged. The eventual substitution of death imagery for the sight of actual death is merely one aspect, if a very important one, of a trend that would in time change the way we experience the world.

LONGER LIFE, FADING DEATH

As lives gradually lengthened, people grew increasingly attached to life and more frightened of its end.[5] The secularization of religious customs, combined with the new strength of family ties that emerged in the later eighteenth century, meant that individual death was retreating from the status of a public ritual—strangers no longer came to the bedside—to that of a private family affair. Two apparently contradictory attitudes to death developed: the gothic and romantic movements turned it into a lugubrious, morbid, aestheticized fascination, horribly beautiful in its way; and death was made cozily beautiful with a new concept of heaven, where earthly loves continued in snug cottages with married partners. The gothic was born in England and the domestic afterlife took strong hold there, but both spread far. The shuddery aestheticization of death was essentially secular, whereas the reduction of heaven to a suburban bourgeois utopia was set in a religious framework; both could be considered imaginative means of coping with heightened anxieties about death.

Life expectancy continued its slow upward climb in the nineteenth century. But statistics like those that indicate slowly declining death rates in England and Wales[6] mask the difference in life expectancy of the various classes. In London in 1830, the average age of death for the gentry, professional people, and their families—the people who would read the illustrated papers when they became available—was forty-four. For tradesmen, clerks, and their families it was twenty-five; for laborers twenty-two. The reformers were well aware of the discrepancies and in time improved sanitary conditions enough to make a difference. Edwin Chadwick, in his famous report to Parliament in 1842, said that the sanitary reforms he advocated would extend the life expectancy of the laboring class at least thirteen years. In America at the end of the century, the average life expectancy for all classes was forty-seven.

Twenty-two, forty-four, forty-seven—they do not sound like much to us, but changes in expectations of life, even if only barely perceptible, must make a difference in attitudes to death. And in the later nineteenth century, there were some promising medical developments that may well have raised people's hopes beyond the possibilities of the science of the time to fulfill them. By 1858, Louis Pasteur had developed the principle of pasteurization. In 1864, Joseph Lister proposed that microorganisms on doctor's hands could spread infection, and in the 1870s and '80s the microbes responsible for cholera, tuberculosis, rabies, and many other diseases were discovered. Doctors fought Lister's idea hard, but everywhere that it was accepted and sanitary measures were taken, mortality rates after deliveries or surgery declined, sometimes radically. Anaesthesia was discovered, fever hospitals in London were moved away from residential areas and redesigned to give more air and light and to isolate infectious patients, and Florence Nightingale successfully campaigned for trained nurses, which also improved hospital care.

The result was that people lived somewhat longer and had more hope of doing so, and that many more, rich as well as poor, went to hospitals for treatment, and more died there, out of sight.[7] The process of removing death to hospitals has vastly speeded up since the 1930s, but death has been steadily removing itself from view for almost two centuries by the extension of life and the removal of the dying from the home.

The corpse and its care also left home over the course of the nineteenth century. The family had traditionally washed and dressed the body and laid it out in the parlor for friends and relatives to see. By the third

quarter of the century, the undertaker began to assume some of those responsibilities. This was partly because life insurance took hold in Britain in the late eighteenth century, in America in the 1840s, and a little later on the Continent[8]; people had money for extravagant funerals and undertakers leaped to exploit a growing business. Societies of undertakers were organized in the 1880s, the U.S. College of Embalming was established in 1887 (embalming having begun here during the Civil War), and the funeral parlor replaced the private home's parlor, which was then rechristened the "living room."

The dying and dead were slowly fading from the field of view. Cemeteries, which had been attached to churches in town centers, were moved into the countryside. In 1763, when French gravediggers and some residents of houses next to the churchyards died suddenly from graveyard fumes, the authorities decreed that cemeteries should be moved out of town. This began in earnest when the king issued his own decree in 1776. The Metropolitan Interments Act of 1850 forbade interments in London churchyards or within two hundred yards of any house. English cemeteries in the 1850s, like those of the rural cemetery movement in America, were experienced as delightful places in which the proper burial "must tend to rob death itself of its most repulsive features"[9]—including visibility.

Violent death as an organized spectacle—public execution—was also on its way out. The upper classes mingled with the lower at executions, although it was only the better educated who began to voice their unease in the late eighteenth century. Enlightenment voices declared public torture and execution an "atrocity," and by the first quarter of the nineteenth century, such violent means of death as breaking on the wheel and quartering had been eliminated altogether. But the people felt entitled to their theater and complained loudly when the guillotine replaced the gallows because they could not see as well.[10] However, the enormous crowds and unruly celebrations at these events attracted pickpockets and other criminals and sometimes occasioned riots. Already in the eighteenth century, the authorities began to see public executions as a threat; eventually they were transferred to the inner courtyards of prisons.

During the nineteenth century, the number of such public executions declined steeply. When the century began, England had 160 capital crimes on the books, and by 1810 had 320; France had 115. A British citizen could be executed for stealing five shillings or cutting down a tree as well as for more serious crimes, although the death penalty was by no means

universally applied. The second decade of the century brought the beginning of a great reformation of the British penal code; this was seen (properly enough) as evidence of an advance in morality and civilization. By 1850 England had fewer than ten capital offenses, and the punishment of death was rarely imposed except for treason and murder; in France it was rare, although the Commune changed that.

Although England did not permanently give up capital punishment until 1969—more than two centuries after Henry Fielding had called for its abolishment—and France in 1981, both countries had long since ceased to make it a public spectacle. By the late nineteenth century the French carried out their executions at dawn with the crowd held off by a cordon of police. In the first two decades of the nineteenth century, approximately 2,700 people were executed in England and Wales; in relation to the population, that was twelve times as many as during the single decade of 1841–50.

Although public executions were still occasional and riotous spectacles, they were clearly declining. By the 1850s, executions in Germany and America were carried out in private. Step by step, death was leaving the home and the public square as efforts were made to draw the curtains of privacy about it. Today in America the issue is not merely whether we shall have more private executions, but whether they should go public once more, this time on TV.

Death, Fear, and New Responses

Even as death receded, ever so quietly and slowly, from view, nineteenth-century urban society remained fixated on it while attempting to restructure social and personal responses and keep the inevitable at a remove. Extended mourning rituals were often socially, rather than religiously, formalized and degrees of mourning were prescribed down to the last detail. The moral and salvific force of what were once personal visits to deathbeds was transferred to the new literary form of the novel: most of the great books of the age include an extended death scene. Once the cemeteries were shifted away from city centers, the rural cemetery was turned into a delightful garden and the old casual acquaintance with dead bodies was transformed into a spectacle or viewing opportunity. In Paris, people idly dropped in on the morgue, where the door was always open, if they were passing by, and the catacombs, where the bones that had welled up from

earlier cemeteries were arranged in ranks and galleries, became a popular site for tourists.

Ingenious ways were found to mask the terrors attendant on fixation. Hiding it was one way, beautifying it another, taming it yet another. In January 1860, *Harper's Weekly* advertised a chromo-lithograph of Rembrandt Peale's *Court of Death*, first painted in 1820, for ten dollars. "There is not a skeleton or anything repulsive in the picture," this ad boasted. (Again the word *repulsive*; death was being cleaned up for middle-class consumption.) "It is a work to DELIGHT THE EYE AND IMPROVE THE HEART. It can be studied and understood by a child, while its sublime conception affords scope to the strongest imagination." What's more, nothing could be "a more impressive, instructive, or beautiful PARLOR ORNAMENT."

Embalming was one way to hide death with a simulacrum of life, to improve its looks, to render it no longer fearsome. There were others. Memorial jewelry, which had earlier been decorated with skeletons and coffins, now held tiny photographs of the departed or, even more significantly, were made of their hair—an anonymous, unfleshly, undecaying fragment of the body. In mainstream fiction, young heroines died nobly and were assured of an afterlife—Beth in *Little Women*, Little Nell in *The Old Curiosity Shop*, little Eva in *Uncle Tom's Cabin*, the Little Match Girl. In 1858, Henry Peach Robinson, a well-known British photographer, made a famous composite photograph called *Fading Away*, in which a beautiful young woman lies wanly, and beautifully, on a chaise while the family sits by in quiet grief or gazes hopelessly out the window. The image sums up the intensity of family relations and the determination that dying should be well composed, peaceful, and attractive.

In America, and somewhat less in Europe, postmortem photographs—the next frame in the story, as it were—were popular in many households throughout the nineteenth century. They were commonly displayed on mantelpieces and parlor tables. (The custom of taking professional photographs of the dead persisted into World War II—and is apparently still current in some places—but as death has become no longer publicly acceptable, the images are now usually tucked away in albums.) Postmortem photographers specialized in making the dead look tranquil, in keeping with the new idea of the afterlife as a comfortable bourgeois existence. Southworth and Hawes, the preeminent Boston portraitists, advertised in 1846 that "We take great pains to have miniatures of Deceased

persons agreeable and satisfactory, and they are often so natural as to seem, even to Artists, in a quiet sleep."[11] (One twentieth-century photograph of a dead baby shows the child with wide open eyes—which have been pasted onto his portrait.[12]) It was suggested that cemeteries would be better places to visit if only they were filled with photographs of the dead as they had been in life, and indeed patents for preserving daguerreotypes on tombstones were taken out at least by 1851.

HERE IS THY STING

As the nineteenth century grew older, its face no longer managed to be quite so pretty all the time. Flaubert's Madame Bovary imagined herself dying in a transcendental swoon, when, alas, she merely had flu; later, when she poisoned herself, her death was hideous. Tolstoy's Ivan Ilyich died a lingering, distinctly unromanticized death, in which his body became dirty and his fate unimportant to those around him. Death, now rather less uplifting, had begun to hide itself away, and attitudes toward it changed in many ways. Oscar Wilde said: "One must have a heart of stone to read the death of Little Nell without laughing."

The century's fixation on death, like fixations in general, doubtless indicates intense anxiety. The gradual decline of belief, especially in the afterlife, makes that all the more likely. For many, death became a negation, the dead person a nonentity, a nothing. The Goncourt brothers wrote: "The dead person is no longer revered as a living being who has entered into the unknown, consecrated to the formidable 'je ne sais quoi' of that which is beyond life. In modern societies, the dead person is simply a zero, a non-value."[13] Artists such as Manet and Degas painted this "zero" factually and dispassionately. There were several religious revivals during the century, and many people held tightly to belief in a welcoming heaven. Others adopted the Enlightenment notion that immortality resided in the memories of those still here. But once biblical exegesis, Darwin, and modern science got to work, wide currents of unease began to spread. By 1878, one English funeral establishment offered different forms and colors for funerals, depending on whether the survivors believed the dead slept until the Second Coming, went to Purgatory, or were totally extinguished.[14]

The Goncourts, in 1852, declared religious painting "dead with that which has died"—by which they meant faith.[15] In 1867, Matthew Arnold wrote in *Dover Beach*:

The Sea of Faith
Was once, too, at the full, and round earth's shore
Lay like the folds of a bright girdle furled.
But now I only hear
Its melancholy, long, withdrawing roar

Manet's two paintings of Christ in the 1860s make no obvious attempt to inspire religious devotion; he painted them because he thought it an artistic challenge to deal with the traditional iconography. By 1898, an American writer, William Henry Johnson, could say that "the traditional belief is undergoing rapid alteration and, in some quarters, disintegration. Forces are at work which have affected the old dogma more seriously in twenty-five years than all the thought of all the ages since man began to think."[16]

The prospect of death is newly terrifying if nothing comes after, and in a culture that once felt it had a guarantee of eternal life, blissful or miserable, the undermining and loss of that cherished belief must have created an especially intense anxiety. Photography, which soon after its invention began to represent death, even assayed the afterlife. In the second half of the nineteenth century, "spirit photography" claimed to have tapped into the other world, provoking considerable controversy. Portraits were taken of people who wanted to get in touch with deceased relatives; when the pictures were developed, ectoplasmic figures or faces mysteriously hovered above the firm lineaments of the living. These were nothing but double exposures, in which an undeveloped plate with an image of, say, a child, was reused for the current sitter, but many thought they had found the key to the continuing life of those they had lost. (Or to the invisible world of other kinds of spirits, such as fairies.) Arthur Conan Doyle was a firm believer in the power of spirit photography.

The struggle to come to terms with death is built into the human condition. As Freud pointed out, one cannot fully imagine one's own death, but always remains a live spectator watching the event in imagination. A terrible need for answers, a deep and implacable denial, and a desperate yearning for mastery buttress our combined fascination, fear, and avoidance of scenes of death.

DEATH, VIOLENCE, AND FASCINATION

In the nineteenth century, as even Jesus' death was, in many instances and at least in such countries as England, France, and America, replaced by

images of his life as the central religious icons, death was glossed over and negated as far as possible. The sight of death receded faster than the reality, but both were clearly diminishing. I would suggest that the fact that representation so rapidly rose to fill the gap, and that illustrations so often veered toward violence, indicates that the technology and marketing devices of the modern world, arriving at about the same time as the new anxieties of life, intuitively took advantage of these and often enough contributed to or exacerbated them.

Photography would in time be crucial to the accelerated display of death and violence, but in some cases, such as deathbed and postmortem pictures, it must have aided the mourning process. Photographic images were believed to be entirely truthful and wholly realistic, so that even a wood engraving in a weekly paper that was labeled "after a photograph by Mathew Brady" (or whomever) was more *convincing* than the work of the finest artists, if by no means as artistic. This high reality-quotient may have made the peacefulness of postmortem photographs more reassuring than they could otherwise have been.

And images, whether photographs, wood engravings, or motion pictures, can offer a kind of ambiguous comfort and control that reality does not, especially for those who look at a picture repeatedly or watch the same film more than once. Having a still picture in hand predicates a kind of control over it, which becomes yet more meaningful when the picture is a photograph, with its credible traces of reality. This may be stared at, queried, turned away from, put away and later taken out again. It does not call for action, as coming upon a dying man or a murder would, and the spectator determines whether to pay it attention or not. (There is also a ritual aspect to repetitive viewing of moving pictures. Knowing when the violence and death will turn up allows a certain monitoring of one's own emotions. And since everyone dies only once, watching the same people die over and over tends to erect one poor barricade against the reality of death. Besides, the stars are truly immortal. As Melina Mercouri's character says of the Greek tragic actors in *Never on Sunday*, after the play they all go off to the beach. Film stars go on to make another film, perhaps to die again.)

Throughout the ages, sculptured reliefs, vase paintings, and murals have depicted death in battles and proclaimed the triumphant brutalities of warrior kings. In the Christian West, Jesus' violent death was always visible, at least in church, and the hideous deaths of saints loomed large in paintings, occasionally in sculpture, and, after the fifteenth century, in illus-

trated hagiographies. The tortures of hell were also generously offered to view. Death in battle never disappeared, but in the postclassical and Renaissance world was a very small fraction of artistic production. More peaceful endings, at least in most of Western Europe, were provided by scenes of the Virgin's death, by tomb sculptures, and by *ars moriendi* books.

While the deaths of relatives and strangers might seem random and be hard for the human mind to fathom, Christian depictions of death were purposeful. They carried religious, moral, and instructional messages. Except in the *ars moriendi* books, they concentrated on holy figures who could save the viewer, although he or she was highly unlikely to share the fates depicted.

But mechanically reproduced illustrations in the nineteenth century—far more numerous than any previous pictorial medium—brought to the fore not only more depictions of death, but more depictions of secular, violent, and essentially uninstructive death. Aside from respectful deathbed pictures, much of the time death in print and images, from the earliest years of the illustrated press, was ruthless, brutal, vicious—murders, executions, disasters, wars—although not often explicit or detailed.

Not only did *depicted* death swagger violently onto the stage, but new means and forms were also found to keep it before the public eye. Public executions may have been declining, but the journals made sure that whatever there was, even within prison walls, could still be seen. What's more, the illustrated newspapers exponentially increased the number and proportion of depictions of accidents and natural disasters: railroad crashes, shipwrecks, explosions, floods. These had neither religious significance nor redemptive force, but since they might happen to anyone, they may well have contributed to an increasing sense of angst that was hovering over the century.

Disasters are undeniably news, but in other respects the papers were only responding to a fascination with accounts of violent death that ran alongside the movement to tame and beautify the end of life. The ghosts and ghouls and miasmas of gothic fiction lost their great hold on the imagination in the 1820s, but the gothic fascination with grisly death persisted in waxworks like Madame Tussaud's, in which victims of the Terror and criminals painfully executed were simulated as faithfully as possible, and the Chamber of Horrors was popular among high and low, men and women. The dioramas early in the nineteenth century, those fool-the-eye performances in which clever painting and lighting made scenes seem to

change and people to advance before the eyes, often included funerals and scenes of dead shades returning.

The most obvious and successful repository of the gothic and romantic fantasy of adventure, struggle, and death was the theatrical melodrama. This was lowbrow hack work, churned out rapidly to formula, with music underlining the emotions (as in cinema). It appealed mainly to the lower classes, and it appealed to them mightily; these dramas were the narrative counterparts of the broadside ballads. Theater had already begun to feed off the widely popular murder trials of the day. In one instance, a play was mounted while the trial it depicted was still being conducted. The defense counsel understandably had it enjoined; the curtains were raised once more after the murderer was hanged.

The passion for crime that gripped the public in the last century is astonishing. Prints of notorious murderers had been around for a couple of centuries, but reproduction and distribution were limited. In the nineteenth century, various accounts say that well over a million copies of some murder broadsides were sold in England. It so happened that as England in the post-Napoleonic era was enjoying a lengthy peace and simultaneously reshaping death in the semblance of angelic children and marriages revived in heaven, the country witnessed a startling number of sensational murder cases, culminating in Jack the Ripper.

On February 1, 1851, the *Illustrated London News* went so far as to say that thirty-five years of peace in Europe "has allowed no vent for the malignant passions but in those acts which the law undertakes to prevent or to punish." (In fact, the number of violent crimes had decreased in the eighteenth century, and the number of crimes against property had risen as wealth accumulated. Even in the eighteenth century the concentration of people in cities and the growth of broadsheets, popular prints, and newspapers of one sort or another may have made people more conscious of violent crime, as has happened in our own day.)

Do away with war, the British periodical said, and criminals will have to express themselves in their usual ways. Perhaps. Doing away with war, and beginning to push death aside as far as that was possible, seem only to have heightened fascination with the grimmest kinds of deaths, as if there were some level of interest, some level of fear, that had to be satisfied in one manner or another. As it happened, the spate of peacetime murders occurred just as the new popular press swung into high gear; the

journals wasted not a second in bringing murder in all its details into the light of day.

It may be mere coincidence that the penny papers and illustrated journals should have come along at the same time as a slew of murders—or, more likely, it was the print media that made these murders notorious and inscribed them in popular culture for decades.[17] It is no coincidence that the press made much of crime. Up to the 1820s the press was largely political or mercantile and dealt with party issues or such matters as shipping news. A real newspaper, as we understand it today, chronicles breaking events; crime qualifies in major ways. Criminal trials had already found popular outlets in booklets reproducing the trial transcripts, and some of the new papers continued this tradition. Others bettered it with dramatic and often sensational accounts, and by the time the world's first true illustrated paper, the *Illustrated London News*, appeared in 1842, some expanded on the tradition with images. The first issue of *L'Illustration*, an illustrated Paris weekly, on March 4, 1843, had accounts of two murders and an assassination; two of the articles were illustrated.

Bad news is good news for a paper. On March 5, 1859, *Harper's Weekly* claimed that their circulation exceeded 75,000 copies. On March 12 they published a big story about Daniel E. Sickles, a member of Congress, who had killed a man he believed was his wife's lover. The story was illustrated with portraits of the three principals as well as pictures of the Sickles house, the congressman's clubhouse, and an artist's version of the shooting, which took place on the street. On March 19, the front page of the paper proclaimed: "Of the last number of this journal 120,000 copies were sold." In January 1862 the same paper advised its advertisers that "The great exertions made by the proprietors of HARPER'S WEEKLY to illustrate the [Civil] WAR have been rewarded by a large increase of circulation." The British and French papers had similar experiences. In 1868, *Figaro* claimed an increased circulation of 30,000 after it provided detailed accounts of the murder of six members of one family in the French provinces.[18]

Print descriptions of all sorts of crimes, especially gruesome murders, brought people flocking to the newsstands, but illustrations brought more. The debate about violence in the media today is complicated by the visual nature of so much of our communications systems. Most of us would testify that pictures are capable of producing more immediate, visceral, emotional responses than are commonly called up by the printed or spoken

word. No doubt the visual response is more primitive; at any rate, the eyes believe what they see before the brain believes what the eyes read or the ears hear.

Violence and Middle-Class Morality

The rapacity with which the press reported crime, and the avidity with which even the gentler sex hung on the details of crimes and trials (or of the journals' reports), were offensive to those attempting to set moral standards for the rising middle class. The illustrated papers were trying to do just that. They believed that the press should instruct and moralize, and although they printed numerous illustrations of violent deaths, they often tried to soften the images by distancing them, or omitting details they were willing to print in the text. They advertised themselves as "family papers," and they spent decades trying to figure out how to deliver the worst news in an acceptable form.

For reasons that are not clear to me, both the American and British middle-class illustrated journals—*Harper's Weekly, Leslie's*, the *Illustrated London News*—covered murders in some detail in their first two or three decades and then almost stopped doing so. Conceivably, they found it impossible to compete with the cheap tabloids and opted for abstinence. For they disapproved mightily and vociferously of the explicit descriptions of violent crime in the cheap daily papers. In its January 20, 1866, issue, *Harper's* condemned the kind of publicity given to "infamous crime."

> *To say, as has been lately gravely asserted, that, because a revolting crime has been committed in a city, all the citizens are therefore "compelled" to listen to the loathsome details, is as ridiculous as to assert that, because the police may have descended upon a nest of ill-houses in Mercer Street, the public are "compelled" to listen to a minute account of all that was discovered in those houses. That the public will eagerly read such descriptions, and the more greedily in the degree of their prurient detail, is very possible.*

The *Illustrated London News* made similar complaints. *L'Illustration* in 1849 refused to print the debates about an assassination with which the press maintained the public's mournful curiosity. *Plus ça change.* Note that the American paper assumed that people would be offended (if fascinated) by detailed accounts of sex, but obviously not by similarly detailed—and

by implication similarly prurient—accounts of violence and murder. *Harper's* believed they should be offended—a losing cause if ever there was one. In this century, this puritan country's film codes have always spelled out limits on violence as well as on sex, but the censors have always been tougher on sex than on mayhem.

By the nineteenth century, Jesus' torture and crucifixion had ceased to be a major subject for artists. Manet's dead Christ was said to look like a coal miner, Gauguin's crucifixions were attempts to depict the primitive faith of the French provinces more than images of the sufferings of the son of God. In fact, conscious attempts were made to minimize the impression of Jesus' physical torment. In 1850, an English writer remarked on a painting of Jesus ministered to by angels after the Temptation: "The painter has attempted to portray divine resignation and exhaustion, free from the more acute bodily suffering under which the Saviour is generally represented."[19] When the last, violent moments of a few ordinary people became increasingly visible in images, they offered a tenuous and temporary security of a sort that was not meaningful in images of Jesus: this was not me; for this moment at least I have been saved from the particular fate I have just witnessed.

The popularity of images of violent death, then and now, conceivably has something to do with its relative rarity in real life: it is "safer" to fantasize about something unlikely to occur than about death from cancer or Parkinson's. The nineteenth-century journals, incidentally, reported outbreaks of cholera in India and Egypt, often to warn that sanitary measures had best be taken at home because after some months the disease could very well travel. (Would that we had the lag time they had.) But the weeklies did not illustrate the ravages of cholera any more than papers today, which have a good deal less shame, illustrate the incursions of the flesh-eating virus.

The illustrated weeklies may have cut back on murders after a time, but they still published occasional pictures of executions, assassinations, lynchings, and the means of execution in various countries. The journals leaped to illustrate current wars, revolutions, and riots, with their quotas of dead bodies. Sometimes these images contained a shocking amount of death—see a July 7, 1855, illustration in the *Illustrated London News* of the interior of a fort, with corpses everywhere, draped over rocks and breastworks and buried beneath stones. These images were often based on

sketches made on the scene and were therefore more truthful than paintings or broadsides. They were still somewhat distanced by the medium, but perhaps less so for the reading public of the time, which had not previously had access to so many eyewitness or near-eyewitness views.

During the American Civil War, photographers took the first widely visible on-the-spot photographs of dead soldiers. Alexander Gardner and Timothy O'Sullivan took pictures of the dead at Gettysburg that were exhibited in Mathew Brady's studio in New York, and were reproduced and sold. No one knows how many were printed or precisely what effect they had on the civilian population, but Oliver Wendell Holmes, who had been to the battlefield to look for his injured son, said looking at the pictures was so like visiting the battlefield that he hid them away. The *New York Times*, awed by the faithfulness of photographic reports, speculated about the effects of some wife or mother recognizing her beloved in the image.

These pictures gave the lie to the tradition of battle paintings, as some illustrations like the interior of the fort mentioned above had begun to do. Leaders did not always die nobly, nor did lesser men necessarily die bravely in a series of stock gestures. Death in battle did not look so good in the photographs, which nonetheless sold. The bodies had been on the field for two days of rain before the photographers arrived; they were bloated, dark, and stiff. There was an abundance of death in the engraved illustrations in magazines, but in none were the corpses bloated—any more than they are now in printed images of war or even in feature films.

A QUESTION OF CLASS

By the early nineteenth century, class differences in literature and theater were already well established, especially in Britain and America, and the newspapers quickly fitted themselves into these grooves. One of the tasks of defining a paper as "middle class" was precisely the control and aestheticizing of accounts of murder and violent crime.

Middle-class illustrations, including pictures of murders, were occasionally gory. In 1857 in America, one Dr. Burdell was viciously stabbed in his home. On February 21, *Frank Leslie's Illustrated Newspaper* had a two-page spread with a picture of the body in a coffin in the room where he had been killed; a picture of the doctor's face, complete with wounds, as it appeared in the coffin; a drawing of his sleeve full of blood; one of the heart

showing what wounds it sustained; pictures of other rooms; of a bloody doorknob; and one of sharp instruments. (Even today a slashed heart would probably not appear in the paper; the photographs of Nicole Simpson's and Ronald Goldman's bodies were not shown to the television audience during O. J. Simpson's trial.) The next issue of *Leslie's* had pictures of the coroner's jury as well as an artist's rendition of the supposed manner of the violent attack. And then the paper tried to explain why the public was so wrapped up in this case. Murder is always interesting, it acknowledged, but a recent rash of robberies and disappearances had left the populace so fearful that major crime had become a fixation. Fear breeds more fear, and growing metropolitan centers and rapid communications had heightened the possibilities both for crime and for awareness of it. *Leslie's* said: "It is this feeling of insecurity, this idea that no man's life was secure, that has kept alive the excitement, and made every incident of terrible importance." The paper did not say that its own reports certainly added to the excitement and possibly to the insecurity. The demand for the issues illustrating "the Burdell tragedy" was so great that *Leslie's* had to electrotype its forms in order to fill the extra orders.[20]

At the same time, *Harper's Weekly*, which commenced publication in that year, complained bitterly about the prevalence of murder in the papers. "Yes Murder will out!" it cried on its front page.

> *It infects the whole country with a pestilential air; it fills our houses with its gloomy horrors; it taints our breath with its poison; it dogs our daily walks. . . . You rise in the morning; a word of tenderness and love is hardly spoken to the little ones gathered about your knee, when with eager excitement, you clutch the morning paper, and you read: "THE BOWN ST. MURDER!" "THE BUTCHERY IN OUR CITY!" "INCREASED EXCITEMENT!" "HORRIBLE DETAILS!" "DREADFUL MYSTERY!" "EXCITEMENT UNABATED!" "MORE BLOODY GARMENTS!" which stare you in the eyes, and fix them in a spasm of concentrated attention on the page. The wife appeals fondly to you for a share of the horrors; even the little children gape, with open mouths. . . .*

Harper's was not even talking about pictures, but, as if it were over a hundred years later, it was concerned that the press would spur crime and immunity to it: "This spreading abroad of the information of a crime, if it

does not give rise to a criminal epidemic, which may break out in similar acts of violence, at any rate so far infects the moral sentiment of the community by its contagion as to ferment a taste for the horrible, and to harden the sensibility of the public conscience to vice." The paper went on to ask whether there might not be a danger of growing too fond of horrors from seeing so many of them in the papers.[21]

The new newspapers, at once violent and domesticated, defined a new level of sensationalism: more detailed than that of the broadsides, somewhat more credible, and apparently slightly more respectable—at least the journals entered the homes of middle-class families that might not have been so eager to be seen buying broadsheets. The urban setting that had spawned a wide middle class fostered new fears—of strangers on the street and anonymous murderers. What's more, some of the juiciest murders were committed by people of fairly good standing, so that now one had to be afraid of one's own kind as well. All of which fed the need for more information, more news, more sensational revelations, more images of violence and death.

But the illustrated papers knew that pictures were all too effective. Although they castigated the penny journals for reports that went beyond bounds, the journals were willing to give details in their own text that they would not permit in illustrations. On November 17, 1855, the *Illustrated London News* published an article called "Horrible Atrocities in China," about a place where sixty to seventy thousand executions had been carried out since the previous February. They had received a sketch and a description of how the executioner would cut his victims in various places before plunging a knife into the heart. He then took down the body, cut off the head, hands, and feet, then removed the heart and liver. This gruesome account was illustrated by a picture of a street with a few people on it and two crosses, which to a casual observer might seem to be local monuments, fixed in the ground—a pleasant enough foreign street-scene. A year and a half later, on March 7, 1857, the paper reproduced the letter and, referring to their previous publication, said: "In the Sketch itself, we omitted the live and the dead personages who were portrayed in it, fearing to shock our readers and subscribers by a scene so brutal, so disgusting, and so horrible." The editors added that they hoped to reproduce the sketch exactly in the following issue. But by the following week, they had evidently changed their minds.

The prodigal stream of inventions in the nineteenth century made available a huge supply of murderous images. Not only was the press newly capable of delivering information and images in quantity, but the steam engine that powered railroads and ships carried news with unprecedented rapidity over great distances, and the telegraph delivered it almost instantaneously. Consequently, the daily papers could report not only on distant wars but on far-off disasters—and they did. The illustrated weeklies, which advertised for sketches from any newsworthy scene, received them from the far reaches of the globe.

These papers did not always have images of natural or man-made disasters—sometimes for weeks there would be none—but other times they were served up with some regularity. The *Illustrated London News*, for instance, on July 6, 1850, reported on a "Terrific Explosion at Benares," with an article saying that at least five hundred people had been killed, and "limbs and shattered portions of human beings lay strewed far and wide." A sketch of the ruins of the explosion was much calmer, with some distinctly whole bodies lying about, leaving the imagination to fill in the particulars. The July 13 issue carried an image of a wrecked brig at Trinidad (looking, to an unpracticed eye, perfectly fine). The same issue had pictures of a fire at Bristol and one in San Francisco. The July 27 issue had two pictures of a steamboat explosion at Bristol, the August 3 issue a picture of a bull goring a matador in Madrid.

Disasters were not always so plentiful, but fires, floods, shipwrecks, and railway accidents anyplace were generally illustrated within a couple of weeks or more, depending on how far the information had to travel. Often, although by no means always, there would be bodies lying about or being carried off, or a wounded person raising himself up, but no emphasis was placed on gore or details of wounds. Volcanoes, earthquakes, explosions, and building collapses were also occasionally illustrated; they did not happen so often and were not usually so immediately threatening. Anyone could be affected by fire or flood, fires being a particularly great and frequent hazard to life, residences, and business. Shipwrecks threatened both travelers and business. The railroads, which had opened up travel to thousands, had scandalous accident records in most countries; passengers might be risking their lives for the chance at an outing.

People needed to know the risks if only to press for higher safety standards, but every report of a railway accident raised the general level of

anxiety. In fact it seems likely that the generic anxiety of modern life—the sense we have today, on the evidence of Chechnya, 9/11, the Iraq war, Sudan, and rampant terrorist bombings, that the world is rapidly going to hell—was already beginning to be set in motion by newspapers in the nineteenth century.

Life in the eighteenth century had most likely been filled with more present anxieties, especially as there was so little hope of controlling or conquering disease. But when the daily and weekly news became a necessary adjunct of daily life and steadily presented evidence that crime, torture, and disasters were many and widespread, the mind had a much wider territory and greater number of incidents to fear. An odd duality can operate on the reception of such news: what is far away does not directly affect *me*, which offers a certain reassurance; on the other hand, railway and steamship accidents are generic and may affect me in the future, and if dangers turn up in every corner of the world, I can scarcely feel safe where I am. And the more fearful I am, the more news I need to know, so that I may judge the odds, plan ahead, know where I have to protect myself—and the more palpitatingly I hang on to those images of death.

THE NEW MEDIA

The general consensus today is that the news, heavily invested in descriptions and images of violent death from the beginning, has gone ever further in the same direction. Every new medium has added to the store, from photography to motion pictures to television, video, and now computer games. Photography expanded the range of postmortem pictures, which had previously been limited to a few paintings and prints. A photograph was also proof of death, and a picture of Jesse James's dead body was as important in its day as the famous pictures of a dead Che Guevara or the sons of Saddam Hussein in ours. In the late 1930s and '40s, Weegee took so many pictures of murdered mobsters for the tabloids that he practically drove himself out of business by oversupply.

By the time cameras were capable of stopping action, murderous action became a major subject. Many of the most famous news photographs of the twentieth century have to do with death: Ruth Snyder in the electric chair. (Taken on the sly in 1928—not only were executions off-limits to the public but cameras were not permitted in the chamber. The *New York Daily News* gave its entire front page to the picture.) Piles of bodies in concentration camps. A monk immolating himself in Vietnam. Jack Ruby

shooting Lee Harvey Oswald. Robert Kennedy dying on a kitchen floor. General Loan blowing out the brains of a Vietcong suspect on a Saigon street. A dead American dragged through the streets in Somalia. A tangle of bodies thrown into a river and washed down by the current in Rwanda.

When cinema was introduced in 1895, it laid claim to a more extensive and intimate view of death. One of Thomas Edison's kinetoscopes, those brief films viewed individually through an eyepiece, presented the viewer with the execution of Mary, Queen of Scots—not entirely convincing, but she did lay her head on the block, the executioner did swing, and a head did roll onto the ground. The first true narrative movie in history, *The Great Train Robbery* (1903), had several murders. Styles of dying change over time; in this film, all but one of those shot throw their arms up over their heads before falling down; they don't seem to do that anymore.

The cinema moved in close on death in war, avoiding excess gore but not excess death—see *The Birth of a Nation*—and on death at home, often from unnatural causes, such as the girl's death from a beating, the murder of her father by the Yellow Man who loved her, and his subsequent suicide in D. W. Griffith's *Broken Blossoms*. *Nosferatu* brought to the screen the apparent terror of not quite dying that had raged at various times in the nineteenth century. Gangster films in the 1930s made multiple deaths something of a commonplace. Like the nineteenth-century melodrama, these sometimes borrowed from actual and recent crime accounts—*Little Caesar*, *Scarface*—so that the audience came anticipating a heightened emotional impact from a story that had already elicited a strong response. Pulp fiction of the time, usually detective stories, was also full of violent deaths. Westerns too served up large helpings, and World War II films kept the heroic death on view.

In the years after the war, when the audience had become acquainted with the real thing, violent death on screen began to change. In the 1950s, some of the exaggerated violence and death that had been the domain of adolescent boys and lower-class types edged into mainstream movie houses. Late in the decade, partially in response to the threat of the atom bomb, the science-fiction film was crossbred with the horror film, and new ways to die were invented—in the jaws of monsters, in the embrace of a protoplasmic blob of vegetable matter. The industry has become ever more inventive about means of death as film technology and special effects advance, so that now men may die from alien creatures bursting out of their breasts or from powerful rays that make them simply disappear.

More common forms of violent death turned more explicit and gruesome in the 1960s. *Psycho*, in 1960, came in close on a vicious stabbing, the camera changing angles so rapidly that the audience was continually off balance—and seldom aware that they never saw the knife entering flesh. *Bonnie and Clyde*, in 1967, riddled its protagonists with so many bullets at the end that they performed a virtual dance of death. In *Bullitt*, the following year, a shot blew an informer off his feet and jammed him up against a wall in a spurt of blood—or more precisely, a plastic bag full of fake blood, assisted by lurch cables. In *The Wild Bunch* (1969), the big killing scene orchestrated a veritable deluge of death, with bodies flying through the air and blood in quantities unseen before. The progress of death on screen—including the television screen, in both action series and nightly news—between that film and *Natural Born Killers* and *Pulp Fiction* is surely well enough known to need no introduction.

It is not enough for someone to picture more, and more violent, death; someone has to want to look at it. James Twitchell has written that in general the audience for violence in America is an audience of adolescent boys. There have been more of them since the baby boom, they have more disposable cash, they see films more than once, and they need to learn the mythic lessons that action and horror films teach.[22] That is probably true, but it does not explain why adults also patronize such films—and read such fiction, and see many more images of violent death in the papers and on TV, and read many more obituaries than teenagers do—or why such films play so well abroad.

The adult audience after World War II had a new fear of death: the bomb. In 1953, the U.S. Secretary of Defense announced officially, for the first time, that America and the U.S.S.R. each had the capacity to wipe out the entire human race. Rather suddenly in the 1960s, people who were already trying to find ways to live with terror of that magnitude were confronted with a devastating series of assassinations. The most violent films have never eclipsed the Zapruder tapes, which were so explicit that many frames have never been shown to the general public. Adults also witnessed Oswald's murder on TV, no doubt a first, and also a last, such sighting for millions. Television sales vaulted upward in the late 1950s and early '60s, so images of the deaths of Medgar Evers, RFK, and Martin Luther King Jr. were more widespread than such images had ever before been.

During the first four or five years of the Vietnam War, death was implied often enough by scenes of bombing, patrols, burnings, but there

was not so much killing on the screen. Around 1968, as the media themselves began to turn against the war, the imagery of death heated up: General Loan, My Lai, Larry Burrows's color photographs of bloody soldiers in *Life* magazine. Real death in terrible circumstances was all around. The audience was effectively primed for violent fictional deaths, which at least offered the solace of being fictional. Action films and special effects made falls from high buildings and death in car chases so acrobatic, so fantastic, that one could admire the skill of the actor or the technician and keep the terror of death at some distance.

THE DEATH AND RESURRECTION OF DEATH ITSELF

Obviously the fascination with death is multidetermined. One other factor operating during this period takes us back to the beginning of this essay: death was disappearing from view, and this time rapidly. In 1935, sulfa, the world's first antibacterial infection drug, came on the market. Penicillin, discovered in 1928, commenced commercial sales in 1945. A treatment for tuberculosis was discovered in the 1950s, the first polio vaccine in 1955. Between 1945 and 1955, mortality from influenza and pneumonia fell by 47 percent, from syphilis by 78 percent, and death from diphtheria almost disappeared.[23] Life expectancy, which had been climbing throughout the century, continued to do so. People died—or rather, "passed away"—in hospitals, and soon in nursing homes, often at great, invisible distances from families and friends.

By the 1950s in America and England, and to a somewhat lesser degree in other Western countries, death had just about vanished from view. For a while, there was a peculiar fantasy that maybe we had it beat, and there was a tacit social compact not to discuss it, not even quite to believe in it. But of course it does not work that way, and we need to know, or think we need to know, what it is, how it looks, what it does to us, what we can do about it. Images step up and offer their services. Geoffrey Gorer, in "The Pornography of Death," his seminal essay of 1955, said: "While natural death became more and more smothered in prudery, violent death has played an ever-growing part in the fantasies offered to mass audiences."[24]

I would say that's right. But I would also say that it is not new, only larger and bolder. Images had begun to fill in, to substitute, to heighten the terror and often, at the same time, to calm the nerves by their sheer improbability, over a century before Gorer wrote. They began their dance with death long before that, but they hit their stride almost as soon as mass reproduc-

tion and a mass audience began to take shape, at the moment that death began to shift from ritual to news and entertainment.

NOTES

1 *Harper's Weekly*, December 31, 1859, p. 836.

2 Ludwig Feuerbach, *The Essence of Christianity*, trans. Marian Evans (New York: Calvin Blanchard, 1855), p. 10.

3 William Knight, ed., *The Poetical Works of William Wordsworth*, vol. VIII (London: Macmillan, 1896), p. 185.

4 Oliver Wendell Holmes, "The Stereoscope and the Stereograph," *Atlantic Monthly*, June 1859, p. 112; reprinted in Vicki Goldberg, *Photography in Print* (Albuquerque: University of New Mexico Press, 1988).

5 See Philippe Ariès, *Hour of Our Death*, trans. Helen Weaver (New York: Oxford University Press, 1981), p. 28, on the general conception of a "tame death" and a resignation in the face of death that persisted into the eighteenth century. He suggests that the terror of death did not manifest itself until life became more precious.

6 See B. R. Mitchell, *Abstract of British Historical Statistics* (Cambridge, U.K.: at the University Press, 1962), p. 36.

7 The annual reports of London's Local Government Board show not only a marked decline in smallpox deaths among the London poor between 1871 and 1881, but an increase in the percentage of deaths in hospitals over deaths at home. In 1871–72, the total number of dead was 9,742, of which 6,509 had died in private houses. In 1881, the death total was 2,371; 797 had died at home. See Geoffrey Rivett, *The Development of the London Hospital System 1823–1982* (London: King Edward's Hospital Fund for London, 1986), p. 91.

8 On January 8, 1853, the *Illustrated London News* wrote that "Life Assurance" was important, but only 240,000 people had taken it out. That was already a large enough number to swell the tide of fancy funerals, and if this paper was urging people to buy insurance, presumably the matter was a topic of some interest. See John Gudmundsen, *The Great Provider: The Dramatic Story of Life Insurance in America* (South Norwalk, CT: Industrial Publications, 1959), pp. 20, 36.

9 *Illustrated London News*, July 24, 1858, p. 77. On the Metropolitan Interments Act, see John Morley, *Death, Heaven, and the Victorians* (Pittsburgh: University of Pennsylvania Press, 1971), p. 50.

10 Michel Foucault, *Discipline and Punish: The Birth of the Prison*, trans. Alan Sheridan (New York: Pantheon Books, 1977), pp. 55, 58, 59.

11 Stanley B. Burns, *Sleeping Beauty: Memorial Photographs in America* (Altadena, CA: Twelvetrees Press, 1990), n.p.

12 Barbara P. Norfleet, *Looking at Death* (Boston: David R. Godine, 1993), p. 97.

13 Henri Loyrette, "History Painting," in Gary Tinterow and Loyette, *Origins of Impressionism* (New York: Metropolitan Museum of Art, 1994).

14 Though the general decline is unmistakable, religious belief and its diminution are notoriously difficult to pin down and vary from place to place and time to time. See, for instance, John McManners, *Death and the Enlightenment: Changing Attitudes to Death in Eighteenth Century France* (Oxford: at the University Press, 1985), p. 440, on the "de-Christianization" of death rituals in France in the late eighteenth century. See also Henry Pelling, "Religion and the Nineteenth Century British Working Class," in *Past and Present*, no. 27 (April 1964), pp. 128–33, for a brief discussion of the decline of religion in large cities in England in the nineteenth century, especially among the working classes, although Scotland, Wales, and Ireland, as well as smaller English towns and rural areas, remained more religious. See also Morley, *Death, Heaven*, p. 31.

15 Loyrette, in "History Painting," cites Jean-Paul Bouillon, ed., *La critique d'art en France, 1850–1900: Actes du colloque de Clermont-Ferrand 25, 26 et 27 mai 1987* (Saint-Etienne: CIEREC, 1989), p. 51, n. 26.

16 William Henry Johnson, "Immortality: Its Place in the Thought of Today," in *Arena* 19 (May 1898), p. 590. Quoted in James J. Farrell, *Inventing the American Way of Death, 1830–1920* (Philadelphia: Temple University Press, 1980), p. 87.

17 My thanks to Joel Wollman for reminding me that these crimes might scarcely have existed for the public, or for history, had it not been for the press.

18 *Harper's*, March 5, 1859, p. 1; March 12, 1859, pp. 168–69; March 19, 1859, p. 1; January 4, 1862, p. 2. *Figaro*: reported by *Harper's* on October 30, 1869, p. 698.

19 See Anne Coffin Hanson, *Edouard Manet, 1832–1883* (exhibition catalog, Philadelphia Museum of Art, 1966), p. 89.

20 *Frank Leslie's Illustrated Newspaper*, February 21 and 28, and March 14, 1857.

21 *Harper's Weekly*, February 14, 1857, pp. 95–96.

22 James Twitchell, *Preposterous Violence: Fables of Aggression in Modern Culture* (New York: Oxford University Press, 1989), *passim*, and especially pp. 182, 200.

23 Edward Shorter, *The Health Century* (New York: Doubleday, 1987), pp. 5, 37, 44, 45.

24 Geoffrey Gorer, "The Pornography of Death," in *Encounter*, vol. V, no. 4 (October 1955), p. 51.

From *Why We Watch: The Attractions of Violent Entertainment*,
ed. by Jeffrey H. Goldstein (New York: Oxford University Press, 1998)

FOR THEIR EXPERT EDITING AND WARM SUPPORT, I wish to thank Erla Zwingle and David Schonauer at *American Photo* (formerly *American Photographer*), Marilyn Minden and Annette Grant at the *New York Times*, Wayne Lawson at *Vanity Fair*, and for her tireless good services on this book, Diana Stoll at Aperture.

I also wish to thank the Harry Frank Guggenheim Foundation for generous support that enabled me to write "Death Takes a Holiday, Sort of."

V.G.

INDEX

TEXT AND PHOTOGRAPHY CREDITS